THE FOCAL EASY GUIDE TO

AFTER EFFECTS

For new users and professionals

CURTIS SPONSLER

AMSTERDAM • BOSTON • HEIDELBERG • LONDON • NEW YORK • OXFORD
PARIS • SAN DIEGO • SAN FRANCISCO • SINGAPORE • SYDNEY • TOKYO

Focal Press is an imprint of Elsevier

ELSEVIER

Focal Press

i180638810

Focal Press
An imprint of Elsevier
Linacre House, Jordan Hill, Oxford OX2 8DP
30 Corporate Drive, Burlington MA 01803

First published 2005

British Library Cataloguing in Publication Data
A catalogue record for this book is available from the British Library

Library of Congress Cataloguing in Publication Data
A catalogue record for this book is available from the Library of Congress

ISBN 0 240 51968 X

For information on all Focal Press publications visit our website at www.focalpress.com

Typeset by Newgen Imaging Systems (P) Ltd, Chennai, India
Printed and bound in Italy

Working together to grow
libraries in developing countries

www.elsevier.com | www.bookaid.org | www.sabre.org

ELSEVIER BOOK AID International Sabre Foundation

Contents

Building Your Project 67

Advanced Compositing Features 153

Appendices

Acknowledgements

The development of this book would not have been possible were it not for several people's influence and encouragement:

Gary Davis, author of *The Focal Easy Guide to Discreet combustion 3* – he is responsible for suggesting me to Focal for this book. Thanks Gary (said with only a slight sarcastic tone).

Team After Effects – to the many dedicated geniuses (mad scientists) who unleashed desktop digital content creation to us all and forever changed the animation world, my deepest appreciation. I hope this book is worthy of your endeavors and dedication.

Rick Young, keeper of the AE Portal (http://msp.sfsu.edu/Instructors/rey/aepage/aeportal.html), a superb resource for all that is After Effects. Thanks for passing along your tips.

Peder Norrby, Trapcode, another mad scientist whose incredibly cool plug-ins have made many design and animation projects more intriguing and amazing. Thanks for the tools that make my projects fun!

Marie Hooper, Focal Press – with her encouragement and direction I was able to complete this undertaking without losing my passion for the subject of this book. Congrats on your new little girl!

My deepest thanks go to my family, who endured and encouraged this book to completion: to Alec, my little boy who astounds me with his incredible perseverance and achievement to everything he tries (the sports gene must be recessive), and to Erin, my little girl who inspires me with her creativity and artistic flair (my grandfather lives in her imagination) and makes me joyful every day with her warm and delightful smile.

But my most indebted and earnest thanks go to my wife of 17 years – the young lady whom without her inspiration, dedication, and faith I would be lost. She set me straight and kicked me in my academic butt. I am forever thankful for her appreciation and tolerance of my digital avocation. Forever I will love her.

THE FOCAL EASY GUIDE TO

AFTER
EFFECTS

The Focal Easy Guide Series

Focal Easy Guides are the best choice to get you started with new software, whatever your level. Refreshingly simple, they do not attempt to cover everything, focusing solely on the essentials needed to get immediate results.

Ideal if you need to learn a new software package quickly, the Focal Easy Guides offer an effective, time-saving introduction to the key tools, not hundreds of pages of confusing reference material. The emphasis is on quickly getting to grips with the software in a practical and accessible way to achieve professional results.

Highly illustrated in color, explanations are short and to the point. Written by professionals in a user-friendly style, the guides assume some computer knowledge and an understanding of the general concepts in the area covered, ensuring they aren't patronizing!

Series editor: Rick Young (www.digitalproduction.net)

Director and Founding Member of the UK Final Cut User Group, Apple Solutions Expert and freelance television director/editor, Rick has worked for the BBC, Sky, ITN, CNBC, and Reuters. Also a Final Cut Pro Consultant and author of the best-selling *The Easy Guide to Final Cut Pro*.

Titles in the series:

The Easy Guide to Final Cut Pro 3, **Rick Young**

The Focal Easy Guide to Final Cut Pro 4, **Rick Young**

The Focal Easy Guide to Final Cut Express, **Rick Young**

The Focal Easy Guide to Maya 5, **Jason Patnode**

The Focal Easy Guide to Discreet combustion 3, **Gary M. Davis**

The Focal Easy Guide to Premiere Pro, **Tim Kolb**

The Focal Easy Guide to Flash MX 2004, **Birgitta Hosea**

The Focal Easy Guide to DVD Studio Pro 3, **Rick Young**

The Focal Easy Guide to After Effects, **Curtis Sponsler**

INTRODUCTION

It's 4:37 a.m. and your project is almost finished. You run a full-resolution rendering out to video for final review, and there it is – your live-action source footage is stuttering, the moving text looks blurry, and the motion tracked effects are not staying aligned to their targets.

I've been there plenty of times: it's really late (or early depending on how you think about it), I'm tired, and my project just sucks. All because I failed to properly set one little option. And now all I have to do is figure out what option it was that I overlooked.

Even with all the excellent on-line help resources available, often I just wanted to keep a simple reference at hand to flip through, guiding me toward the resolution of my problem. That was the impetus of this book – an easy-to-follow, sufficiently detailed, cheat-sheet to get me back up and running, and back to bed.

For Beginners with Experience

This *Easy Guide* is not intended to teach the complete animation neophyte the basics of film and video functions and techniques – it is aimed at the user who understands the basic concepts of video production and operation. It's meant for editors, broadcast graphic artists, 3D animators – the people who already are exposed to everyday motion graphics or animation for video but have not had any or enough hands-on exposure to After Effects. It's for people who both want and *need* to use After Effects.

Author Polishing Forehead

Though there are countless useful features in After Effects I wished I could have covered in more detail (or included at all), I had to keep the scope narrow enough to keep it an *Easy Guide*. Inside I've discussed what I and some other advanced After Effects designers feel are the critical features for day-in and day-out broadcast and animation production: the fundamental aspects that make us better artists as well as make us money.

This is Not a Windows Only Book

I have chosen to use the Windows-OS interface for this book because it's the primary Operating System I use for After Effects and for my 3D animation programs. There is no insidious reason or snub intended by my using Windows screen grabs.

If you are a Mac-OS user, as you progress through the book all screenshots should be fairly representative of what you'll see on your monitors, but with different colors, fonts, and frames. The only change you'll need to keep in mind as you read is the Keyboard Shortcut Keystroke differences:

- Windows-OS 'Alt' = Mac-OS 'Option'
- Windows-OS 'Control' = Mac-OS 'Command'.

For most instances, these simple substitutions should suffice.

Be Not Intimidated

At first click After Effects may look intimidating, but users quickly become drawn in to its web of creative tools. Soon, you can't live without it and find yourself unaware of the hours you spend designing cool new projects to one-up your nearest competitor. But most people simply find it's fun to use – and that's reason enough to know it.

This is not your single function book where each feature is discussed in detail one after another – the overall style of the *Focal Easy Guide for After Effects* is more practical versus theoretical. I'll introduce the key settings to ensure your work looks right. By knowing in advance the technical nuances of After Effects, you'll be less likely to run into some of the more common stumbling blocks that frustrate novice (and many intermediate) designers. You'll discover the interface and key functions used within the production workspace. Then you'll progress to building simple compositions where critical daily features are explained. Finally, you'll move into the advanced feature-set of After Effects. As you progress through each chapter and section you should grasp an ever-increasing array of tools and capabilities. Hopefully you'll learn enough to expand upon this book's lessons to grow beyond what is provided herein.

So read on and find out why After Effects is so compelling and discover a program that will well and truly change your life.

Interface Navigation

The After Effects Workspace

Before you delve right in to creating a project, you should understand the basic structure of the After Effects interface. If you're familiar with most Adobe products, After Effects should look familiar – that's intentional and welcome. But to people who use many other programs, the interface can appear daunting. Trust me, After Effects is as simple a program to use as it is complex in its capabilities. Let's examine the interface and dispel any concerns about its intimidating layout.

A glance at the image below shows what a typical (though colorized) 'workspace' might look like. It contains the three primary production windows that you'll be continually using: the **Project Window** (in yellow), the **Timeline Window** (orange), and the **Composition Window** (green) or Preview Window as others might call it.

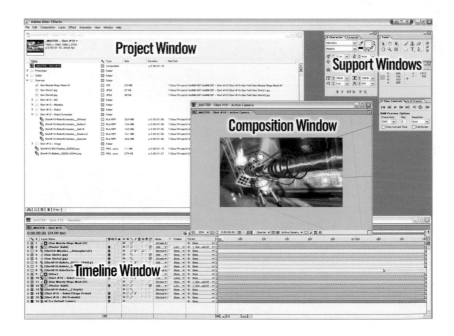

Primary Workspace Windows

The **Project Window** is where you organize all your assets (movie clips, photo and graphic stills, vector files, etc.). The Project Window looks similar to a Finder

or Explorer directory window you might use to navigate through your computer's hard disk. It shows file names, the type of file it is, their size, duration, and location.

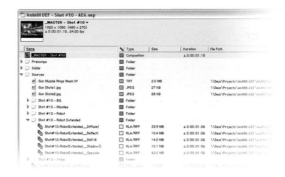

The next two windows are directly associated with one another. The **Timeline Window** and the **Composition** (preview) **Window** are where project design and construction take place. The Timeline Window should look familiar to any editor with its rows of project element layers and Timecode indices. Here's where you apply effects, create Keyframe animations and generally develop your projects.

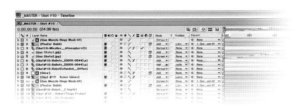

The other main window, the Composition Window, is where you view your project results and physically manipulate your resource elements. Here you can move, scale, and rotate your files, zoom in/out of your rendered composition, create masks, paint/clone, and modify text.

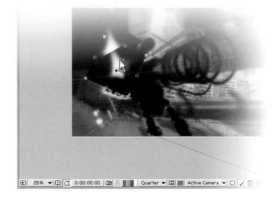

Support Windows

Along with the main windows are several smaller free-floating palette windows (three seen at next page) that provide special functions and options to

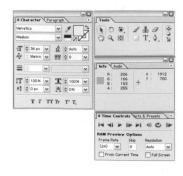

the production process. You can access these under the **Window** menu at the top menu bar of After Effects.

All palettes can be reconfigured, attaching to each other as 'tabbed' floating groups or free to be placed wherever you prefer.

The most common palettes accessed depend on the kind of work primarily created:

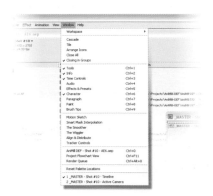

designers might use Tools, Time Controls, Info, and Character controls, whereas effects artists might keep Paint, Tracker Controls, and Smart Mask instead of the Type tools. For this section we'll briefly describe the three most commonly accessed tools and some of their icons' functions: **Info, Tools**, and **Time Controls**. When available, shortcut keys identify the icon feature described.

Info Window – This provides critical functional data about current tasks. There are three areas where information is provided.

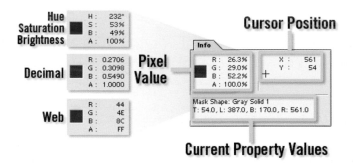

1 **Pixel Value** – tells about the color of the current pixel residing under the cursor. Clicking on the Info Window will switch the readout for different Color-Space modes. HSV = Hue (color), Saturation (vividness), Value (brightness); Web = Web Browser color number in Hexadecimal

or RGB precision where the individual primary additive colors are displayed in Web Hexadecimal, Percentage, 8 bit, 10 bit, or 16 bit depth.

2 **Cursor Position** – provides the coordinates where the cursor's point is located in the **Comp, Layer,** or **Footage Windows.**

3 **Current Property Values** – shows the information about any function being currently performed: rotation angle, scale change, timecode position, etc.

Tools Window – This is the primary resource for cursor functions. Many of the icons have multiple capabilities, which can be accessed by repetitive presses of the icon's shortcut key or by click and dragging on the icon to open a fly-out menu of options:

- **Select & Move** – used to reposition or activate layer items.
- **Grab Hand** – moves the whole workspace within the Comp Window.
- **Zoom** – either magnifies or reduces the workspace.
- **Pan Behind & Anchor** – repositions the pivot point of layers' and slides' Timeline layer elements for editing function.
- **Mask** – creates an oval or square matte inside layers.
- **Type** – allows for direct typography upon the Comp Window.
- **Pen** – creates or modifies Spline Vector Paths for flexible Masks or paths for objects to follow.
- **3D Axis Modes** – set the method for 3D Cameras, Lights, and Layers to respond to cursor input.

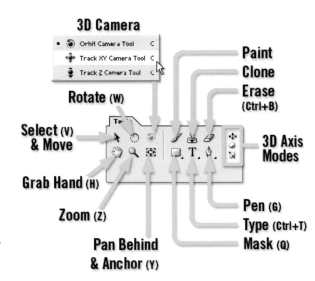

- **Erase** – works with the Paint Tools, functioning like an eraser in Photoshop or any Paint program.

- **Clone** – transfers an image's selected area to another area to hide or modify a feature in the target image.
- **Paint** – allows for direct touch-up or complete paint work upon any layer. This operates in a vector paint mode where all strokes are recorded as Illustrator Splines, permitting continuous modification and non-destructive design.
- **3D Camera** – operates upon the position, rotation, and zooming on any 3D Camera placed in a compostion.
- **Rotate** – selects and spins any layer in either 2D or 3D modes.

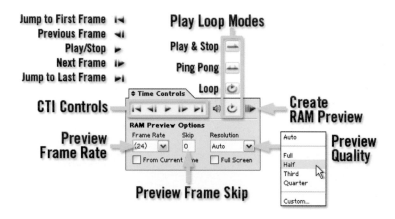

Time Controls – Use this menu to perform RAM Previews or to manually examine the flow of your project. Think of these as your VCR/DVD remote functions for your project's playback.

- **CTI Controls** – operate the RAM Preview playback or allow for control of any layer's review in the Layer or Footage Windows.
- **Preview Frame Rate** – sets the speed the RAM Preview will play back in Frames Per Second.
- **Preview Frame Skip** – permits RAM Previews to jump every 'nth' frame to accelerate the preview creation and use less system memory.
- **Preview Quality** – sets the workspace pixel accuracy to render the RAM Preview. Lower quality percentages increase preview speed and use less memory.
- **Create RAM Preview** – activates the rendering of a Composition or the playback of the Footage and Layer Windows for real-time playback.

- **Play Loop Modes** – sets the method of playback, for either looping or one preview then stop.

The Project Window – Where You Gather Your Work's Resources

As described earlier, the Project Window is where you collect all your production resources or elements and organize your project. With the Project Window you can:

- Make folders to help keep your project tidy
- Import and modify properties of your resources
- Create projects for immediate rendering
- Search/rename/delete/identify resources
- Open movie clips and other resources to preview
- Update/modify/change used resources.

The Project Window's upper left corner displays a thumbnail image of every item you select and provides information about that item. Clicking on one of the little triangle arrowheads and the folder it points at will twirl open to reveal its contents.

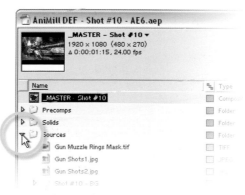

I've emphasized good habits for the organized designer – use folders and use them often. If you don't use folders, your Project Window could end up looking something like the image at

right – and that was just a small project.

Project Window Buttons

There are five small buttons along the bottom left of the Project Window, as seen here.

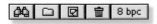

From left to right, they are:

- Find Project Item
- Make Folder
- Make Composition
- Delete
- Project Bit Depth.

Importing Resources

There are several ways to add items to the Project Window: using the Import dialog and by drag and drop from your Finder or Explorer. For consistency I'll be focusing on the Import dialog method because of its similarity to other file management techniques used throughout After Effects.

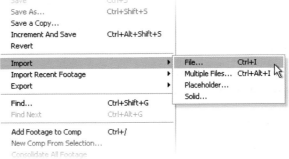

On the main menu bar under **File** you'll find the Import function. With this you can gather all the elements or resources you need to build your projects.

You are offered several methods how to import your resources:

- Single File import
- Multiple Files import
- Placeholder creation
- Solid creation.

With **Single File** (Ctrl + I) you can grab just one file, clip or a continuous sequence (sequential frames) of related images for import. Alternatively, by holding either the Shift of Control keys you can select consecutive or random groups of files that reside in the same folder.

With the **Multiple Files** selection (Ctrl + Alt + I) you can gather numerous individual resources, as well as multiple sequences, residing in different folders at once.

The **Placeholder** function allows you to build projects while elements are still being created in other programs (i.e. while a 3D logo is being rendered, or a designer is illustrating a logo), allowing you to set up an After Effects composition in advance. Placeholders show up as frames of colorbars.

> **Tip:** Get into the habit of using the keyboard shortcuts offered throughout this book. See www.focalpress.com/companions/024051968X for a list of the major keyboard shortcuts you should learn.

Solid import is similar to Placeholder but creates color-filled boxes useful for many effects applications. However, you'll be better off creating your Solids resources as you build your projects.

Additionally, you can access the **Import** dialog box by two other methods: either by double-clicking inside the Project Window (this opens the 'Single File' Import dialog) or by right-clicking inside the Project Window to reveal a floating menu.

The Import Dialog Box

Press 'Ctrl + I' to open the 'Single File Import' dialog. It looks similar to any Adobe style 'Open' dialog box with its simple navigation tools to move around your computer or network.

You can change the method of how files are displayed inside the dialog by clicking on the 'View Menu' (in the upper right corner) button to the right of the

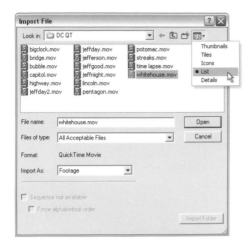

'New Folder' button. I often switch modes to 'Details' to assist in the selection of the most up-to-date files.

At the bottom of the dialog box is a drop-down menu (shown left) that changes how After Effects manages certain imported files. Herein lies one of After Effects' great capabilities: automatic creation of compositions from Photoshop or Illustrator files while retaining a majority of the file's settings.

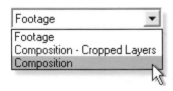

The 'Composition – Cropped Layers' option better isolates your layers' contents. For example, if you have a composition with many small graphics elements per layer, then imported the composition as Cropped Layers, each layer in After Effects would have its elements contained (seen below) within a tight bounding box, excluding all unused space outside the elements' boundaries. Selecting 'Composition' will make a full layer out of each element (see top of next page) filling the entire composition's size – which could be a huge waste of space and RAM, and especially annoying when it comes time to move each element.

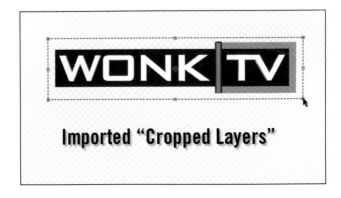

Imported "Cropped Layers"

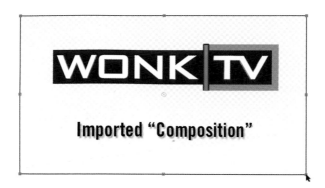

Imported "Composition"

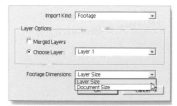

Another method of importing Photoshop files is as 'Footage'. When you choose this option, a second dialog box opens, offering you even more import options (seen left). Here you can select each layer to import individually.

Again, just as importing the whole composition, you can specify whether or not it crops each layer on import.

The Timeline Window – Where You Build Your Work

The main production window for After Effects is the **Timeline Window**. It's here where people get most intimidated and overwhelmed – and that's quite understandable. With its dizzying array of columns, and rows upon rows (if you're working with an already created composition) of layered items, it's very easy to get anxious and lost.

To an editor who is familiar with non-linear editing programs (such as Final Cut Pro, Avid, and Premiere Pro), the window should be familiar. It has time control indices that show the frame/timecode range of your project, layer numbers and

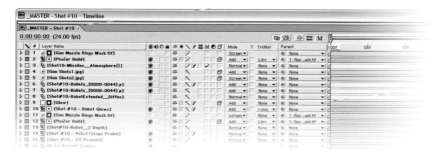

file names, and functions that let you show or hide your files. But there the similarities end, for After Effects offers considerably more options per layer than any editing program.

Top is Front – Bottom is Back

The first thing to know about After Effects is that it builds in a top-down mode – that is, the top item in the Timeline Window, layer 1, is the layer seen foremost above all other layers. Conversely, the bottom row layer will be furthest in the background of your project. Of course, as with all rules the exception occurs when you work with 3D layers – this will be discussed in a later section.

Composition Settings

Let's begin with a clean sheet and create a new project.

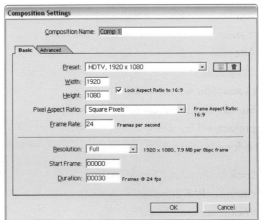

1 Press 'Ctrl + Alt + N' or use the main menu File > New > New Project. If asked to save your present work, click 'No'.

2 In the Project Window, at the bottom of the frame, click the 'Make Composition' button (Ctrl + N) to the left of the trashcan. Alternatively, you can use the main menu Composition > New Composition.

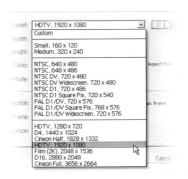

3 The 'Composition Settings' dialog opens, displaying production options for composition size, frame rate, duration, and more.

After Effects has several commonly used industry settings available under the Preset drop-down menu. Each is user modifiable and can be saved as a new

preset. For example, the default HDTV preset is for 1920 × 1080 at 24 fps or digital cinema production. If you find that you work HDTV at 29.97 fps (for those of us stuck in the NTSC compatibility dark ages), all you have to do is change the Frame Rate number to 29.97, then click on the little floppy disk icon (seen right) next to the Preset name, type a new name 'HDTV 1080|29.97i', then press 'OK'. It's then added to the bottom of the Preset list.

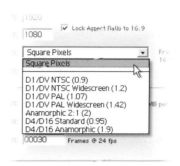

Pixel Aspect Ratio (PAR)

To those of you who have no idea what this refers to (see 'Practical Concepts of Things You Need to Remember' section), know this: it was invented by sadistic TV engineers (not After Effects programmers) to drive us artists crazy. This setting determines how the final production will be viewed: Widescreen or Standard. It is critical to know how your final project will be viewed prior to beginning work or else you'll be spending hours re-formatting your Composition's layers to fit the correct screen size.

Look at the 'Pixel Aspect Ratio' drop-down menu and you'll see the most common PAR settings for production: Square Pixels, Digital TV, 16:9 Widescreen, and Cinema Anamorphic. These presets determine the method used to physically scale images within the Timeline and Composition Windows, and how your project will render at output.

Timeline Columns and Options

The Timeline Window (shown below slightly altered from default settings) can be modified almost to the point of dysfunction, especially if you only have one monitor.

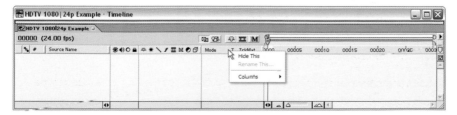

By right-clicking the mouse cursor on the column headers, a list of **Column Options** will appear.

This list offers users many options to customize their Timeline Window. Editors might like to have the In, Out, and Duration columns showing, while someone reviewing another designer's project might use the Comments column.

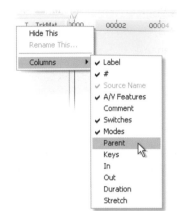

You can also rearrange the order of columns by clicking on a column's header, then dragging the header to a new position in the Timeline Window. I like to move the **A/V Features** column after the **Source Name** column; to me it makes sense to have the layer numbers leading the rows. I also add both the **Modes** and **Parent** columns because they are both accessed often.

Timeline Window Tour

At the top left corner of the Timeline Window (seen below), move the mouse over the underlined blue **Current Time** numbers. Hold down the Control (Ctrl) key and click on the numbers to change **Time Display** modes. It cycles from 'Frames' to 'Feet + Frames' (for you cinema people) to 'SMPTE Timecode'. Also, scrubbing the mouse cursor over the numbers causes the Timeline's **Current Time Indicator** (**CTI**, seen right) to scan across the Timeline Window.

The far left **Arrow** (bottom right highlight) functions the same as the Project Window's **Expand Folder** arrow: it opens the various adjustable properties available to that layer.

The square **Label** box, next, allows you to highlight each

layer or groups of layers in different select colors – as based on predefined (adjustable in the Preferences menu) label colors.

Next is the layer **Number**. Unlike other programs, there is no preset limit to the number of layers you can build.

The **Source Name/Layer Name** first displays the Source Name of all layers – that is, the name shown reflects the name displayed in the Project Window. To rename a layer:

1 Select (highlight) the layer you want renamed, then press 'Enter'.

2 Type your new Layer Name (limited to 31 characters of any kind), then press 'Enter' again.

The column header title changes to Layer Name once you rename a layer. Clicking on the column header will revert back to Source Name.

Notice also that some columns have a 'handle' at their edge. Dragging on this with the cursor will expand and contract a column's width.

The **A/V Features** column is next. The eyeball is the 'Video Hide/Show' switch. This either allows the contents of that layer to be seen (or not) in the Composition (preview) Window. Next to that is the 'Audio Play/Mute' switch (if your source has audio). Following the 'Audio' switch is the 'Solo' button. This button isolates the selected layer (think of it as a video show override) from all others, allowing users to focus their work on that layer's options/effects. You can 'Solo' multiple layers at the same time. Beware forgetting when they are on. This can become an issue when you 'Solo' layers within a nested Precomp or that are scrolled offscreen. Lastly in the A/V Features is 'Lock'. Quite simply, it prevents any changes to the selected layer, intentional or not (except any switch changes made in the A/V Features).

Next up are **Switches**. The funny looking face is the 'Shy' button. Click on it and, when the main 'Shy' button (at right) is activated,

all 'Shy' layers are hidden from the Timeline Window, but are

still used in the final output. This is helpful when your project becomes unwieldy, with too many layers to scroll through.

> **Important Hint:** Keep track of using the 'Shy' button; if you have a number of layers hidden and you continue to add more layers, observe the layer's **Number**. Sometimes a layer can interfere with a hidden layer (or vice versa) without you knowing it until you render the project.

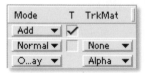

The second to last column is **Mode**. Mode provides two tasks: 'Mix Mode' and 'Track Matte'. Mix Mode is the method where a layer's images are applied to layers beneath (additive, subtractive, lighten,

darken, saturation, color, etc.). We'll discuss this concept in detail later.

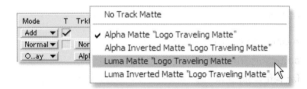

Track Matte activates a layer's traveling matte, or video mask, that is captured from the layer above. When you have a separate matte/Mask/Alpha clip or image, Track Matte is the quickest way to apply it to your fill layer. Again, this will be clarified later.

The large right area is the actual **Timeline**, where your various clips, images, and compositions are assembled. These layers are given a range of time where they affect the composition as a whole. These segments look like a thick line with a ramp at the start and end. The ramp is a handle where you can edit a segment's **In** and **Out Points**. The actual clip's In/Out Point is where the ramps touch the color **Timeline Bar**. Each layer can have only one Timeline Bar applied.

At the top of the actual Timeline above the frame/timecode

numbers (where the CTI is dragged) is the Work Area identifier bar. This gray bar has its own In and Out markers that you set to define where previews and renders will begin and end. You can either drag the markers with the cursor or set them precisely by placing the CTI at the times you want marked, then press 'B' to mark the beginning and 'N' for the end. You can also drag the Work Area as a whole by click and dragging the center hash marks (shown on the previous page), then moving the bar to its new location.

Composition Window – Where You See Your Work

You preview your project in the Composition Window. For most instances, this is a true **WYSIWYG** rendering of your project. The only exception to this is in regard to field renderings. Here you can make changes to your elements (move, resize, rotate, make masks), compose text, distort layers, and more. It has several preview modes and many options to how you interact with your layers.

Along the bottom edge of the Composition Window are several buttons for adjusting the responsiveness and modes of your previews. Beginning with the far left boxed arrow, when there are multiple Composition Windows open this locks the view you select as the view seen in RAM previews.

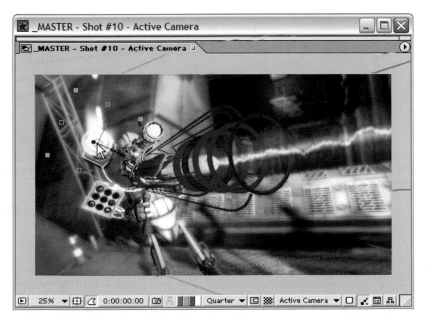

To the right of that is the **Magnification Ratio** pop-up. This setting zooms your view either tighter or wider within the window, allowing you to work more precisely or loosely. You select the precision of your view by clicking on the percentage then dragging to the setting you need, or press the Comma (,) key for **Zoom Out** or the Period (.) key for **Zoom In**.

Next is **Title/Action Safe Generator** (image below). When you build projects, you need to ensure that what you build is what is seen. But you often cannot know how someone is going to view your project, so by using the **Title/Action Safe** grid you have a better chance to ensure that your most important information (text particularly) is not cropped out of view by a bad screen. In addition, if you Alt + click this button you access the Grids overlay. The grid spacing is adjustable in the Preferences menu. Press Apostrophe (') to activate Title/Action Safe Generator.

The little curved icon next to the **Safe Generator** is the **View Masks** button. It either hides or shows the displayed outlines of masks, but does not affect the masks' function.

The **Frame/Timecode** display shows the current Frame Number, Footage Count, or Timecode of your Timeline. Click on it, or press 'Ctrl + G', to open the **Go To Time** dialog.

The small camera icon (below) captures quick screen **Snapshots** of your present view. You can then use snapshots for reference by pressing the next button (the person's figure – **Show Last Snapshot**) to toggle between the saved Snapshot and the present view.

The four color bars allow you to isolate the **RGB** and **Alpha** color channels of your composition. This is helpful when adjusting your matte settings or when trying to analyze your images for color

accuracy. When you select any of the bars a corresponding color frame surrounds the preview window to remind you that channel button is active.

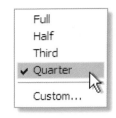

To save on memory and speed up the rendering process, you can adjust the Composition Window's resolution accuracy: Full, Half, Third, Quarter, or Custom. You can link the **Resolution** to the **Magnification** in the Preferences menu. The advantage to this linking is a clearer image with a saving of RAM and corresponding speed increase for the screen size viewed. One quick note: for every halving of screen resolution/magnification, the memory requirements drop by a factor of 4.

Sometimes you need to isolate a specific area in your Composition Window to increase the responsiveness of the interface. You can use the **Region Of Interest**

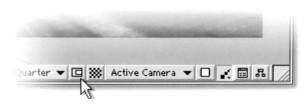

(**ROI**, seen above) tool to create a screen-wide mask that excludes all unselected areas from affecting some effects' calculations and reduce file updating.

Clicking on the **Transparency Grid** toggle (to the right of the ROI button) will swap the Composition Window's background from the default color (selectable by pressing 'Ctrl + Shift + B') to a clear checkerboard pattern as seen in Photoshop.

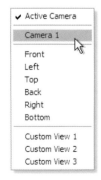

Next over is the **3D View** selector. When you are using 3D layers and cameras, use this drop-down menu to choose the view to preview. You can even have multiple views active by changing the number of **Composition Views** under the main menu bar > **Window** > **Workspace**, then select the number of windows you want to see.

The next four buttons in quick succession do the following:

- **Pixel Aspect Ratio compensation** – corrects your Composition Window's view to account for an image's anamorphic/widescreen squeeze.

- **Fast Previews and OpenGL interactivity settings** – change the mode of your screen's interactive redraws. If you have a fast OpenGL video card, you'll see significant responsiveness increases by using OpenGL. As an alternative to OpenGL, you can use Adaptive Resolution to compensate for slow redraws.
- **Timeline Button** – quickly brings to the foreground the associated Timeline of your present view. If you ever get lost with zillions of Timelines, press this button to find the Timeline that matches your Composition Window.
- **Flowchart view** – opens another window where you can navigate through your composition in a more visual iconic interface.

At the upper right corner of the Composition Window is the **Options** button. Click on this to access various options and settings regarding the Composition Window's function.

Support Palette Windows – Pop-up Tools for Productivity

Click your cursor on the main **Window** menu to open a list of additional floating support palettes. These little windows offer various effects, tools, and functions that you'll access less often than the primary windows. Depending on the screen real estate available, you can either keep several of these open or open them only when needed.

Workspace	▶
Cascade	
Tile	
Arrange Icons	
Close All	
✔ Closing in Groups	
✔ Tools	Ctrl+1
✔ Info	Ctrl+2
✔ Time Controls	Ctrl+3
Audio	Ctrl+4
Effects & Presets	Ctrl+5
✔ Character	Ctrl+6
Paragraph	Ctrl+7
Paint	Ctrl+8
Brush Tips	Ctrl+9
Motion Sketch	
Smart Mask Interpolation	
The Smoother	
The Wiggler	
Align & Distribute	
Tracker Controls	
AniMiil DEF - Shot #10 - AE6.aep	Ctrl+0
Project Flowchart View	Ctrl+F11
Render Queue	Ctrl+Alt+0
Reset Palette Locations	
✔ 1 _MASTER - Shot #10 · Timeline	
2 _MASTER - Shot #10 - Active Camera	

Each palette can be docked to one another or attached as 'tabbed' groups by dragging a window on top of another. I find the most useful palettes to keep open to be:

- Tools
- Info and Audio
- Time Controls and Effects & Presets
- Character and Paragraph.

However, depending on the kind of work you do most, your list might be different. For example, let's say you do a lot of Rotoscoping and Paint Cloning work, you'll

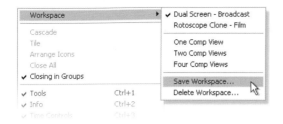

probably want to keep the **Paint** and **Brush Tips** and the **Tracker Controls** open, but not have the **Typography** tools available. The idea is to keep your interface clean and uncluttered.

Once you have the After Effects interface looking the way you like to work, you can save your screen layout so if someone mucks up your settings, you can quickly reset everything to your preference. At the top of the **Window** menu is the **Workspace** menu. Within the sub-menu is the 'Save Workspace' command. Click on it then type in a name for your preferred layout. That workspace will then appear at the top of the sub-menu for future access. Then all you have to do is click on your workspace name and the screen will rearrange to your layout.

Notice there are several alternate screen layouts: One, Two or Four Comp Views. These options are useful when working in 3D camera modes, allowing you to see different perspectives of your project at the same time. 3D animators will appreciate these settings, but for most design work 'One Comp View' will be sufficient.

Help – The Most Ignored and Overlooked Menu

OK, so now you know where everything in After Effects is and how to access every effect and option available – right? Not even close. There is a vast list of other options, settings, shortcuts, and hints that I can't even begin to touch on in this guide. That's why the User Reference exists – to provide a plethora of knowledge to the user in simple concise paragraphs. The writing team for After Effects has spent many months preparing the User Guide, Tips, and Help system to make it accessible to everyone who has the wisdom to follow their advice.

Take, for example, the 'Text Preset Gallery'. Here you'll find a great array of cool effects you can access in the **Effects & Presets** tool palette. Then there's the

vast pool of hints and general knowledge in the table of contents listed on the left of your browser. Use this guide – it really offers help that is genuinely helpful.

Focus on the Timeline Window

As described in the Interface Navigation section, the Timeline Window is where the vast portion of your work in After Effects takes place. The Timeline Window is the true paintbrush to the Composition Window's canvas. It's the workbench in the auto speed shop where engines are constructed and performance is boosted. With the Timeline Window you can apply a wide assortment of functions, such as:

- Infinitely assemble a wide assortment of media files
- Transform (move, scale, rotate) and blend footage clip layers
- Keyframe animate practically every function, attribute, or option in every layer
- Embed or nest other Timelines within one another to create an expanding array of interwoven compositions – precomping.

In this section we'll examine more closely the Timeline Window and the more commonly accessed array of layer options available to the designer. Later in the book we'll expand on the Timeline Window's capabilities and explore its more advanced feature set.

Mix and Match Files

One of the reasons why After Effects was developed was to allow the unfettered mixing of different media file formats. With After Effects it matters not that you have a 15 fps cruddy web downloaded video clip in the same project as a 4K-resolution digital camera still, 24 fps film-shot, live-action, blue-screen actor, with an MP3 music track. In fact, that's what you're supposed to do – use every resource you can think of and let After Effects sort it all out.

Projects vs Comps

There is a common misunderstanding of what constitutes an After Effects Project versus a Composition (Comp). Consider a Project the 'binder' containing many Comps. Your Project is the actual master file saved and opened on your computer, while a Comp is where you design, create, and render your work.

A Clean Slate

1 Create a new Project (Ctrl + Alt + N) and a new Timeline Window (Ctrl + N) using any of the Composition Settings presets. When you make a Timeline, a Composition Window will also be created.

2 Organize your workspace to resemble the illustration below.

3 Now import (Ctrl + I) the following files: *CloudsLoop.mov, Hair-16.mov, Lines.tif, AniMill_Countdown.mp3, WONK Logo Master.ai*, and *WONK Logo.png*. If you haven't downloaded these samples, try to grab a diverse assortment of media and formats upon which to experiment.

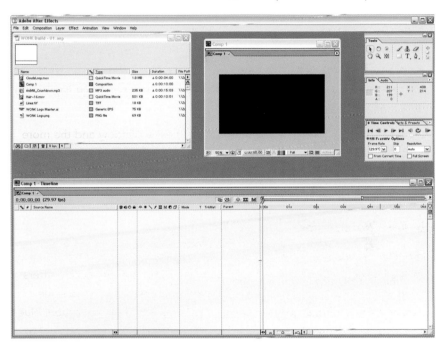

A Note on Downloading Exercise Resources

Each example can be downloaded from the Focal Press website at www.focalpress.com/companions/024051968X. I've prepared all the resources as small, highly compressed, and virus-free elements. Even on a slow modem you should be able to acquire the files without much headache. You can of course use your own materials, but it's important that you try to match the formats of the examples I provide.

Composition Settings

Begin by modifying your composition's settings – with the Timeline Window active (selected), press 'Ctrl + K' to open the Composition Settings dialog box.

1 Modify the following: change the Composition Name to 'WONK TV – Design Test_Build 01', then set the screen size to 640 × 360 with Square Pixels at 24 fps, and change the Duration to 10:00, but do not close the window.

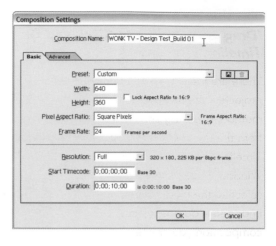

I used a long name to show you an After Effects limitation – as of this version's release, file and composition names have a 31-character limit. This does not imply that your imported resources can't have longer names than that. It only means that your long-file-name resources will have their names truncated in the Project Window and Timeline Window layers.

2 Notice also that the Timecode Base for the Composition Settings might be set to 30 (though it could be 25 for PAL). Click 'OK' and return to the Timeline Window – you'll probably need to reconcile the Timecode Base differences. To demonstrate this conflict with your project's Timecode Base, press the 'End' key to jump to the last frame of the Timeline. Look at the time display ('Ctrl + click' on the blue numbers to cycle through the various numerical display options) and you should see 0:00:09:28 (PAL numbers will be different). This is because the display Timecode Base is set to 30 fps.

3 Open the Project Settings dialog, **File > Project Settings** (Ctrl + Shift + Alt + K), then change the Display Style – Timecode Base to 24 fps and press 'OK'.

4 Back to the Timeline Window – the last frame now displays 0:00:09:23.

Remember, keep your Project Settings' and Composition Settings' time bases matched!

'Drag and Drop' and 'Click and Drag' – Moving Timeline Elements

There are many ways to build your projects – the most common method is to drag and drop items from the Project Window into the Timeline Window. In the Project Window, drag the mouse cursor to select all the media clips you imported – do not select the composition you created. Once they are selected, drag all the items down into the Timeline.

You'll notice that wherever you drag the selected clips, a little '+' icon follows the cursor. This indicates that you are in 'drag and drop' mode to build your composition.

Continue to 'drag' your items into the left area of the Timeline Window, then release

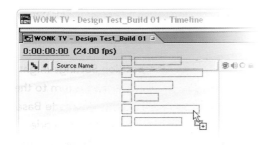

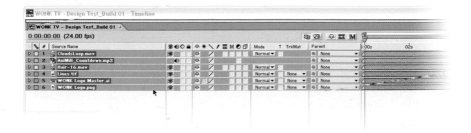

the mouse to 'drop' them into the Timeline. If nothing went wrong, the Timeline should look something like the image at the bottom of the previous page.

However, there's also a good possibility that your dragged items ended up completely in the wrong place – more like the image at left showing all the clips just barely within the Timeline. This can happen when the Current Time Indicator (CTI – blue arrow) is at the end of the Timeline.

This is After Effects trying to help you – it wants any clips dragged into the Timeline to align with the current position of the CTI. This can be a great help or drive you crazy, depending on how you construct your layers.

If this 'drag and drop' misplacement happens, and it happens to all of us, here's a simple fix:

1 With the Timeline active, select all the layers (Ctrl + A) or the individual layers you want to align back to the start of the Timeline.

2 Press 'Alt + Home' and all the selected layers will 'snap' to 0:00.

3 Likewise, if you simply want to align any layers to the CTI's position, press '[' (the open bracket key) to snap all the selected layers to the CTI's position.

Compositions Are Like Onions – They Have Layers

Now that you've created your first composition (Comp), let's examine some layer management techniques and animation functions. Currently, the layer order is all wrong for this project – you need to change it. Move the topmost layer (*CloudsLoop.mov*) to the bottom position (layer 6). Do this by click and

dragging the layer name down the list and place it under layer 6's current position. As you do this, a thick black line follows the dragged layer, indicating where

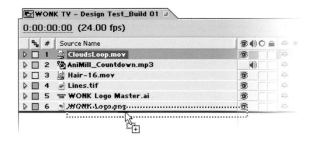

it will place the layer once you release the cursor.

This is the crux of After Effects – manipulation and ordering of layers with the media they contain. You could have just as easily selected all the layers beneath layer 1 and dragged them upwards above the *CloudsLoop.mov* layer. Shuffling layers becomes the *modus operandi* for most designers and keeping track of them as they grow (the layers, not the designers) becomes arduous and exhausting. We'll discuss methods of better organizing your Timeline layers later in the book.

For now, we'll keep it simple. Reorder the layers to the following positions:

1 > *Hair-16.mov*

2 > *Wonk Logo.png*

3 > *Lines.tif*

4 > *Wonk Logo Master.ai*

5 > *CloudsLoop.mov*

6 > *AniMill_Countdown.mp3.*

Audio layers can exist any order in the layer tree. But since they take up valuable workspace real estate, consider placing them at the bottom of your Comp list. Having an audio layer between image layers can cause some confusion and conflicts if you forget its place in the list.

Layer Components

Every layer has animation properties that can be accessed by twirling (clicking the arrow causes it to 'twirl' open) the white arrow in front of their color label and number.

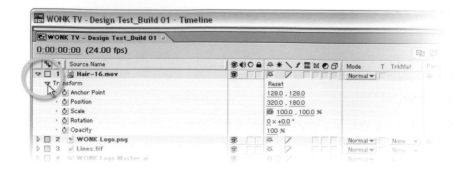

The basic property in every layer is **Transform**. It has five animation attributes that can be applied to all image media:

- Anchor Point
- Position
- Scale
- Rotation
- Opacity.

Each of these Transforms controls how the layer's image will be viewed and changes as the Timeline is animated.

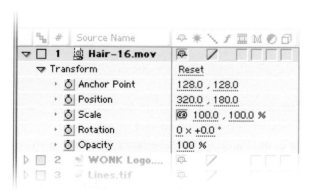

A closer look shows (with a more compact view of the previous Timeline) the correlation of each attribute to their numerical values.

Each image can have different numerical values, so only use the image at left as a reference while we discuss their meaning.

Reset – To the direct right of the sub-option title, Transform, is the Reset function. Clicking this will simply make all the function's numbers revert to their nominal or original values.

Anchor Point (A) – This number identifies the image's physical center point. It is where all interaction with respect to position, rotation, and scale occurs.

Position (P) – The numbers here refer to the image's current X and Y coordinates within the Composition Window. They define where on the screen an image, with respect to its Anchor Point, is located.

Scale (S) – You can alter your image's vertical and horizontal size either together (constrained) or individually. You can unlock the constraint, make a size alteration, then re-lock the constraint to allow for proportional scaling of the new values.

Rotation (R) – Spin your image with this. Rotation values are set to the image's offset angle in degrees plus the number of full rotations as an integer. An image rotated $+765°$ would translate to $2 \times 45°$, while the number $-435°$ would translate to $-1 \times -75°$.

Opacity (T) – Here is your image's overall transparency setting. At 100% your entire image is visible, at 0% it's gone.

Notice that each of the Transforms has an associated keyboard shortcut letter next to the Transform's name.

There are several ways to alter any of the Transform values:

- Float the mouse cursor over any of the blue numbers and the cursor will change into a hand with two arrows (image at right). Clicking then dragging right or left either increments or decrements the values.
- Single-click onto any number and the values will appear highlighted in a small box ready to be manually set via the keyboard.
- 'Right-click' on the name of the transform and a menu opens allowing you to either Reset that function's value or Edit the numbers manually. Alternatively, 'right-click' directly on the value to access the same Edit Window.

Transform Values Edit Window

Of the five Transforms, **Scale** has the most variables in its Edit Window. The example on the next page, top right, has the Width and Height currently set in

'% of source' – the values pertain to the image's size. If you change the Units drop-down menu to '% of composition' the values will relate to the overall composition's proportions. With 'Pixels', the values are an absolute pixel count of screen width and height. 'Pixels' is

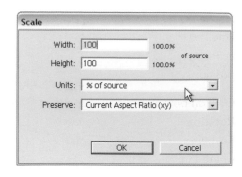

an excellent method to get image sizes to precisely match each other or to the composition's size.

Audio Layers

Twirl open the audio layer and you'll see another function controller – Audio (I bet you weren't expecting that!). If any of your film clips have an embedded audio track, this additional function will appear beneath the Transforms. Further, twirling open the Waveform option will reveal a visual representation of the

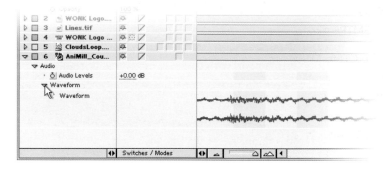

audio track's signal. This is useful for synching audio events to visual cues.

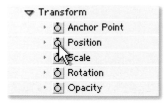

Animating Layer Transforms – Adding Keyframes

Each of the layer's Transforms is fully animatable – it's the reason After Effects exists.

Notice that next to each of the Transforms (Audio included) is a little blank stopwatch. Clicking them 'on' makes that item animatable and inserts a Keyframe into the Timeline at the position of the CTI.

Click on both the **Position** and **Rotation** stopwatches to create new Keyframes. Notice in the Timeline where the CTI is positioned, two diamonds will appear. Also, in the A/V Features column of the Timeline Window you'll see that two new check-boxes have appeared. A check

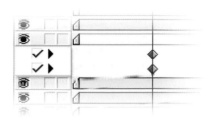

indicates that the CTI is positioned over a Keyframe applied to that Transform.

Press 'Ctrl + G' to bring up the **Go To** Window – type '1.' (number 1 followed by a single decimal point), then press Enter. This is another favorite shortcut of mine – simply typing the number 1 with one decimal point is interpreted by After Effects as meaning the same as '0:00:01:00' but takes far fewer keystrokes. Likewise, if you had typed '1..' the CTI would have jumped to '0:01:00:00' and so forth. To go to '0:00:09:09' you would type '9.9' – this only works in SMTPE Timecode and Film Footage display modes.

Return the CTI to '0:00:01:00'. Now the check-boxes are both empty and have little black arrows pointing backwards. To create a new Keyframe, either click inside the boxes or just manually change one of the corresponding values to a different number, thus forcing a new Keyframe. You should see something like the image below.

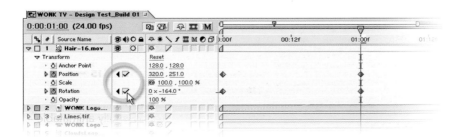

If you click on the black arrows next to the Keyframe check-boxes the CTI will jump to the closest previous Keyframe. Similarly, when a right-facing arrow is showing, clicking on it will jump the CTI forward to the next Keyframe set.

Another favorite helper of mine is the **Solo** switch (right). Click on it when you need to focus your attention on one (or more) layer's adjustment. Just don't forget to switch it off before you render! Now save your work (Ctrl + Shift + S) as 'WONK TV Design – Build 01.aep'. You'll be using this project in the next few sections.

Blending Modes

A brief look at the Composition Window will show that the layers we added to the Timeline Window create an unfinished image. The *Hair-16.mov* layer appears as a black box on top of the WONK TV logo, which is on top of the Lines, which blocks everything else behind. What is needed is a way to mix the various layers, permitting each to be seen or used as a source for another layer's effects.

After Effects performs this mixing of layers through the use of the **Blending Modes** – an assorted selection of transfer methods of one layer's contents to the layers beneath. If you are familiar with Photoshop and its Layer Blending selections, then you already understand After Effects' Blending Modes – if,

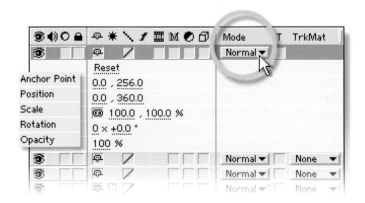

however, you've never used any graphics programs with blending or transfer modes, then do try to keep up.

Return to the Timeline Window and reset the Transforms in layer 1. Then set the 'Anchor Point' and 'Position' to the values above; this places the hair in the lower right corner of the Composition Window.

If, for some reason, the **Modes** column in the Timeline Window is missing, right-click on one of the column headers to reveal the Columns Chooser, then check Modes. Click on the drop-down menu button with 'Normal' listed directly under the Mode title (highlighted above). A long list of Blending Mode options will appear. Select 'Lighten', then look at the Composition Window. The hair's black background has now been blended out because 'Lighten' transfers the brighter pixels of an image to the layers below while fading the darker pixels and completely hiding the black.

This is just one mode out of 34 (as of After Effects 6.5) – each has a unique effect it applies to its layer. Some Blending Modes have a compound effect on all layers beneath, while others may only affect the layer they're applied to.

To see what a few more Blending Modes look like, set the following layers to the listed Mode:

1 > Lighten
2 > Normal
3 > Overlay
4 > Screen
5 > Normal.

Now look at the Composition Window; the design now looks a little better – but not yet complete. We'll fix the rest of it in the next section, 'Focus on the Composition Window'.

Normal
Dissolve
Dancing Dissolve

Darken
Multiply
Linear Burn
Color Burn
Classic Color Burn

Add
✓ Lighten
Screen
Linear Dodge
Color Dodge
Classic Color Dodge

Overlay
Soft Light
Hard Light
Linear Light
Vivid Light
Pin Light
Hard Mix

Difference
Classic Difference
Exclusion

Hue
Saturation
Color
Luminosity

Stencil Alpha
Stencil Luma
Silhouette Alpha
Silhouette Luma

Alpha Add
Luminescent Premul

Track Matte

The final and a key (get it?) component of
layer capability is the **Track Matte**. Think
of Track Matte as a separate key source
or another Alpha Channel for a layer to
use. This key source will come from the

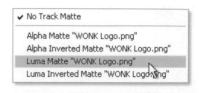

layer immediately above the layer using a Track Matte. In layer 3, click on the
button adjacent to the Mix Mode (set to Overlay) and another menu opens.
This is your Track Matte selector and it will only reference the layer above the
Track Matte layer.

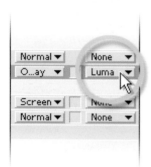

Choose 'Luma Matte' and then notice the
following results. First, layer 2 has been switched
off (no eyeball showing) – that's because now
that it's been referenced as the Track Matte
source, you don't (generally) want it mixing its
image into the comp. Second, two new icons
have appeared signifying that the two layers are
related as the Track Matte source (matte) and
Track Matte image (fill). And third, the WONK

TV logo has turned into a
zebra textured logo that's
blending into the clouds layer.

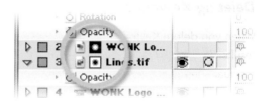

Now cycle through the three
other Track Matte options to
see what the settings all do.

You might want to activate the Solo switches of layers 3 and 5 to better
demonstrate the options. The images below illustrate the differences between
the four Track Matte modes. When you select either **Alpha** mode, only the
source layer's **Alpha Channel** is used as the key channel, while the 'Luma'
options pull from the source layer's luminance values to determine the fill layer's
opacity levels.

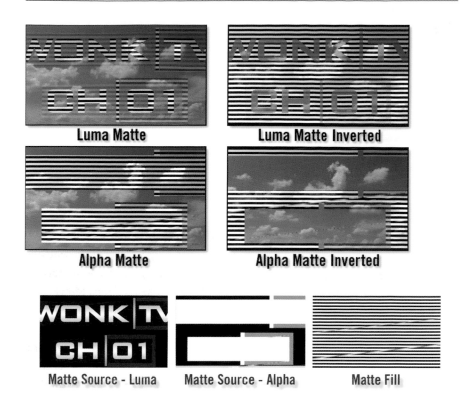

Luma Matte Luma Matte Inverted

Alpha Matte Alpha Matte Inverted

Matte Source - Luma Matte Source - Alpha Matte Fill

Deleting Keyframes

When you delete Keyframes in the Timeline, you may get some unexpected results. There are several ways to delete Keyframes, each yielding different residual numerical values for the animated item:

- Highlighting all Keyframes of a property then pressing 'Delete' will result in the property's value matching the value of the first Keyframe.

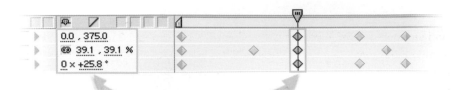

- Leaving a Keyframe after deleting all others will set the property's value to the remaining Keyframe's value – then, deleting that remaining Keyframe will still maintain that value.

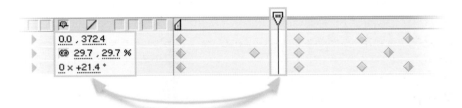

- Switching off the stopwatch of any animated property will set the values to the current numbers indicated by the location of the CTI on the Timeline.

Nudge Nudge – Know What I Mean?

With all the Transform Windows and Numerical Inputs available to you, often it's simplest to just nudge (not fudge) your frame numbers, layers or property numbers. This is accomplished by a few quick strokes of the keyboard.

- **Page Up (PgUp)** – moves the CTI backward one frame.
- **Page Down (PgDn)** – moves the CTI forward one frame.
- **Arrow Down, Up, Left**, and **Right** – nudge a selected object one pixel at a time in the direction of the arrow pressed.

You can modify these shortcuts to multiply their actions by a factor of 10 by holding down 'Shift' as you press one of the nudge keys, i.e. 'Shift + ↓' will nudge an object down by 10 pixels, while 'Shift + PgDn' will jump the CTI forward on the Timeline 10 frames.

And yet there's more: if you have the Comp/Layer Window magnification set to a value other than 100%, your arrow nudges will also be affected. For example, if the Comp Window is set to 200% a single arrow stroke will move an object half a pixel, while a setting of 25% will result in a single arrow press moving your object 4 pixels.

Go To Dialog Box Idiosyncrasies

When using the Go To dialog to move about the Timeline, you can either enter the exact time, 'Absolute Mode', or you can type in the numbers you want to increment forwards or backwards, 'Relative Mode'. 'Absolute Mode' input is best when you are jumping to a location where you know the exact value, whereas 'Relative Mode' is most convenient for jumping precise incrementing values. To move forward in 'Relative Mode' you type a Plus sign (+) followed by the value you need to increment. But here's a quirk: to move backward you have to type Plus followed by Minus (+ −) to instruct After Effects that you 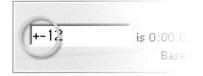 are inputting a negative value. This isn't too difficult to remember if you consider the '+' sign as the instruction for 'I'm entering relative values to calculate'.

Focus on the Composition Window

Comp Window, Preview Window, Output Screen – they all refer to the window where users view their project results: the Composition Window. All the knowledge of the Timeline Window serves no purpose if you don't see what you're creating, and here's where you see your creation. With the Composition

Window (Comp Window) you can:

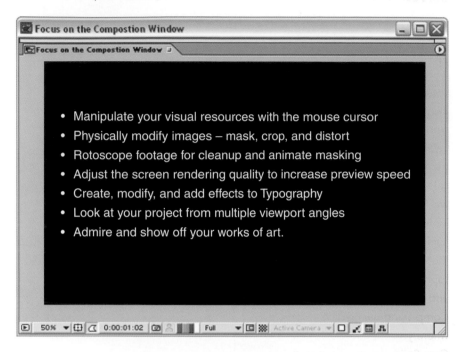

Pixel Perfect Preview

Many designers prefer to work in the Comp Window rather than twiddle with a layer's value precision in the Timeline. They just want to build their project, transform (move, rotate, and scale) their images, and then preview their work in the Comp Window. This is, after all, the WYSIWYG screen of After Effects and if your project doesn't look good here, it isn't going look any better when rendered (as usual, there are exceptions).

This is what it's all about – visual interactive animation design. After Effects is, at its heart, an animation program to bring otherwise flat art to life. And the Composition Window is where we see our results: as we construct our project, tweak it, and then output the finished product. Many print publishing programs claim to be WYSIWYG; however, their final printed result is often hampered by inconsistent printers and presses. With After Effects, the Composition Window shows you exactly what your audience will see once rendered. This is a boon to production accuracy, but can also be quite aggravating when its precision and clarity unveil every mistake you've made.

Selecting Layers

To begin with, open the project *Focus on Comp Window.aep*. This project consists of the six layers we previously assembled in the Timeline discussion plus a Solid layer used to overlay some film grain effects.

Using the mouse, click and drag on the 'WONK TV' logo inside the Comp Window, then move it upwards. No matter where you try to grab the logo, you won't be able to select that layer. As a matter of priority, the first layer the mouse will select in the Comp Window will be the foremost layer in the Timeline directly under the cursor's current position. Since the Gray Solid 1 layer is the topmost layer in the Timeline and since it covers all of the Comp Window, no matter where you click and drag, the Gray Solid 1 layer will always be selected.

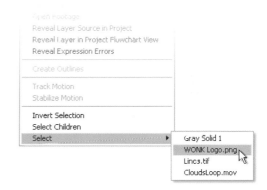

There are several methods to avoid this feature:

- Lock any layers in the Timeline you do not want to interact within the Comp Window.

- Right-click in the Comp Window – at the bottom of the pop-up window will be 'Select'. Choose your layer here.

- Switch off any layer you don't want to select.

- Select the layer in the Timeline Window you want to move, then return to the Comp Window.

For now, go ahead and turn off layer 1. Now you can just click and drag the WONK logo around the screen with ease.

Fast Previews – OpenGL Preview

As you drag layers around the screen, notice in the lower right of the options bar (bottom edge of the Composition Window) the Fast Previews button may change color to green. This indicates that the Comp Window is in OpenGL mode. This is used to accelerate the responsiveness of layer manipulation and interactivity.

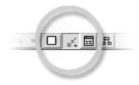

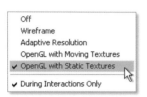

Clicking open the Fast Previews button menu will offer you several options how the Composition Window reacts to your input. If you have a good OpenGL video card, the default selection will provide superior performance. If you do not have a fast card, or you feel that the OpenGL mode is sluggish in responding to your input, you should select Adaptive Resolution. In this mode, when layers are moved, the Composition Window temporarily alters the quality setting (as preset in the Preferences), degrading the overall image – sacrificing quality for speed.

There are times where you'll want to set the Fast Previews to 'Off'. If you have a powerful enough computer, 'Off' may not cause any significant degradation of speed, allowing you more precise adjustments to your project.

Drag and Drop Construction

Just as in the Timeline Window, you can add layers directly to the Comp Window via drag and drop. In the Project Window, select *WONK Logo Master.ai* then drag it, but don't release, into the Comp Window. As you bring the file into the Comp Window you'll discover that the file is represented as a simple bounding box with an 'X' across the center. Drag the file toward the center of the window and watch as it snaps to the Comp Window's center. Likewise, dragging the file to any window edge will snap the bounding box's adjacent edge to the window edge.

Place the file to snap at the center of the Comp Window then release it. Just as when dragging files into the Timeline Window, wherever the CTI is pointing to

(current time) is where the new layer will begin. But unlike in the Timeline, the layer you drag into the Comp Window will always become your new layer 1. If you select more than one item to drag into the Comp Window, the order you select your items in the Project Window will be the order the new layers will begin in the Timeline.

Motion Constraints

When moving layers around the Comp Window, you can constrain the layer's motion to either vertical or horizontal directions. Do this by holding the 'Shift' key as you drag your layer around the window. If, instead, you press both

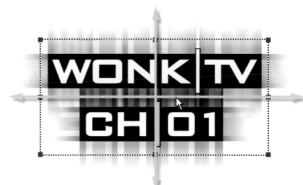

'Ctrl + Shift', the layer will snap to the edges and center – just as when originally dragging the file into the Comp Window.

Transform Handles

Every layer has a virtual bounding box surrounding the layer's contents at the time of import. In some file format cases (Photoshop or Illustrator) you can tell After Effects to set the bounding box to an object's size (excluding all empty space surrounding the image) or the document's size (as set in the canvas size). Otherwise, the bounding box will match the imported file's dimensions. By grabbing any of the four handles at the corners of a layer, you can freely scale your layer. Holding the 'Shift' key switches the mode to uniform scale, where the layer maintains its current aspect as it changes size.

Pressing 'Alt' switches the mode to Wireframe, where the layer's contents are replaced by the bounding box frame, allowing for even faster interaction.

But notice that, unlike Photoshop or other image editing programs, if the mouse cursor is outside the bounding box the cursor does not change into the rotate mode icon. To rotate your layers you need to change the cursor tool to the Rotate cursor. Either select the Rotate tool in the Tools

Floater or press the 'W' key (why not 'R'? – because 'R' is the shortcut for selecting the Transforms Rotate in the Timeline Window). In the Comp Window, your cursor is now a little arrow circle (as seen here, left).

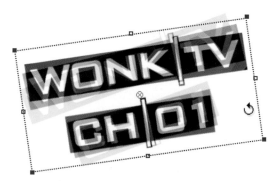

Layers rotate and scale from a common locus identified by the circle with an 'X'

inside. This is the Anchor Point of the layer and it's moved by using a different cursor tool – Pan Behind (Y).

This tool is used in both the Comp Window and the Timeline Window. By clicking on the Anchor Point inside the bounding box (seen right) you can reposition the layer's locus to anywhere you need. This allows the user to make layers rotate like a movie clapperboard or 'stretch and squash' from one corner of an image. This can also be animated in the Timeline under the layer's Transforms > Anchor Point.

Look Ma – No Handles!

Conspicuously absent in the Comp Window are any of the standard window scroll bars users are accustomed to sliding to move around the screen. These scroll bars were eliminated in version 6.0 of After Effects (so if you still see them,

ignore this paragraph) and replaced by the Hand Tool (H) in the Tools menu floater. Selecting the Hand Tool allows the user to move freely about the full Composition Window canvas – even offscreen. This offers superb flexibility to the designer, eliminating any restrictions to accessing any objects placed far offscreen in any direction.

The Layer Window – Editing Clips

The Composition Window has another function: double-clicking on a layer in the Timeline Window opens that layer's resource in another window, tabbed

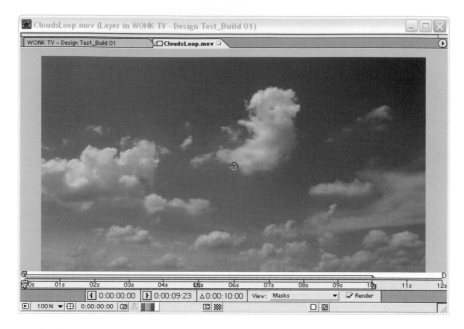

inside the Comp Window, called the **Layer Window**. In previous versions of After Effects (prior to 6.0), the Layer Window would open as its own dedicated window separate from the Comp Window. In addition to performing simple editing functions, the Layer Window allows the user to create and modify:

- Paths and masks
- Motion tracking and stabilization
- Painting and clone brush rotoscoping.

In the Timeline Window, double-click on layer 6 (*CloudsLoop.mov*) and the **Footage Window** will open inside the Comp Window, as seen in the example below. The overall duration of the clip is displayed across the 'Timescale' under the image area. The 'Time Ruler' (yellow bar) shows the segment of the clip currently active within the Timeline.

Beneath the 'Time Ruler' are several Timecode (or footage counter) readouts. The left one marks the **In Point** of the selected clip, the middle one marks the **Out Point**, and the right one shows the selected segment's active duration.

Use the mouse cursor to perform the following tasks that demonstrate the use of the various editing tools within the Footage Window. The letters correspond to the images below.

A **Footage Drag** – grab the center of the Time Ruler (where four hatch marks indicate the point to grab), then drag the bar right and then back again.

B Notice as you drag the Time Ruler that the 'Duration' is maintained while the **In and Out Points** change.

C **Edit In and Out** – grab the Out handle (right end) of the Time Ruler and drag it to 0:00:10:10. As you drag both the Duration and Out Point displays change. Drag the In Point to 0:00:04:12.

D **Timeline Zoom** – above the Time Ruler is a white bar with two round end-caps and a thin yellow copy of the Time Ruler. Dragging either end of the bar will zoom into the Timeline, increasing the temporal resolution of your window. Notice also a mini-version of the CTI that when grabbed controls both CTIs in the Timeline and the Footage Window.

An even simpler method to mark your clip's In and Out Points is to use the 'Set IN/OUT' buttons. In the last example below, wherever the CTI is located on the Time Ruler or Timescale,

clicking on either Set button will cause the Time Ruler's In or Out Points to snap to the CTI's current location.

Every alteration to your footage clip's time is applied directly to its corresponding layer in the Timeline Window. But more interesting is how the Timeline reacts to the Footage Window's editing, as the following demonstration shows:

1 Revert the project back to *Focus on Comp Window.aep* then re-open the *CloudsLoop.mov* (layer 5) within the Footage Window.

2 Drag the Timeline Window's CTI to 0:00:03:00 (or use the shortcut 'Ctrl + G' then '3.' – the number 3 followed by a single period to identify seconds, then enter).

3 Click Set IN on the Footage Window.

4 Yikes! Why did the Timeline CTI jump back to 0:00:00:00? When using the Set IN button the system assumes that you want to retain the Timeline's original IN point's current time position.

5 Drag Timeline layer 5's range segment bar to the right until the IN point is near 0:00:02:00. Then drag the CTI to around 0:00:06:00.

6 In the Footage Window click on the Set IN marker. Notice that again the Timeline maintained the range bar's IN point while the whole clip slid forward.

7 Drag the Timeline CTI to 0:00:04:00 then click the Set OUT marker in the Footage Window. This time the clip simply timed its OUT point to match the CTI's current position.

8 Press Home and suddenly the CTI is gone. The Timeline's shortcut keys for Home and End are now assigned to the Footage Window, matching the first (Home) and last (End) frames of the whole clip.

The Footage Window – Layer Window Lite

There's another type of Footage Window with a couple of additional functions you can use for editing your clip more like a dedicated video editing program.

In the Project Window press 'Alt' then double-click on *CloudsLoop.mov* and another Footage Window opens within the Composition Window. But this one looks a little different from the first one opened. It has several options along the bottom edge missing, while the timecode readouts have two additional functions to their right in place of some window preview and masking functions.

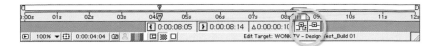

These two additional editing functions allow you to pre-edit your clip then drop the finished clip into the Timeline as:

A **Ripple Insert Edit** – the selected clip's active area is added to the Timeline as a new layer 1 at the current CTI position, while *all* other layers get split in two with their latter portion moved further down the Timeline aligned to the end of the new clip's OUT point.

Ripple Insert | Overlay

B **Overlay Edit** – the clip's active area is added to the Timeline, aligned to the CTI, as a new layer 1, not affecting any other layers.

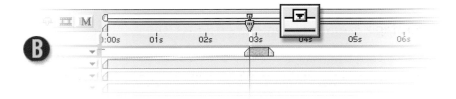

51

Preparing Imported Resources

Danger Will Robinson!
You have a simple choice now: proceed to the next chapter, where you'll begin to create projects and compositions, learning how to animate and apply effects. Alternatively, you can spend a few minutes prior to the fun stuff to learn how to avoid technical traps and pitfalls of file format settings. Many experienced After Effects designers I know all wish they had grasped file quirks and how to adjust them before delving heavily into the actual animation and rendering process. In After Effects, ignorance is not bliss.

You should already know how to import (Ctrl + I or Ctrl + Alt + I) various file types: movies, stills, audio, and projects. Now we're going to cover some critical tweaks, called Interpretation, that need to be applied to each imported file. We'll be examining file Alpha Channel options and Frame Rate assignment. That often-frustrating subject of Field Order deinterlacing will be clarified, as will how 24 fps film or Progressive Scan HD/SD footage can be manipulated to let you work more efficiently. Additionally, we'll squeeze in a look at Anamorphic image compression and how Pixel Aspect Ratio affects your images.

Interpretation Rules!

The Interpret Footage dialog (accessed in the Project Window by selecting a file then pressing 'Ctrl + F') defines how After Effects will dissect a file as it is being utilized in a project. If you don't have the correct interpretation settings, your project won't render correctly. Each media format has its own unique set of options that must be 'interpreted' differently: Still Images, Movie Clips, and Audio. There are even instances where you'll actually have multiple

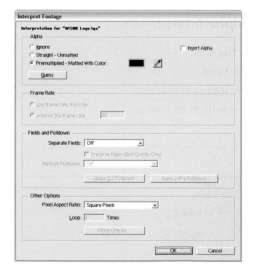

imports of the same single media file, each with its own interpretation rules applied.

Alpha Channel Support

Gather some assets by using any of the previously described Import methods: 'Ctrl + I', > **File** > **Import** > **File**, or double-click anywhere inside the Project Window. Import the following: *WONK Logo.png, WONK Logo.tga*, and *Lines.tif*, then double-click on *WONK Logo.tga* to open the image in the Footage Window. Select *WONK Logo.tga* in the Projects Window and then press 'Ctrl + F'. This opens the Interpret Footage dialog (seen above). The dialog is composed of four sections:

- Alpha
- Frame Rate
- Fields and Pulldown
- Other Options.

Since a Still Image has no frame rate, that area is currently inactive for the file selected. However, notice that Fields and Pulldown is active. That's because if you have a still grabbed from a video, it could have interlaced fields visible that need separation. This can be a big 'Gotcha' if you're not careful how you use these kinds of stills.

Alpha Interpretation

In the section 'Practical Concepts of Things You Need to Remember' later in the book, I explain the Alpha Channel and its modes of blending. It's here, in the Interpret Footage dialog, where you adjust a file's Alpha to make it work correctly. If you set your Preferences' (**File** > **Preferences** > **Import**) 'Interpret Unlabeled Alpha As: Guess', then *WONK Logo.tga* should be already set to 'Premultiplied – Matted With Color' with black as the color selected. If, however, Straight – Unmatted is selected, you'll need to change it to Premultiplied.

Interpretation for "WONK Logo.tga"

Alpha

- ○ Ignore
- ○ Straight - Unmatted
- ● Premultiplied - Matted With Color:

Guess

Generally, you'll be using Premultiplied for most applications. Knowing when to change settings is critical to your project's correct rendering and client's use. If you don't understand the difference between the two modes, please refer to the subsection 'Premultiplied vs Straight Images' in the section 'Practical Concepts of Things You Need to Remember'.

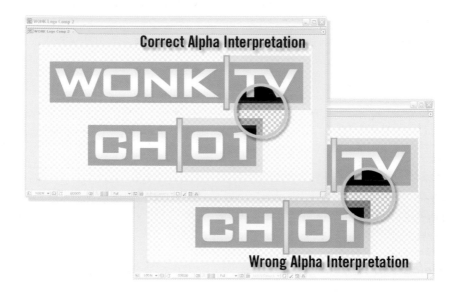

Return to the Project Window and drag *WONK Logo.tga* down to the 'Create a New Composition' button at the bottom of the Project Window. Both the Composition Window (Preview Window) and Timeline Window will open, showing the WONK logo in use. Now look at the actual logo in the Composition Window. If the Alpha Interpretation is set correctly, the transparent purple box outlines should look like the first image above. Try switching Alpha Interpret modes to see what the image looks like with the wrong setting. This is a helpful way to learn what to watch when using Alpha Channels.

One other little thing, and this should be pretty self-explanatory – but if for some reason your keyable image with Alpha is showing up as a hole surrounded by a blank area, you'll probably just need to toggle on the little 'Invert Alpha' switch at the right of the box.

Also, if an imported image is invisible when it's used, it might have an incorrectly labeled Alpha Channel. Switch the Alpha Interpret to 'Ignore' and the image should reappear.

Frame Rate

The next file to import will be a background movie we'll use – *CloudsLoop.mov*. This is a highly compressed QuickTime file, but it'll work fine since it'll be treated with effects and textures. Open the Interpret Footage dialog for *CloudsLoop.mov* (Ctrl + F). Notice that the Alpha area is now inactive – the file has no Alpha to consider. Instead, we need to adjust the movie clip's Frame Rate.

If you're in a PAL country, change the setting to 25 fps, while NTSC users need to set it to 29.97 fps. This is just a good habit to follow

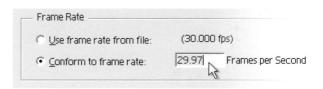

– keep your Frame Rates consistent. Of course, you can intermix different Frame Rate footage, often for unique effect, but for most circumstances keep it consistent – match your footage to your intended project and output rate.

Fields and Pulldown – Part 1: Separate Fields

Nothing can drive a designer/editor/animator/brain surgeon crazier than Field Order issues. Some people hate them, while I have no problem with them and actually prefer using them (and in ways that most animators don't consider). In fact, I often mix use of both systems (fields with frames) for different effects. If you have absolutely no idea what fields are, jump to the Glossary for a quick definition or hop on-line and go to www.focalpress.com/companions/024051968X.

Usually, when you import movie format footage (QuickTime or AVI) the Field Order has been embedded into the file, and After Effects will automatically set the correct Field Order. But, just as often, some clips

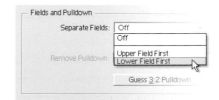

do not identify their Field Order. This is especially true for importing Sequential Still Frames rendered on some other animation program (3D or 2D). Below is a procedure you can use to reliably determine a footage clip's Field Order.

Identifying Correct Field Order

1 **Import** your footage (Ctrl + I), then select the file to test.

2 Open the **Interpret Footage** dialog (Ctrl + F).

3 Set **Separate Fields** to 'Upper Field First' or 'Lower Field First' – it's your choice – then click 'OK'.

4 Press 'Alt', then double-click on the file to open it directly in the Footage Window.

5 Now advance the blue **Time Marker** to a point in your footage where motion is clearly visible.

6 Press, in slow succession, the Page Down key to advance the footage one frame at a time.

7 Carefully observe the direction of travel of motion in your footage. If, as you press 'PgDn', the motion appears to stagger (move forward on one frame, then jump back a little on the next frame, then jump forward again next frame), this is a good indicator that the Field Order is reversed.

8 Return to the Interpret Footage dialog and swap the Separate Fields setting, then click 'OK'.

9 Perform the test again (6 and 7 above) to confirm the correct setting. If all is OK, the clip's motion should progress in smooth consistent increments.

The next page illustrates what you might see with different Separate Fields settings. The first column shows the letters TV rotating incorrectly – the frames stagger forwards then backwards, then jump forward again: Separate Fields wrong. The second column shows the TV logo progressing forward each frame: Separate Fields correct. The final column displays the raw interlaced frames: Separate Fields off.

Separate Fields - Wrong

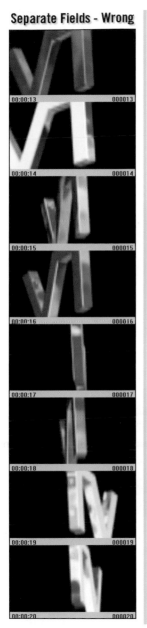

Separate Fields - Correct

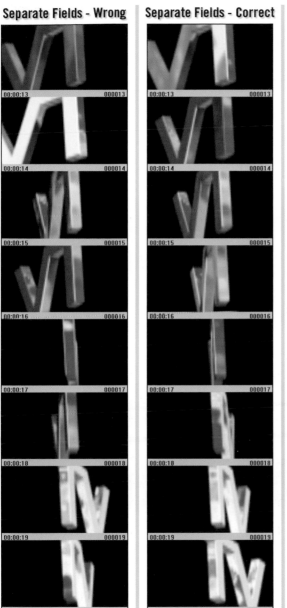

Separate Fields - Off

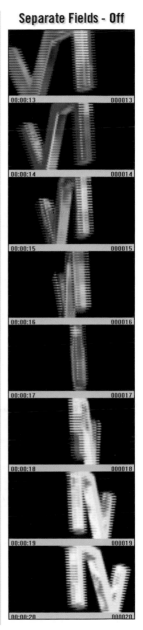

Fields and Pulldown – Part 2: The 3:2 Pulldown

There are times you *need* to use this next option in the Fields and Pulldown section of the Interpret Footage dialog, and there are times you'll *want* to use it. Knowing when to '3:2 or not' can offer a huge boost in productivity and quality.

When you import movie clips containing the 3:2 Pulldown, generally you have to both deinterlace the footage *and* eliminate the extra split frames to recreate the 24 fps footage faithfully. After Effects has another option in the Fields Pulldown section of the Interpret Footage dialog that performs these processes.

Import *DEF-BirdCrash.mov*, then open the clip in the QuickTime preview window by double-clicking (*do not* 'Alt + double-click' or the Footage Window will open and you won't see the split fields). Slowly advance the Time Marker to examine each frame.

Notice the interlaced fields of split frames?

The first occurrence of the split fields determines how After Effects will process the 3:2 Remove. Now open the Interpret Footage dialog for the *DEF-BirdCrash.mov* clip and look at the Fields and Pulldown section. After Effects automatically determines the correct Separate Fields and Remove Pulldown for movie clips with this information embedded. But all too often you'll be forced to manually adjust these settings. Click on the Remove Pulldown window (if you can't activate it, you first must choose a Separate Fields mode) and notice the variety of processing patterns. You can either let After Effects 'Guess' for you or manually choose the appropriate setting.

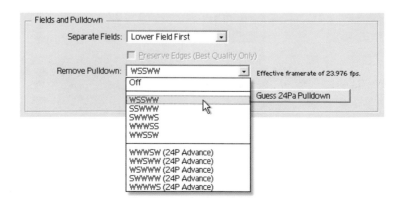

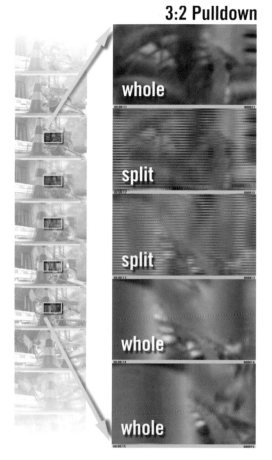

3:2 Pulldown

whole

split

split

whole

whole

Take the clip at left – its correct 3:2 Pulldown would be the WSSWW pattern (one whole, two split, two whole).

Sometimes you'll have movie clips with pre-edited film or HD footage with different 3:2 Pulldown patterns per shot on the same clip. Or, if the movie clip simply doesn't have an obvious 3:2 pattern for After Effects to calculate, you'll have to manually set the pulldown.

Use the same technique described earlier to determine Field Order (Part 1 – Separate Fields) as to derive your correct 3:2 Remove.

Begin by selecting the first pattern (WSSWW), then examine the frames sequentially in the Footage Window (Alt + double-click the file, then press PgDn or PgUp) to look for any interlaced frames. If you find any, return to the 3:2 Remove drop-down menu in the Fields and Pulldown dialog, then change the process to SSWWW. Do this until interlaced frames can no longer be seen in the Footage Window – that is, in the segment of footage you are using. This brings us to the issue of Duplicate Imported clips.

The Case for Duplicate Imported Clips

When you consider the many ways movie clips (or other resources) can be used, you'll come to realize that you'll probably have a use for multiple copies of the same imported clips, each with different Interpret Footage settings. Whether you have a movie clip with different shots, each with different 3:2 Pulldowns, or you have a 3D generated logo that was rendered in fields, but you need to freeze on

a frame at the end (we'll cover this soon), keeping multiple copies of the same imported clips can make your production life much easier.

24P Video and its Unique Issues

One more item – when using footage recorded on a 24P video camera (some HD but mostly DV), you'll need to use the '24Pa Pulldown' removal process. It's nearly the same as the standard film 3:2 Pulldown, but handles certain technical details slightly differently. But all that matters is the final result: a consistent stream of clean 24 fps deinterlaced footage.

Frame Rates Revisited – The Real Frame Rate of Film in TV

OK, so for the past few pages I've described how engineers and programmers have made 24 fps film or HD footage fit into standard NTSC or digital TV 30 fps footage. What I neglected to elaborate is the true frame rate at which film or HD footage runs. You should already know that NTSC runs at 29.97 fps, so when film is transferred to video it is actually running at 23.976 fps. Again, be certain to set your movie clips to their actual frame rates and keep your projects consistent with your footage. Why is this important? Because if you improperly set your frame rates, your project can have difficulties synchronizing with audio you might need to use or you can run into rotoscoping difficulties that will drive you crazy. Trust me on this – consistent frame rates make for consistently good project output.

Other Options – Part 1: Pixel Aspect Ratio

If you thought Field Order was an annoying enough concept, well, welcome to the bizarre world of non-square pixels. Pixel Aspect Ratio refers to the mathematical relationship of an individual pixel's height and width versus the overall image's screen dimensions. First, it's important to understand the term Aspect Ratio – the width versus the height of a rectangle. A square has an Aspect Ratio (AR) of 1 to 1 or 1:1. Your standard TV has an AR of 4:3 or 1.33:1. HDTV is 16:9 or 1.777:1, while cinema Academy equals 1.85:1 and cinema anamorphic equals 2.35:1.

When you import files (stills or footage) you must keep their PAR in mind. An improperly set PAR will make an image look distorted and respond with unusual results when manipulated in your project.

In an earlier section (Interface Navigation), we saw that when you make a new composition, we have the same Pixel Aspect Ratio options as in the Interpret Footage

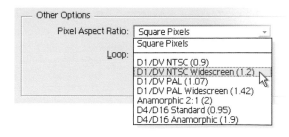

dialog. I also explain PAR in the 'Practical Concepts of Things You Should Remember' section. There are many different ways to build projects concluding with the same final viewable results. So it is with footage – you can have native 16:9 DV-NTSC footage (864 × 480 with PAR of 1.0) or Anamorphic DV-NTSC (720 × 480 with PAR of 1.2). Both yield the same visual product, but the native footage will not suffer any degradation due to the anamorphic compression process.

Loop – Extend Your Footage

A nice little addition to the Other Options section is the Loop setting. All you have to do here is type in the number of times you want your movie footage or sequential stills clips to loop from end back to start. When you change this number, the new multiplier will affect the overall clip's duration as seen in the Project Window's info area, i.e. a 300-frame-long clip looped four times will be seen as a 1200-frame file in the Project Window.

Other Options – Part 2: EPS and Illustrator Files Get Special Treatment

Finally, at the bottom of the Interpret Footage dialog is the More Options button. This is only available when you are adjusting EPS or Illustrator vector files. If you have a complex EPS or Illustrator file containing some detailed color gradients, try setting this option to More Accurate to better interpolate the colors.

Replace Footage – 'Where Did My Files Go?'

More often than not, when you open a project supplied to you from another designer, or open your own project on a

workstation other than where all the resources were imported, you will be startled by a nice little warning dialog informing you that your resource files have gone AWOL. This can be extraordinarily disconcerting, and sometimes plain scary, if you've spent many hours gathering data files for a project – now After Effects is telling you all your files are gone.

Like many editing programs, After Effects does not embed the actual resource files into the project. Links are stored identifying where every local and network file resides. These links are what you see in the Project Window.

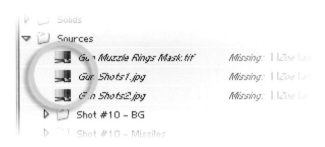

You can rest assured After Effects has a wonderful capability to help you recover any lost files' links, seen as tiny Color Bar icons in the Project Window along with the word 'Missing' preceding the last known File Path text string. Double-clicking (or 'Ctrl + H') on a missing file link automatically opens the Replace Footage File dialog box – a close kin to the Import Dialog box. All you have to do is navigate to where the file resides, select it, and click 'Open'. In addition to re-linking the selected file, After Effects tries to re-establish any additional missing file links neighboring the selected file. When it's finished locating as

many links as it could find, it then returns this much more friendly dialog. For any remaining missing files, repeat the Replace Footage File process.

Proxy Footage – Use Really Big Files and Not Kill Your Computer

There is one last File Import function to consider when you have significantly large and cumbersome files to work upon: Use Proxy Files. Proxy Files are low-resolution, highly compressed copies of high-resolution uncompressed files, i.e. Digital Cinema, HD, Print Files, etc.

Even with the accessibility of cheap RAM, you can quickly run out of memory when using HD or higher resolution file formats. With a Low-Rez Proxy, you can scrub the Timeline without causing the program to update the Comp Window with such huge memory demands. At Render time, the Original High-Rez file automatically replaces their Proxy Files, so your finished project maintains its expected quality.

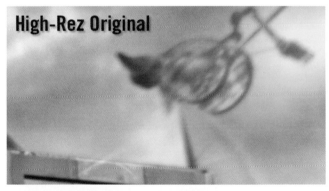

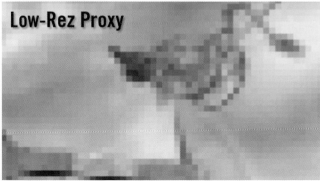

To apply a Proxy File you select a file in the Project Window:

1 Right-click on the file's name > **Set Proxy** > **File . . .** or press 'Ctrl + Alt + P'.

2 Select the file to use as a **Proxy**, then click 'OK'.

After Effects automatically resizes the Proxy File to match the Full Resolution file's size, so when you see the Proxy in use, it matches the original file's position and layout – the image just looks very low quality.

But the loss in quality during the production process is well worth the dramatic increase of interactivity you experience.

You can identify when a Proxy File is in use by looking at the file's name in the Project Window. A small box is added to the left of the Original file. When the box is solid (first image below), the Proxy File is being utilized in the project. When the box is empty (second image below), the Original file is displayed. Notice that the active file has its Information Thumbnail's name shown in bold type.

Proxy Active

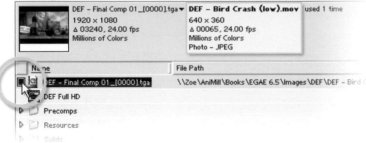

Original Active

Avid Windows AVI Codec Issues

Avid Editing systems
running on Windows
OS machines have a
special configuration
issue where the
installed AVI Codec
defaults to PAL use –
this is a problem for
NTSC users.

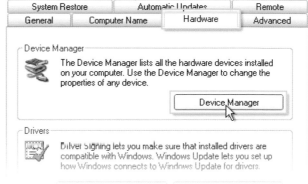

To change the AVI
Codec setup, you
need to delve deep
into your Windows OS Management.

1 Open your **System Properties** dialog via > **Start** > **Control Panel** > **System**.

2 Select the **Hardware** tab, then click on 'Device Manager'.

3 Expand the **Sound, video and game controllers** properties list and right-click on 'Video Codecs' to open the **Video Codecs** Properties dialog.

4 Select the **Avid AVI Codec . . .**, then click the 'Properties' button.

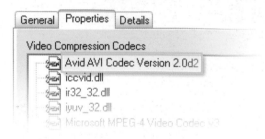

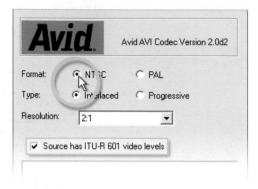

5 In the **Avid AVI Codec** . . . dialog, click on 'Settings . . . '.

6 Now select the **Format:** 'NTSC' radio button and check the **Source has ITU-R 601** . . . if you use this mode for video levels (if your video levels look washed out, uncheck 601).

BUILDING YOUR PROJECT

Layers – Part 1: Discovery

Building Your Projects – One Layer at a Time

Unlike many other compositing programs, After Effects encourages creative artistic experimentation just as if you were using any paint or illustration program. It is this free-form design that sets it apart – its inviting workspace and common sense workflow lure designers into spending hours trying to perfect that new unique look guaranteeing us a spot in the Adobe demo reel. And it all starts with layers.

Layers are the literal building block to every project composition. In the 'Focus on the Timeline Window' and 'Focus on the Composition Window' sections, we were exposed to how layers are constructed, manipulated, and edited. This chapter will build further upon those instructions by introducing these, and other, more advanced concepts:

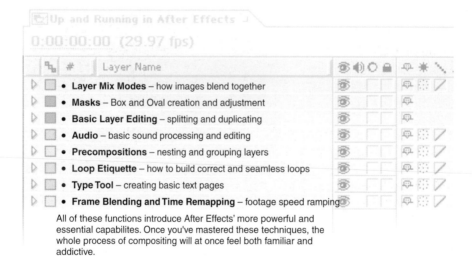

Layer Mix Modes – how images blend together
Masks – Box and Oval creation and adjustment
Basic Layer Editing – splitting and duplicating
Audio – basic sound processing and editing
Precompositions – nesting and grouping layers
Loop Etiquette – how to build correct and seamless loops
Type Tool – creating basic text pages
Frame Blending and Time Remapping – footage speed ramping

All of these functions introduce After Effects' more powerful and essential capabilities. Once you've mastered these techniques, the whole process of compositing will at once feel both familiar and addictive.

Blending Modes – Pixel Mixing Your Layers Together

As we assembled our example project in the last chapter, we briefly touched on a layer's Blending Mode potential. At its most simple, Blending Modes instructs After Effects how to blend its layers together. There are 34 unique modes to select, each affecting layers in different ways. The best way to discover the

differences is to build a simple project with a few layers, and then experiment with each mode – mixing and matching various layers and modes. However, to speed things along, let's briefly discuss some of the more commonly used modes, and how they pertain to our WONK TV design and your future projects.

Eight Blending Mode Groups

When selecting a layer's mode, a long pop-up menu opens offering eight groups of modes where each group contains several modes that are stylistically associated with each other. The eight groups are listed below, and one example from each group is displayed on the following page.

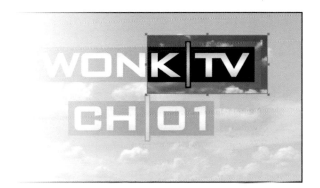

Users of Photoshop (or most paint programs) will recognize many of these modes.

A **Solid Mix** – the top group is the simplest mode because pixels have no alteration effect to layers beneath; the contents obscure all layers unless opacity is adjusted.

B **Subtractive Mix** – the second group transfers and blends their darker pixels' values to layers beneath; this is similar to mixing color inks

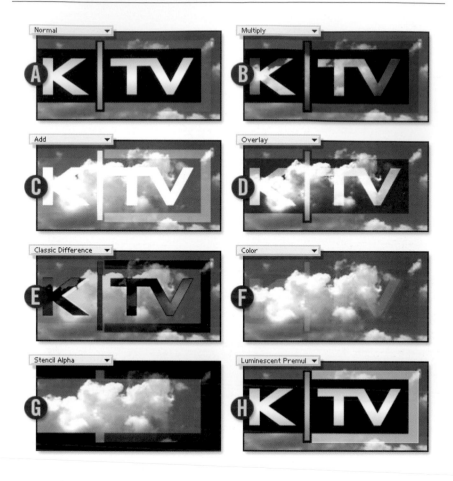

together to create new colors and shades, where the source layer is the new ink mixed to the older color ink.

C **Additive Mix** – this group transfers and blends their pixels' lighter values; this is similar to projecting different color lights onto one common object, making a new, often brighter, color light pattern.

D **Blending** – in this fourth group, pixels share aspects of both Additive and Subtractive modes, creating richer, more vibrant and contrasting results; here the 50% luminance point affects the bottom layer the least.

E **Inverting Alteration** – pixels beneath the layer using these modes become inverted, creating opposing colors and shades of the source

layer; white on top of white makes black, blue on top of red makes magenta, etc.

F **HLS Shift** – modes of this group transfer one of the source layer's visual traits, either its hue, value, or saturation, affecting only one of the HLS traits to the layers beneath, or by tinting the layers below with the colors present in the source layer.

G **Alpha Masking** – this group creates a mask, based upon the source layer's alpha or luminance, cascading to all layers below.

H **Special** – the last group offers modes for correcting improperly mixing Alpha Channels from two of more layers or for fixing a layer with bad Alpha/fill blending.

Let's return to the WONK TV logo build to examine some of the more common mix modes and their effects, as well as a lesson on Basic Masking functions. Open the project *Mix & Masks.aep* and examine the few Blending Mode settings already in use. Layer 1, for example, currently uses an Overlay mode – return that layer to Normal for a moment. This layer contains animated film grain that gives the overall project a cinematic feel. A Solid gray layer was utilized because grain is imperceptible when it's applied to white or black. So by using gray as our base color, then applying the Overlay mode, the gray disappears, leaving only the noise to affect the underlying layers. Try cycling through the seven different modes within the same blending group of Overlay to see their different effects, then switch to different Mode groups and experiment with the multitude of options available. Then, return everything to their initial settings (> **File** > **Revert**).

Masking – Part 1: Making Box Masks

Masks are boundaries that limit what is shown from an image. They can be both astoundingly simple and amazingly intricate at the same time. They can be as simple as boxes used to block out offending animation errors from a poorly prepared resource, and as complex as hundreds of converted font outlines forming paths for other effects and objects to use. In this section we'll examine the most basic forms of masking: Rectangular (Box) and Elliptical (Oval) Masks.

We'll use a Rectangular Mask to isolate some effects footage placed behind the purple glass of the **TV** and **CH1** elements, making them shimmer with highlights.

1 Switch on the *GlimmerLoop.mov* layer (4) in the Timeline.

2 In the Comp Window, zoom into the purple glass behind TV by pressing the Period (.) key twice. This performs a Magnification without expanding the whole Comp Window (as if you pressed 'Control' plus the '+' sign).

3 Press 'H' to select the Hand Tool, then click and drag inside the Comp Window to center the view on the TV glass (you might have to manually expand the Comp Window's overall size by dragging any of the corners outward).

4 With layer 4 (*Glimmer . . .*) selected, press 'Q' to activate the Mask Tool (or mouse click the Mask Tool in the Tools Floater menu).

5 Drag a Box Mask from the upper right corner of the TV glass to the lower left corner.

As you drag the cursor, the mask immediately crops away anything outside its box, allowing you to real-time preview where the mask affects the image. The advantage of using the zoom-in 400% is that it allows you more precise control of the cursor. At 400% the accuracy of your cursor movements is increased fourfold – this is due to the calculations of Subpixel Precision.

Subpixel Precision – A Brief Voyage of Enlightenment

One dramatic difference with working in After Effects versus some paint programs is what happens when you zoom into your Comp Window and manipulate Masks (or Transforms) – instead of the cursor snapping from pixel to

pixel, depending on the level of zoom, the precision of your cursor's position is increased. Because our present example has been magnified to 400%, the cursor precision has been increased by dividing a single pixel into 4 × 4 increments. If you had selected only 200% magnification, the pixel division would only be 2 × 2.

Another way to visualize how this precision increase functions is to imagine a single pixel subdivided into a grid of subpixel squares. If you set the magnification to 1600%, the single pixel becomes a cluster of 256 subpixels. Therefore, when the cursor moves (or scales) any vector, mask point, image layer or any painting is done at these expanded resolutions, the cursor moves in much smaller increments relative to the magnified pixels.

After Effects does all its calculations (though unrelated to the magnification you select) with subpixel precision as it previews and renders your project. This permits all the layers to transform over time at precise increments, thus rendering the smooth and crisp motion graphics that made it famous. You can force After Effects to disable each layer's subpixel calculation precision by toggling their Quality switch in the Timeline Window to Draft (where Best is full precision). Changing this switch will usually increase Composition Window preview speed and responsiveness, but the tradeoff is dramatically diminished image quality. While you

are zoomed into your TV glass area you previously masked, try toggling between Best and Draft settings on the *WONK Logo.png* layer. You should see a striking difference in quality between the two settings.

Masking – Part 2: Making Oval Masks

Return your Comp Window to its regular magnification either by pressing the 'Comma' key twice, manually clicking on the Magnification pop-up menu in the Comp Window, or by double-clicking on the Magnifying Glass icon in the Tool window floater (double-clicking this icon automatically resets the magnification to 100%). For this exercise we'll be creating a vignette around the edges of our project, and we'll be creating it through the use of a simple Solid layer and an Oval Mask.

1 Add a new Solid color layer to the Timeline by pressing 'Ctrl + Y'.

2 Select the Eyedropper Tool next to the color swatch.

3 Float it the over the Comp Window – choose a deep blue color from the WONK TV box, then click 'OK'.

A full layer of dark blue should now completely obscure the entire project. If, however, the Solid layer only covers part of the Comp Window, you'll need to change the Solid's size settings – press 'Ctrl + Shift + Y' to re-open the Solid Footage Settings window, then press the 'Make Comp Size' button and click 'OK'.

4 Press 'Q' to activate the Mask tool in the Tools Window, and then press it again to cycle to the Oval Mask tool.

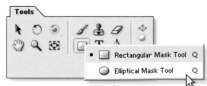

5 Move the mouse cursor over the Solid colored Comp Window, then draw an Oval Mask the same way you drew the regular Mask – click in the window (anywhere in the upper left corner this time),

then drag the cursor diagonally across the image to reveal an oval mask outlined by a rectangle selection box.

6 Once you've established the overall size of your Oval Mask (precision is not important here), release the mouse to set the Mask.

Your finished Oval Mask will appear inside the Solid layer as a thin path with four small square handles tracing the perimeter of the solid color oval. Don't worry if it's not placed correctly, that's what the next section fixes.

Masking – Part 3: Adjusting Masks

To adjust your mask's size and position after you've set it, you can activate a transform box around the mask. But to adjust a mask you need to select the mask (if it's not already selected).

7 Select the layer with the Mask, then press 'M' to open the Mask Shape property in the Timeline Window.

8 Click on the Mask's name (Mask 1) to select the Oval Mask, then press 'Ctrl + T' to activate the transform box around the Oval Mask.

9 Move your mouse cursor over the handles to adjust the individual corner positions, or click and drag inside the whole transform box to move the entire mask (see above). You can also click and drag outside the transform box to rotate a mask.

Adjust the Oval Mask's transform box to keep the blue oval inside the Comp Window's screen, but make it slightly smaller than the overall picture size. Once placed where you want it, double-click inside the transform box (or press 'Enter') to set the mask. There's one small problem, however – the mask

obscures the images we need to see. Back in the
Timeline Window, in the layer with the Mask options
open, you should see a little check-box (shown right)
with the word 'Invert' adjacent.

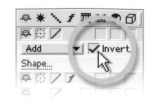

10 Click the Invert box – flip the mask to cover
everything outside its current selection.

To complete the
vignette, we need to
feather the Oval Mask
and reduce its
opacity. To the left of
'Mask 1' is a small,
downward-pointing

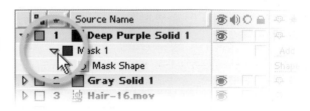

arrow; if you click on this twice to twirl it right, then back down (or press 'M M'
in quick succession), the entire group of Mask properties will reveal.

These properties allow you to:

- Set and animate the Mask's Shape
- Adjust the Feather – either uniformly or individually
- Change the Mask's Opacity
- Expand or Constrict the Mask's affected area.

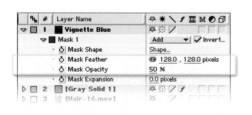

11 Set the Mask Feather value
to 128 and then set the
Mask Opacity to 50%.

12 Change the Solid layer's
Mix Mode to Multiply and
rename the layer as
Vignette Blue.

You can also rename the Masks by selecting their name, then pressing 'Enter'
and typing a new name (using the same method for renaming layers).

13 Save your work as *WONK Logo build 02.aep.*

14 In the Timeline Window jump back to 0:00 (Home).

15 Press 'B' to mark the <u>B</u>eginning of your Work Area for preview, then jump forward to 2 seconds ('Ctrl + G', then '2.') and press 'N' to make an E<u>n</u>d marker.

Now press the '0' key on your keyboard's keypad or click on the RAM Preview button in the Time Controls window floater. After a short time, the Comp Window will display the project in motion.

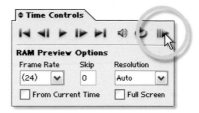

> **Tip:** It's a good idea to save your project *before* you make your previews; computers have this uncanny ability to crash just after you've spent hours building the perfect project and then preview your work.

Box and Oval Masks are the foundation of many other, more complicated Masking functions. As you progress through this *Easy Guide*, several more examples of advanced Masking will be presented: Bezier Masks, Rotoscoping, and converting Illustrator files into animatable Masks. And we'll be revisiting WONK TV every so often to add elements to complete its look, but for now we'll move on to information about layer editing.

Duplicating and Splitting Layers Overview

Layers are what make After Effects special. It's in the manipulation and ordering of layers that defines what your projects will look like once complete. This next section will help you better grasp how to edit your layers through the Duplicating and Splitting functions. For this demonstration we'll be using the project entitled *Logo Rise – Split Layers.aep*.

A fact of motion graphics life is this: Flying Logo Creation (say this in your head spoken with an echo). This example project consists of three layers: the venerable *Logo Rise Text*, an amorphous purple glow, and a deep blue fractal

background. Preview the project as it stands using the 'Every-Other-Frame' RAM Preview shortcut, 'Shift' plus the number zero on your keypad (Shift + 0).

Add the following resources and move the layers to the order listed:

1 > *Logo Rise Text*

2 > *Earth Roll – Fill.mov*

3 > *Purple Glow Rise*

4 > *Fractal BG*

5 > *Earth Roll – Alpha.mov.*

To key the Earth, instead of using a Track Matte from the Earth's Alpha footage, we'll be using an Effect filter. Right-click on the *Earth Roll – Fill.mov* layer to open a pop-up menu, then select

> **Effect** > **Channel** > **Set Matte**.

The Effect Controls window will open (seen below). As you add more and more effects to your work, every layer that has an effect applied will appear in this

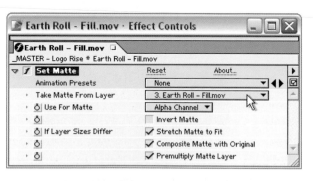

window as a tabbed menu listing each effect used.

Change the following for the Set Matte effect on *Earth Roll – Fill.mov*, then proceed with the steps for Splitting Layers:

1 **Take Matte From Layer** – set this to layer 2 (*Earth Roll – Alpha.mov*).

2 **Use For Matte** – set to 'Luminance'.

3 Scrub the CTI back and forth to both ends of the project.

Off
Wireframe
Adaptive Resolution
OpenGL with Moving Textures
✔ OpenGL with Static Textures
✔ During Interactions Only

The Logo Rise text appears then flies off to freeze in the middle of the screen.

If your Comp Window responds sluggishly, this is one of the times where switching the Fast Previews button in the Comp Window to 'OpenGL with Static Textures' will perform best.

With the Logo Rise text visible, select layer 1 and notice how the text was created. This is an example of text fonts used to create Masks. But this muddle of Masks can become infuriating as more and more masks' paths cover the screen. To help reduce Comp

Window clutter, turn 'Off' the 'Toggle View Masks' (Ctrl + Shift + H) button on the Comp Window. When 'Off', all mask outlines and vertices are hidden.

Splitting Layers

For the logo to work correctly, we want it to rise from behind the Earth, then swoop into the Earth at the end. To achieve these moves, the logo layer will have to be located at first behind the Earth, then switch to the foreground. This is where splitting layers comes into play.

Continue Scrubbing the CTI back and forth. Look for the point where the *Logo Rise Text* layer clears above the Earth's horizon (around *2*:00).

If you still have 'OpenGL with Static Textures' active, the Logo Rise might never appear to clear the Earth's horizon. When using 'OpenGL with Static Textures', both layer footage and effects do not update as you Scrub the CTI, only the Transforms do. Once you release the CTI the scene will re-render with the correct view. Reset the OpenGL to 'Adaptive Resolution' for the remainder of this exercise.

4 Select *Logo Rise Text* layer 1 (either click on the layer's name or press '1' on your keyboard's number pad).

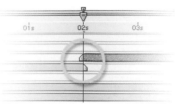

5 Drag it downward behind the
Earth Roll – Fill.mov layer.

6 With the logo layer clearly above
the Earth's horizon, press
'Ctrl + Shift + D' to Split the
layer, making a copy of the logo
layer (Logo Rise Text 2) – the new layer's In Point begins, while the
original layer ends, at the split point.

7 Drag the new layer (already selected) to the top of the layer stack
above the Earth layers.

8 Once again, drag the CTI back and forth to watch the results in the
Comp Window.

Splitting Layers is very useful for solving layer order issues where items shift from
the foreground to the background, pass in front of then behind other items, then
return to the foreground. A few well-placed Split Layers quickly alleviate layer
order contradictions.

We've solved the problem with the logo's order, now we need to make the
logo fly away.

9 Jump to 7:00, then Split (Ctrl + Shift + D) layer 1 again.

10 Drag Earth Roll – Alpha.mov up to the top of
the Timeline stack above the newly split
layer, then switch it 'off'.

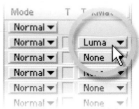

11 Press 'Alt + [' (open bracket, to the right of 'P').

12 Set layer 2's Track Matte button to 'Luma
Matte'.

Notice that the Earth still keys correctly, even when the Alpha's source layer is
both 'off' and has its In and Out Points different from the layer using it as the
Alpha. This is because any layer using another layer as their effect source looks
at the original resource file prior to most functions applied to the source layer.
This is a very confusing concept and, of course, has many exceptions.

Scrub the CTI to 7:20 and review the new result. The logo now flies into the
Earth and disappears into its edge. Save your work.

Duplicating Layers

Duplicating layers requires merely a press of 'Ctrl + D' to complete, but there are issues to understand and some tricks to take advantage of, more than a mere 'Ctrl + D' foretells.

To complete the logo, let's cast a shadow effect on the Earth. For this to look correct, the shadow should only appear as the logo rises above the horizon.

1 Select layer 3, then press 'Ctrl + D' to duplicate *Logo Rise Text 2.*

2 With the duplicate layer selected, press 'E' to open the layer's Effects list.

The Logo Rise Text was created with two standard effects plug-ins. You'll need to disable the Ramp effect. You can either select and delete the effect or simply toggle 'Off' its active state under the A/V Features (seen at right).

3 Change the layer's color (Ctrl + Shift + Y) to dark purple, then press 'New' to apply your color choice.

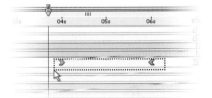

4 Drag layer 3 below layer 4, then press 'P' to open its Position properties.

5 Drag the cursor around the two Keyframes at 4 and 6 seconds to select them.

Make sure that the CTI is located directly over one of the two selected Keyframes (either drag the CTI, or press 'J' or 'K' to jump it to them). This is to ensure that any movement you perform here will be applied to both Keyframes equally.

6 Click and drag downwards inside the Comp Window on the selected layer – drag it down so the dark blue logo is about halfway down behind the color logo, then release.

7 'Ctrl + click' on layer 4's Position property, then press 'Enter' and rename the layer as '*Shadow*'.

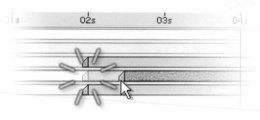

8 Right-click on the Shadow layer (layer 4) and select > **Effect** > **Blur & Sharpen** > **Fast Blur**.

9 In the Effect Controls window, adjust the **Blurriness** to 11.

To make the shadow affect only the Earth's surface, we'll use the *Earth Roll – Alpha.mov* as a Track Matte.

10 Duplicate layer 1 (Ctrl + D), then drag the copy down to place it above *Logo Rise Text 4* (layer 5).

11 Click on the left In Point handle of layer 4 on the Timeline and drag it towards 2:00.

As you drag the In Point handle, press and hold the 'Shift' key to activate the 'Snap To' function. As you get close to the 2-second mark in the Timeline, the In Point will Snap align to the same In Point of the other two *Logo Rise Text* layers. The 'Snap To' align feature works for Keyframes and layer Timelines alike.

12 Drag the Out Point handle to match the Out Point of layer 5.

13 Apply the **Track Matte** > **Luma Matte** to layer 5.

14 On layer 5, change the Blending Mode from Normal to Multiply and set the layer's Opacity (T) to 66%.

Save your work as *Logo Risen.aep*, then create a Preview to view the finished project. If the project takes too long to render, try reducing the Comp

Window's Magnification and Resolution to '50%' + 'Half', or press 'Shift + 0' (the number pad zero) to render every other frame.

Layer splitting and duplicating are critical and integral to everyday After Effects design production – there's no limit to their application. They are more than the mundane functions they appear to be, and can solve countless order issues and help create some superb visuals. Remember this: since there's no physical limit to the number of layers we can use, why not use layers to their fullest ability? Fill up those Timeline Windows 'til your eyes bleed.

Audio – A Sound Primer

After Effects was developed primarily as an image manipulation application, so its audio capabilities are less well rounded than high-end dedicated sound-music sequencer/mixer programs. But, nevertheless, After Effects does offer some rudimentary audio mix and SFX capabilities, as well as the ability to use audio as a source for several of its visual effects filters and other third-party plug-ins.

Timing's Everything

Motion graphics productions often have an audio track for the designer to work from. Whether it be a click-track or full custom-finished mix, knowing how to properly synchronize your visuals to a soundtrack will greatly improve your productivity and indispensability.

Sometimes the music drives the graphic design – other times, the graphics determine the music. Either way, your project's visual cadence should reflect the musical resource's rhythm and attitude.

In the WONK TV project, an audio track has been provided as a foundation for constructing your graphics. Select the *AniMill_Countdown.mp3* audio layer and press 'L' to open the Audio properties; pressing 'L' twice in quick succession opens the Audio layer's Waveform Display.

Press the 'L' key twice. When first opened, the Waveform Display is very narrow and provides only a low-resolution view of your track's amplitude variations – this can make finding critical beats and sync points tough if the track's overall amplitude changes little. Enlarge the Waveform Display by

dragging downward the thin white separator line directly under the Waveform Display (highlighted in magenta below).

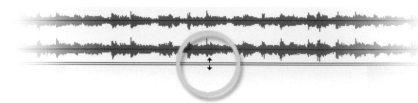

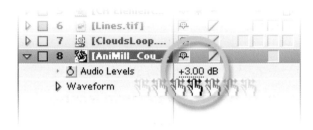

Adjusting the Audio Levels value either boosts or attenuates the track's volume. With the Waveform Display open, change the Audio Levels value. When the levels are raised too high (overdriven) the Waveform clearly shows clipping. Slide the Time Scale Navigator to the right (or press ';') so the Timeline is displaying only a few frames, and the audio track's waveform becomes more defined.

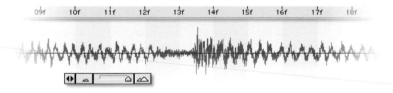

1, 2, 3, Mark

To help assist in the process of tracking audio beats and sync points, After Effects has the ability to place Markers on-the-fly as you preview an audio track. To listen to an audio track you can either double-click on the audio file in the Project Window or press the Decimal key on your keypad to run an Audio Preview. With the former method you can hear the entire track, while the latter only lets you play a duration preset in the > **Edit** > **Preferences** > **Previews . . .** > **Audio Preview** menu (check that the Audio Preview duration in the Preferences is set to at least 15 seconds for this exercise).

You apply Markers to your Timeline by pressing the '*' key on your keypad repeatedly during an Audio Preview. These Markers are applied to any layers that are selected as the Audio Preview plays, but they do not appear until the Preview is halted. The Audio Preview begins at the CTI's current position but does not run the CTI. Audio Previews will play (then loop back to their start) until either the preset duration is reached or until the clip ends – even if the clip extends past the comp's end frame.

In the WONK TV project, an audio track has been provided as a foundation for constructing our graphics. Use this track to experiment setting audio track Markers.

1 Select the audio track – press the Decimal (**.**) key on the keypad.

2 Listen to the track a few times – the **Preview** automatically loops.

3 Once you have a sense of the rhythm, start setting **Markers** for the primary beat intervals by pressing the asterisk (*****) key on the keypad.

4 Press the Decimal key to finish the **Preview** (Audio Preview progresses until you press any other key).

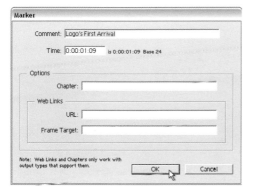

Once stopped, the Markers appear along the individual clip's Timeline color bar. Double-click on a Marker and the Marker settings window opens. You can type a comment or create options to be accessed by other applications using this Timeline (to be discussed later).

Run the Preview again to visually confirm that the marks are synchronized to the music track's primary beat. You can verify the accuracy of Markers by comparing them against the Waveform Display's high-resolution mode (Timeline Navigator zoomed in). In the example on the following page, the left (On-Beat) Marker is clearly aligned to the waveform's beat pattern while the right Marker is offset. Adjusting an offset Marker only takes a drag of the cursor to line them up with a beat's peaking pattern.

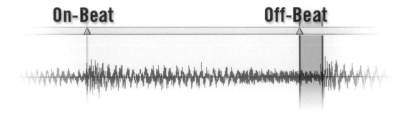

Sound Affects

Image layers in After Effects can use sound as a source for various visual filters (some included with After Effects, others available from third parties). Open the *Sound Affects.aep* example file to view several uses of the Effects filters using Audio as their source. Drop the Comp Window's Resolution/Down Sample to Half to speed up your previews. To dissect each effect, press 'E' on each layer then double-click a layer's effect to open the Effect Controls window.

The two general visual filters for Audio Effects (> **Effect** > **Render** >) are:

A **Audio Spectrum** – displays several different patterns where the elements of the pattern are generated by the frequency and amplitude of the sound as heard at specific time intervals, akin to a Spectrum Analyzer used to calculate sound energy of a limited range of frequencies.

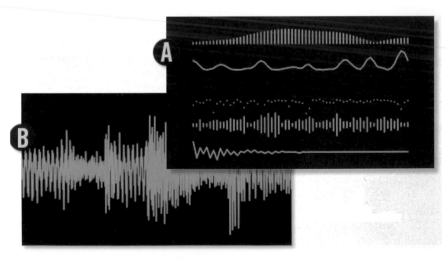

B **Audio Waveform** – displays several different patterns where the elements of the pattern are generated by the audio samples as derived from the actual soundtrack; this looks the same as opening the Waveform Display ('F F') on your audio source layer.

Sound Keys

There are a number of third-party plug-ins available for Audio Effects, but if you're working consistently with audio files there's one I'd highly recommend – **Sound Keys** by Trapcode.com (available at ToolFarm.com). This useful little plug-in takes your sound files then converts various frequency and amplitude changes into animated Keyframes that can be applied to any animatable

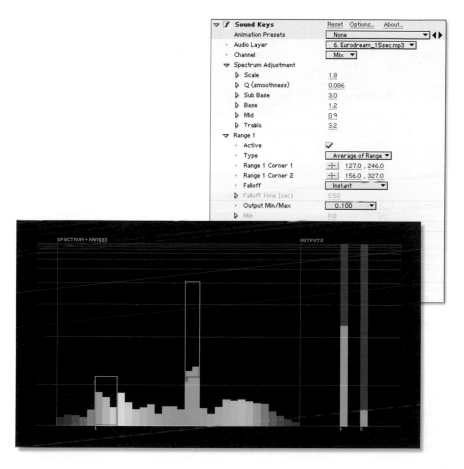

function, property, or other plug-ins within After Effects. You can download a demo version of Sound Keys at Trapcode.com.

Keyframe Animation

I've said it before, I'll say it again: 'If it don't move – it ain't animation.' The whole *raison d'être* for After Effects' existence is to allow you (the designer, editor, animator, or artist) to **animate** and composite visual elements into one finished creation.

Main Entry: **an·i·mate** Merriam-Webster
Pronunciation: -"mAt
Function: *transitive verb*
Inflected Form(s): -mat·ed; -mat·ing
 1: to give spirit and support to: ENCOURAGE
 2a: to give life to b: to give vigor and zest to
 3: to move to action
 4a: to make or design in such a way as to create apparently spontaneous lifelike movement b: to produce in the form of an animated cartoon

By permission from Merriam-Webster's Online Dictionary. © 2004 Merriam-Webster Inc. (www.Merriam-Webster.com)

To paraphrase Merriam-Webster's definition:

 'To animate is to bring your images to life.'

Keyframes are the direction waypoints – the intervals where an instruction change takes place. They can be created by simple mouse drags inside the Comp Window, or as complex mathematically generated expression subroutines referencing multiple layers' transforms and effects. For now, we'll be covering the simpler methods of Keyframe creation and adjustment.

Return to the '*Logo Risen.aep*' project. Drag '*GlimmerLoop.mov*' into the Timeline (starting at 0:00), dropping it in below layer 8 (*Purple Glow Rise*).

Toggle on the Solo for both layers 8 and 9. Select layer 8 and then press the 'U' key – call this the UberKey! Why? Because instead of twirling open an entire layer's properties just to see a few properties' Keyframes, when pressed once only the properties that have Keyframes applied will open.

When pressed twice in rapid succession, anything that has been altered from a layer's default settings will roll open – even if there are no Keyframes applied, the layer's properties just need to be changed in some form. This is a *huge* feature, so remember – UberKey!

Copy and Paste Keyframes

Previous to version 6.0 of After Effects, copying multiple Keyframes from more than one option per layer had been a little difficult (position only, or rotate only, etc.). Now with version 6 and newer, the designer can copy and paste Keyframes from different options (transforms, effects, masks, etc.) at once.

With layer 8's Keyframes open (press 'U' to show all Keyframes), select all Keyframes by either 'Ctrl + clicking' on each transform or selecting the actual Keyframes by dragging the cursor around the Keyframes. Press 'Ctrl + C' to Copy the Keyframes (or use the main menu > **Edit** > **Copy**). Ensure that the CTI is located at the start of the Timeline, then select layer 9 and press 'Ctrl + P' to paste (main menu > **Edit** > **Paste**) the Keyframes into the 'GlimmerLoop.mov' layer.

The Paste function will always apply the copied Keyframes at the CTI's current position. No matter where the source Keyframes are located, they will always paste at the CTI marker's location.

Open layer 9 using UberKey 'U' to display the Keyframes. As it stands now, as you drag the CTI to preview the motion, the *GlimmerLoop.mov* layer follows the Purple Glow. To make the effect, the *Glimmer* layer must be larger than the Oval mask of layer 8.

You could just go to each Keyframe of layer 9 and manually adjust the scale of the image to cover the Purple Glow, but if this layer had a whole bunch of Keyframes, this process would take too

long. A simple shortcut exists for applying a common change across multiple Keyframes at one time.

Go to 3:00, then select all of layer 9's Scale Keyframes (click on the Scale option title or drag the cursor across the row of Scale Keyframes), then in the Comp Window scale the *Glimmer* image larger until it is larger than the Purple Glow (about the size of the whole Comp frame). Notice that in the Timeline a new Keyframe has been created rather than all the selected Keyframes being altered. This is After Effects Auto Keyframing in action and it's usually helpful – except when you're trying to apply a change over multiple Keyframes.

Press 'Ctrl + Z' to Undo this Keyframe. Again, select all the Scale Keyframes, but this time 'Shift + drag' the CTI to Snap directly over any of the selected Keyframes (Snap works with any dragged item). Now rescale the 'GlimmerLoop.mov' layer in the Comp Window. This time, all the Scale Keyframes change relative to the change you made.

Set layer 9 to Overlay (Blending Mode) and choose the Alpha Matte (Track Matte). Turn off its Solo, then turn on layer 8's Video switch (A/V Features), which was turned off when you applied the Track Matte.

Keyframe Creation and Modification

The Logo Rise is a little dull, so let's mess it up a bit by adding some spin. Things will move a bit quicker now.

1 Select layer 7, Logo Rise Text – press 'R'.

2 Go to 1:00 – click on the Rotate stopwatch.

3 Go to 2:00 – change the first Rotate value to '4'.

4 Go to 6:00 – click on the Add Keyframe switch.

5 Go to 8:00 – change the Rotate value to '8'.

All the settings that were made to the first copy of the Logo Rise layer must be copied to the other duplicate layers.

6 Select all the Rotation Keyframes in layer 8 and press 'Ctrl + C'.

7 Select the two other copies of Logo Rise Text and the Shadow.

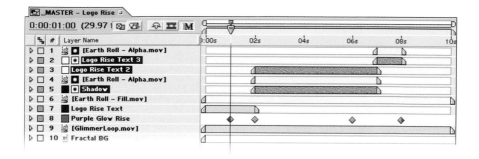

Another convenient feature to After Effects Keyframe management is its ability to Paste one common set of Keyframes from one layer to multiple layers at one time.

8 Align the CTI to the first Keyframe of layer 7.

9 Press 'Ctrl + P' to Paste the Rotation Keyframes to the selected layers.

10 Press 'R' to confirm they all have the same Rotation Keyframes applied.

11 Save your work using the Increment and Save function (Ctrl + Alt + Shift + S).

12 RAM Preview your work at 50% size and Half resolution to speed up the preview (Every-Other-Frame, 'Shift + 0').

The only problem with the animation now is the Logo Rise spins too quickly and stops spinning too early with respect to the Logo Rise landing over the Earth. The second Keyframes need to be moved later to coincide with the logo's landing position.

Moving Keyframes

As simple as it is to make Keyframes in After Effects – so it is with moving Keyframes. With all of the *Logo Rise Text* layers displaying their Rotation Keyframes (select each layer, then press 'R' if you need to see them), then:

13 Drag the cursor around the column of Keyframes at 2:00.

14 Click on any of the selected Keyframes and drag right to 4:00.

Create another RAM Preview – but this time to speed the process even further, restrict the Preview to a small Work Area.

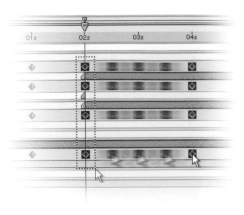

15 Go to 1:20 – press 'B' to mark your Work Area Beginning point.

16 Go to 4:10 – press 'N' to mark your Work Area End point.

17 Press keypad '0' for a full RAM Preview at 100% and Full.

Now we have a new problem: the Logo Rise spin negates our careful Split transition from coming behind the Earth to the foreground. But we can't correct this problem until we make one more adjustment – smoothing the rotation to a stop when it enters, and back into motion again when it leaves.

The Keyframe Assistant

As the logo comes to a hold position in the Timeline, the motion glides to a gentle stop. This is because the Position Keyframes have mathematical Interpolations applied that create an Ease In to its hold position. An Ease is best described as an object's velocity deceleration or acceleration prior to a change in motion.

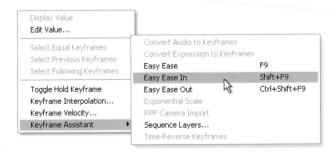

After Effects has several ways to apply this more natural Ease as opposed to the harsh computerized instant stop 'Clunk!' we've all seen before. The easiest technique is the Easy Ease.

18 Select all sets of Keyframes at 4:00 and 6:00.

19 Right-click on any selected Keyframe to open the Keyframe Options pop-up menu.

20 Select > **Keyframe Assistant** > **Easy Ease** (F9).

Run the RAM Preview again to see the difference – notice how the spinning slows to a gentle stop. Move the Work Area Selection Bar down the Timeline to Preview the spinning out point. You can quickly reassign the Work Area of a project

⊠ = Easy Ease (F9)

≫ = Easy Ease In

≪ = Easy Ease Out

by grabbing the four hatch marks in the center of the Work Area Selector Bar along the top of the Timeline and sliding the whole bar to its new destination.

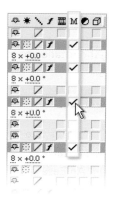

I have a personal preference to select either Easy Ease In (Shift + F9) or Easy Ease Out (Ctrl + Shift + F9) to help visually identify smooth In and Out motions in my Timelines.

To add a little more motion smoothing to the *Logo Rise Text*, we'll add some Motion Blur. This is accomplished by switching on the Motion Blur check-box in the Timeline's Switches column for each of the four layers using *Logo Rise Text*. If you select all four simultaneously and click in any of the Motion Blur check-boxes, all four will activate. All you need to do now is activate the Timeline's Global Motion Blur switch. Now go to 3:00 and look at the difference. Also notice how much longer it took to render the frame with Motion Blur applied.

Perform another RAM Preview of the area around the Earth horizon transitions to see where to adjust the In and Out Points of the various Logo Rise Text layers. Be certain to take into account the direction of travel when making this decision – make the transition when just a little of the leading edge of the spinning logo, rather than the following edge, is touching the horizon.

The new Timeline In and Out Point settings are:

1 Go to 2:05.

2 Select layers 3, 4 and 5.

3 Press 'Alt + ['.

4 Select layer 7 and press 'Page Up' (PgUp) to move back one frame.

5 Press 'Alt +]'.

So why did you have to move the CTI back one frame? When you press the Snap End Point to Current Time Position (Alt +]), the End Point includes a viewable frame from the Timeline's clip. Editors should be familiar with this 'inclusive' marking technique – however, it causes some undesirable results in your Comp Window. If you do not make this single frame backward adjustment prior to the End Point's change and just press 'Alt +]', you'll end up with concurrently overlapping frames which will double the image's intensity on screen. Go ahead – test it for yourself.

As luck would have it, the transition move into the inside Earth's horizon works, but it's not good enough. Go to 7:13 and realign the In and Out Points for layers 1–5 and you'll see that this feels like a better transition point.

Keyframe Interpolation – Temporal (Time)

Easy Eases are the simplest form of Keyframe Interpolation to use, but they are applied solely in the Timeline Window to make property changes. Changing Temporal Interpolation affects a Keyframe's response to time changes. After Effects has several Temporal Interpolation options:

- **Linear** – increments of change between Keyframes remain constant.
- **Bezier** – events change smoothly between Keyframes, but can change abruptly when intersecting the selected Keyframe.
- **Continuous Bezier** – events change smoothly between Keyframes *and* when intersecting the selected Keyframe.
- **Auto Bezier** – applies the most gradual and uniform changes leading into then out of the selected Keyframe.
- **Hold** – locks the selected Keyframe's values from change until the next Keyframe is intersected; it makes *very* abrupt changes.

You can see the effects of these different
Temporal Interpolations in the Timeline. To best
characterize these differences, create a new
Composition (Ctrl + N) and use the settings from
the previous project. You'll use the Type Tool to
create a layer of text to demonstrate the Keyframe Temporal Interpolation
options listed above.

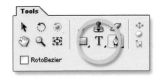

1 Activate the Type Tool (Ctrl + T).

2 Select any font you like, but set the size to 60 px, then set the color to a
bright color that annoys you,

3 Check to see that the CTI is at 0:00 and that the Background Color
(Ctrl + Shift + B) is set to black.

4 With the Type Tool's cursor, click inside the Comp Window, then type
'*Temporal*'.

5 Click the cursor anywhere outside the Comp Window to finish the text.

6 Press 'V' to activate the Selection (Move) Tool.

7 At 0:10 create a Position (P) Keyframe (turn on the stopwatch).

8 Press 'B' to set the Work Area's Beginning mark.

9 Go to 1:10 and in the Comp Window move '*Temporal*' somewhere
different.

10 Go to 1:20 and press 'N' to set the Work Area's End marker.

As you drag the text around the screen, a Motion Path thread extends behind
the object. The Path displays each Keyframe as small 'x' marks, while the dots
indicate individual frames in the Timeline where the object's center (Anchor
Point) follows. The length of the Motion Path is configurable in the Preferences
menu **Edit > Preferences > Display > Motion Path**.

Temporal Changes

As you've seen, each Keyframe starts as a small diamond indicating that
the Interpolate setting is Linear (you can override this default mode in
the Preferences). Make an RAM Preview to see what the default Linear motion

feels like. The motion starts suddenly then stops instantly – very unnatural. Save your work (Ctrl + Shift + S) as '*InterpME!.aep*' for future reference.

Select both Keyframes, then press 'F9' to apply Easy Ease to both. In the Comp Window, look at how the frame indicator dots near to the Keyframes are more closely spaced while the middle dots are spaced further apart. Make an RAM Preview of the motion and you'll see that the text accelerates out of the first Keyframe then decelerates into the last Keyframe in a more natural flow.

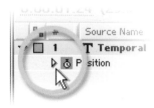

Another way to visualize motion Interpolation is to open the Motion Graph of the Keyframe property. To the immediate left of the Position stopwatch (or any animated layer property) is a small arrow – twirl it open to view the Graph of the Easy Ease Keyframes.

The following illustration shows you what a typical Motion Graph will display. If you reset the Keyframes to Linear, instead of the gentle sine-wave curve, you'll get the flat line of a square-wave.

Click on either Keyframe and blue handles appear. These control how the Interpolation is calculated.

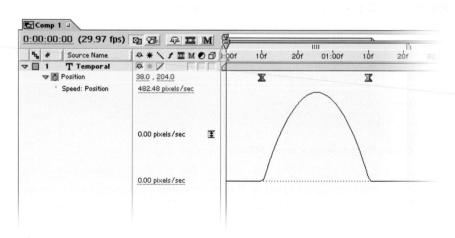

Go to 0:25 in the Timeline, then in the Comp Window move the text around the screen while watching the Motion Graph. As you move the text the Graph

alters its shape and flow, reflecting how smooth or sudden the transitions from Keyframe to Keyframe will play back.

Right-click on the middle Keyframe you just created. Open the > **Keyframe Interpolation** menu. Change the current Temporal Interpolation setting from Bezier to each of the five different settings to experience their effects on the text's motion. RAM Preview each mode to get a

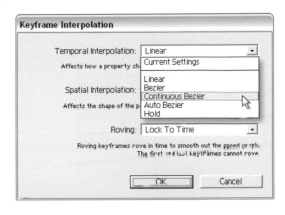

better feel of their impact. Hold and Linear will display the greatest change of behavior, while the Bezier options are very similar in their smoothing behaviors.

But no matter how much you alter the Temporal Interpolation modes or adjust the handles, the image's Motion Path remains a straight line leading into or out of the Keyframes. To make changes to the Motion Path's shape you need to address an object's Spatial Interpolation – its motion.

Keyframe Interpolation – Spatial (Motion)

The second kind of Interpolation is Spatial – relating to an object's position affecting the layer's Motion Path. Spatial Interpolation allows you to create dynamic and flowing paths for your layer's motion.

To illustrate the difference between the two Interpolation types, let's create another text layer using the previous *Temporal* layer as a reference:

1 Revert the project to '*InterpME!.aep*'.

2 Duplicate the *Temporal* layer.

3 Turn off the original *Temporal* layer's Video (Ctrl + Shift + Alt + V).

4 Double-click on layer 1 to select the text; the Type Tool is automatically activated.

5 Type 'Spatial'.

6 In the Comp Window, right-click on the first Keyframe (small 'x' preceding the Path) to open the Keyframe options menu.

7 Select > **Keyframe Interpolation** > **Spatial Interpolation:** > **Continuous Bezier**.

Magnify the Comp Window and center the view on the first Keyframe. A short line has been added coming out from the Keyframe's center – this is a Bezier vector handle. Dragging on this handle will impose a non-linear change to the layer's path.

8 Drag the first handle in any direction to see the object's Path bend.

9 Right-click on the end Keyframe and apply the same > **Continuous Bezier** Spatial Interpolation.

10 Drag the end Keyframe's handle around to exaggerate the path.

11 Save your work, then press the 'Space Bar' to preview the motion.

Using the Space Bar imposes another form of RAM Preview – Preview with Paths. This is helpful for examining where objects intersect each other, or interact with other layers in the Comp Window.

Reactivate the original *Temporal* layer's Video switch and compare their motions. The *Spatial* layer now follows a distorted path rather than the original's linear path. Open the Position property of the *Spatial* layer – neither of the Keyframes has any indication a Spatial Interpolation has been applied. Generally, you don't need a Keyframe Marker icon change to identify the Spatial Interpolation – clicking on a layer to display its path will be clue enough. However, the only time you can see the handles of a Bezier path is to select the property's Keyframes – then the handles will display in the Comp Window.

Interpolation and the Pen Tool

With the project you just created open, activate the Pen Tool (G). This tool allows you to manually insert, delete, or modify any Keyframe

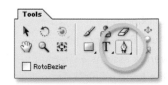

in the Comp Window. If you've used a vector illustration program, or Photoshop's Pen Tool, this tool's functions should be familiar. In After Effects it is used in both Masks and Paths alike.

Open the Position properties for the *Spatial* layer. With the Path for Spatial displayed in the Comp Window, float the Pen cursor over the layer's path. As you move the cursor over the Path the icon changes to the Add Vertex Tool. Click anywhere on the Path to add a vertex (a corresponding Keyframe in the Timeline will be added at the same time), then drag the cursor around the screen to extend the Bezier handles and make the Path more distorted.

Notice when you add a vertex to the Path that the spacing of the dots remains unchanged (unless you physically drag the new vertex's handles after you've added it). This is because adjusting the Path only affects the Spatial Interpolation of the layer's Keyframes. To influence the spacing of the Path's dots you have to alter the Temporal Interpolation. Select the last Keyframe of the *Spatial* layer and make it an Easy Ease In (Shift + F9). Closely examine the Path and you'll see that the dots have shifted, placing them more closely spaced as they approach the final Keyframe while expanding away from the opposite Keyframe. This is the visual representation of how a smooth Ease In will affect a layer's motion.

Converting Vector Interpolation

Every vertex can be quickly altered from one type of Interpolation to another. With the Pen Tool active, float the cursor over a vertex and the icon changes to the Convert Vertex cursor.

Clicking on a vertex causes it to reset to either Auto Bezier or Linear, while click and dragging on a vertex assigns a Continuous Bezier function with the handle lengths reflecting each other.

Also, when Convert Vertex Pen Tools is selected, you can break a Continuous Bezier vector into a normal Bezier (where the handles act independently) by click and dragging a vector's handle.

Take a few moments to experiment with both types of Interpolation and using the Pen Tools to alter your object's Motion Paths. Mastering Keyframe Interpolation, Motion Path modification and Motion Graph tweaking will lead to more organic or frenetic animation rather than the usual staid motion we're all accustomed to seeing.

Precomps – Layers Within Layers

After Effects' Killer-Killer Feature

Every successful program must have a compelling 'Killer Feature' to drive its popularity. Precomping is After Effects' 'Killer-Killer Feature' – the ability to use any composition in any other composition's Timeline. What really sets After Effects above the fray is the different operations of Precompositions:

- **Standard Nesting** – the Precomp layer in the parent composition performs identically to a finished pre-rendered movie clip from the source composition.

- **Collapsed Transformations** – the Precomp performs like its layers are acting as a group of layers still residing within the parent composition. All Blending Modes, 3D layers, and many effects cascade into the parent composition, affecting all layers beneath the Precomp's layer.

It's the second feature, Collapsed Transformations, that makes After Effects shine and will cause the designer much elation and hardship – elation because the resulting visuals are pronounced

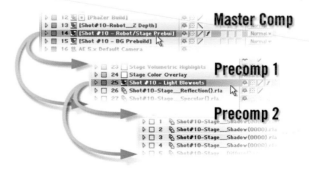

in their boundless effect on a project's development, hardship because the increase of creative development options are, well, boundless.

The easiest way to imagine a Precomp is to think of it as a layer of layers. The image at the bottom of the previous page shows a Master Comp with Precomp 1 as layer 14, then Precomp 1 has Precomp 2 as its layer 25.

We'll expand on this Precomp section by also discussing Looping etiquette – the correct methods for creating seamless and imperceptible loop transitions.

Opportunities Abound

The Precomp has so many applications that its difficult to narrow down just a few examples, but it does help to explain some of the more common uses and which method listed above would most likely be applied.

- Creating a master movie clip composition with complex effects applied that is used in multiple locations throughout a composition and across multiple compositions.

- Creating a graphic element utilizing various filters that will be keyed over many different backgrounds, lower thirds, bumps, IDs, etc.

- Uniting a vast assortment of associated layers within a massive composition into a more convenient single layer.

- Preparing a combined effects resource layer to be used by another layer that requires multiple layer elements to be used at the same time.

- Combining various Alpha Channels and masks from different sources to act as one master Alpha Channel for multiple layers and/or in multiple comps.

- Preparing a 3D object layer (i.e. a flipping slab or box) that will be used in another Comp for transitions or as an insert box.

There are vast options available to the designer in how to use Precomps. Once you start to use them, you'll wonder how you ever worked without them.

WONK TV Returns

We now return to WONK TV's Logo Package design already in progress. Open 'WONK Logo Build 02.aep' to resume its development and to learn about the power of Precomps.

When we last worked on the logo build we added a glimmer effect behind the TV glass. What we'll need to finish this off is two Precomp layers with half of the completed logo each. But first we have to complete the whole logo with all its glimmers and highlights.

Standard Nesting

For the glimmers and highlights needed we'll have to extend layer 5 (*GlimmerLoop.mov*) into a seamless looping Precomp. As it stands, the *Glimmer* file is already loopable – but its duration of 2:12 is not very conducive for looping in this project.

To make the *Glimmer* layer more loop friendly to our Master Comp, we'll make a Precomp that alters the loop duration.

1 Select layer 5.

2 Make a duplicate (Ctrl + D) of layer 5.

3 Press 'Ctrl + Shift + C' to open the Pre-compose Window.

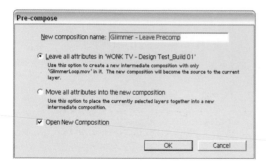

Immediately you are posed with two Precomp creation methods:

- Leave all attributes . . .
- Move all attributes . . .

The first method, **Leave all attributes . . .**, creates a Precomp with its Composition Settings based upon the source file's image size and containing only the source file, while leaving behind in the master composition all effects, masks, and alterations originally applied to the Precomp's layer. It's best to think of this as creating another composition directly from the source file, then the new composition replaces the source file's layer in the master composition.

The second method, **Move all attributes . . .**, creates a duplicate composition using the current Master Comp's settings, then moves the source layer into the new Comp – complete with *all* applied effects, masks, and alterations intact. This method would be the same as: duplicating the Master Comp in the Project

Window, opening that duplicate, deleting all the other layers you didn't want to Precomp, then replacing the layer in the master composition you wanted to Precomp with this modified duplicate.

4 Choose 'Leave all attributes . . .' and make certain that the 'Open New Composition' box is checked.

5 Change the name to *Glimmer – Leave Precomp*.

6 Press 'OK'.

A new Comp Window pane opens tabbed within the existing Timeline and Comp

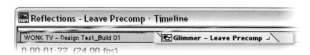

Windows, and a new composition object is added to the Project Window. Since the *Glimmer – Leave Precomp* was created based upon the source layer's settings, the Precomp is smaller than the *WONK TV – Design Test_Build 01* Master Comp; however, the new Precomp's time rate is taken from the Master Comp settings. In addition, the duration of the Precomp is the same as the source layer.

Compare this Precomp to the other method by making another Precomp, this time out of the original *WONK TV – Design Test_Build 01* Master Comp's *Glimmer* layer.

7 Return to the *WONK TV – Design Test_Build 01* Master Comp by clicking on the tab name within either the Comp or the Timeline Window.

8 Select the original *Glimmer* layer (now 6).

9 Create another Precomp (Ctrl + Shift + C).

10 Change the name to *Glimmer – Move Precomp*.

11 Select the 'Move all attributes . . .' option ('Open New . . .' should already be checked – if not, check it).

12 Press 'OK'.

Another tabbed window opens in the Comp Window, but this looks very different from the first Precomp example. Here the second method, 'Move all

attributes . . .', has made a duplicate sized composition from the Master Comp, including all the same Composition Settings as well. The source layer appears with all its masking, effects and settings intact, and all the Transforms (and Keyframes, if it had any) maintained.

Of the two Precomp methods, the 'Leave all attributes . . .' technique is the most appropriate for what we need to do: make a looping build of the original footage source that any Comp can use.

Return to the *Glimmer – Leave Precomp* by clicking on its Timeline name tab. To make this clip loop at a more usable duration, we have to make some adjustments to the layer and the Precomp's settings.

Looping Etiquette – Part 1

A well-designed and prepared movie clip loop must be both seamless and run in durations that are beneficial to the production user. The best looped clips disguise their loop points, making the match point indistinguishable from any other point in the clip.

When the WONK TV Logo ID is completed the logo should be steady onscreen for 4 seconds then loop back on itself so the proverbial client can extend the end hold for as long as they desire. Therefore, the Glimmer clip must loop in some multiple of 4 seconds that's easy to devise. The original clip's duration is 2:12 and is a good loop in itself, but this finished Precomp must be able to span the full Master Comp's Timeline and be a standalone loopable clip at the last 4 seconds of the Master Comp. We'll choose to make the clip loop at 2 seconds.

1 Go to 2:00, Split (Ctrl + Shift + D) layer 1, then press 'Home'.

2 Press '[' to Snap the new layer 1 back to 0:00.

3 Solo layer 1, then right-click on layer 1 and select > **Effect** > **Transition** > **Gradient Wipe**.

4 In the Effect Controls window, click on the 'Gradient Layer' button and select '1. GlimmerLoop.mov'.

5 Click and drag the cursor over the Transition Completion percentage value, setting it to approximately 50%.

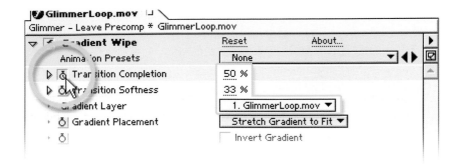

6 Switch on the Transition Completion stopwatch in the Effect Controls window.

7 Click and drag the cursor over the Transition Softness percentage value, setting it to approximately 33% – observe its effect.

8 Deselect the Solo button on layer 1.

The Gradient Transition is an excellent filter for creating loop match adjustments, since it allows for gradually fading dissolves based upon the source Gradient Layer's luminance values. This effect is also one heck of a good luminance keyer.

9 Go to 0:12 and press 'U' to open the one keyframed property in layer 1.

10 Set the Transition Completion value to 100%, then return to 0:00, and set the first Keyframe's value to 0% – do not use the Reset button or the effect will forget all your settings.

11 Drag the CTI back and forth to watch the Gradient Transition in action – the dissolve blends into a mushy fog that is very noticeable.

12 Activate the Invert Gradient check-box to fix this problem. Now drag the CTI – the dissolve is smooth.

13 Go to 1:23 and press 'N', then create an RAM Preview – the loop is perfect.

Now that we've constructed the perfect glimmer loop resource, you need to extend it to the full 10 seconds the Master Comp requires. You could perform

this loop extension by duplicating your two loop layers several times, then manually offsetting each 2-second group, or do the following.

Here's where the 'layers within a layer within a layer' concept of multiple Precomps begins to establish itself more clearly. Select all layers (Ctrl + A) of

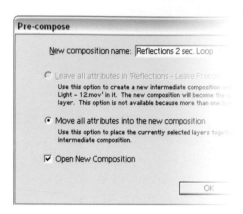

the *Glimmer – Leave Precomp*, then create another Precomp (Ctrl + Shift + C). This time only one of the two Pre-compose Window's options is available and a generic name has been offered. When you have more than one layer, only the 'Move all attributes . . .' function is available because 'Leave all attributes . . .' only works on single layer sources.

14 Change the name to *Glimmer 2 sec. Loop*, then press 'OK'.

15 Change the Composition Settings (Ctrl + K) to a 2-second duration.

16 Close the new Precomp by clicking on the little Close Box located in the layer's Composition Window or Timeline Window name tab.

Back to the *Glimmer – Leave Precomp*. The original layer has been replaced by the *Glimmer 2 sec. Loop* Precomp and has a new color assigned to its Timeline Bar. Running another RAM Preview will result in the identical seamless loop playing. Now we need to duplicate the *2 sec.* Precomp to extend the overall loop's duration.

17 Change the *Glimmer – Leave Precomp* setting's (Ctrl + K) duration to 10:00.

18 Expand the Timeline to show its whole 10 seconds by pressing the semicolon key (;) – you might have to press it twice.

19 Duplicate (Ctrl + D) layer 1 four times.

20 Select all (Ctrl + A) layers.

21 Right-click on the selected layers to open the Layer Options menu, then
select > **Keyframe Assistant** > **Sequence Layers**.

The Sequence Layers
window opens. It assists
you with offsetting
multiple layers with
several options to apply.
Right now, all we want it
to do is offset each
layer to begin where
the previous layer ends.

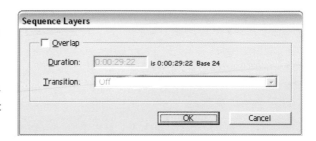

22 Press 'OK', then Increment and Save (Ctrl + Shift + Alt + S) your work.

23 Jump to the last frame (End) and press 'N', then run another RAM
Preview.

Notice that as it renders the preview, once it completed the first 2 seconds
the remaining 8 seconds shot past. That's because once the first layer was
rendered, since the remaining layers were all copies of the first layer, After
Effects didn't need to re-render what was already created. This is its efficient
cacheing at work.

Beware – when using
Sequence Layers the system
will apply the offsets (and
overlaps if you use them)
based upon the order in which
each layer was selected. So if
you were to select each layer
in a random out-of-order
fashion, Sequence Layers will remember your selection order. Experiment with
this selection order function by recreating the previous Sequence, but instead

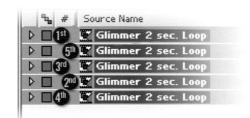

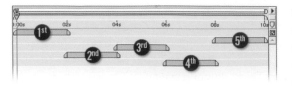

randomly select the layer order (Ctrl + click). The results should be similar to the example pictured at left.

Close the *Glimmer – Leave Precomp* Timeline/Comp Windows and return to the Master Comp. Of the two Precomp method example layers, 'Move all attributes . . .' converted the original *Reflections* layer into its *Move Precomp*, thus extending the layer's duration to the entire length of the Master Comp. The *Leave Precomp* would have maintained the source layer's original duration, but when we made a Precomp of the 'Leave all attributes . . .' Precomp and extended its duration, the adjusted duration shows up in the Master Comp as the long gray bar extension to layer 5's Timeline Bar. The final Precomp needs to be extended the full Master Comp's length. Select layer 5, then press 'End' followed by 'Alt +]' to snap the layer's Out Point fully open, or drag the Out Point's handle across to the end of the layer. To finish up this section, delete the 'Move all attributes . . .' layer (6) to prepare the WONK TV for the next section.

Collapse Transformations – Enhanced Nesting

The most powerful of After Effects' Precomposition functions is Collapse Transformations. Unlike Standard Nesting, which only acts as a normal layer, Collapse Transformations Precomps have several unique abilities.

All Precomps are initially set in the Standard Nesting mode when they are created in or added to a Timeline. The Precomp icons are displayed in the Switches column. When the dotted circle is clicked it switches to solid, indicating that the mode is now Collapse Transformations.

Standard Nesting
Collapse Transformations

Duplicate layer 5 and, in the Comp Window, drag it behind the purple glass of the '01' text. Zoom into the Comp Window to center the new *Glimmer* layer to its final position under '01' – don't worry if it overlaps the other *Glimmer* layer.

Select both *Glimmer* Precomp layers, then change their modes to Overlay and reduce their Opacity (T) to 50%.

Finishing the Logo Design

To make the logo more eye-catching, we'll add some glimmers over the main text. We'll be using the *Reflections* Precomp as the highlight layers with a Track Matte taken from the *Logo* text layer.

1 Select both *Glimmer* Precomps and duplicate them.

2 Drag both duplicates above layer 4 (*WONK Logo.png*).

3 Open both duplicates' Masks (M), select both *Mask 1* shapes, then press Delete.

4 Set their Blending Mode to Overlay and their Opacity (T) to 66%.

5 Center each duplicate over its logo text.

6 Resize both layers to completely cover the text layers, scaled to about 100% by 66% – let them overlap.

7 Rename the *Glimmer* layer located over the *WONK TV* text to *WONK Glimmer*.

8 Rename the lower *Glimmer* layer (located over the *CH 01* text) to *CH Glimmer*.

To mask the logo text glimmers, we need to duplicate the logo layer to act as the Track Matte's source.

9 Select *WONK Logo.png*, then duplicate it twice.

10 Rename one *WONK Logo* duplicate to *WONK text matte*, then rename the other duplicate to *CH text matte*.

11 Select *WONK text matte*, then in the Comp Window create a Box Mask around the *WONK TV* elements.

12 Select *CH text matte* and make a Box Mask around the *CH 01* elements.

13 Drag the *WONK text matte* layer above the *WONK Glimmer* layer.

14 Apply a Luma Matte Track Matte to *WONK Glimmer*.

15 Duplicate both *WONK text matte* and *WONK Glimmer*.

Notice that when you make a duplicate of two Track Matte-dependent layers the duplicates retain their association to each other. Previous versions of After Effects did not retain this association, so you had to manually shuffle the layers to reconnect the Track Mattes.

16 Drag both duplicate layers together down the Timeline stack beneath the *WONK TV Master* layer.

17 Drag *CH text matte* above *CH Glimmer*, then repeat the same procedures from steps 14 to 16 above for the *CH* layers.

The last procedure is to add a Fast Blur filter to the matte sources to allow the glimmers to be seen.

18 Select *WONK text matte*, *WONK text matte 2*, *CH text matte*, and *CH text matte 2*.

19 Right-click to add the filter > **Effect** > **Blur & Sharpen** > **Fast Blur**.

20 In the Effect Controls window, adjust the Blurriness to 64 and set the Blur Dimensions to Vertical.

We'll be creating Precomps of the upper and lower logo elements to independently fly into our project. There's just one last procedure to complete: preparing the *WONK Logo.png* layer for the Precomp assembly.

21 Set the Blending Mode of *WONK Logo.png* (layer 8) to Darken.

22 Duplicate layer 8, then rename the copy to *WONK TV Master*.

23 Enclose the upper text elements with a Box Mask – this Mask need not be precise, it just needs to separate the upper logo from the lower.

24 Apply a Box Mask around the lower *WONK Logo.png* and rename it to *CH 01 Master*.

25 Select the *Glimmer* layer under the purple *TV* glass and rename it to *Reflections – WONK*.

26 Select the *Glimmer* layer under the purple *01* glass and rename it to *Reflections – CH*.

The whole reason for the Collapse Transforms method will become apparent as you Precomp the complete WONK TV Logo Design. Begin by selecting only the layers with 'WONK' named elements: *Wonk text matte, WONK Glimmer, WONK TV Master*, and *Reflections – WONK*. Unlike the Sequence Layers function, the order you select the layers here is irrelevant – Precomping maintains relative layer order.

Press 'Ctrl + Shift + C' to make a 'Move all attributes . . .' Precomp and rename it *WONK Elements build*. Uncheck 'Open New Composition', then press 'OK'.

Carefully observe the results to the newly Precomposed *WONK Elements build* layer – specifically, look at the glass around the *TV* text. It no longer has the rich blue overlay effect, nor does the logo have any of the vertically blurred glimmers extending past the blue background. And more obviously, the text *WONK TV* is no longer transparent – it has reverted to solid white. The upper logo has lost the 'snap' that the *CH 01* elements still display.

Now switch 'on' Collapse Transforms in the Timeline and watch what happens – suddenly the *WONK TV* logo elements look just as they did before the Precomp was created. Toggle the switch 'off' and 'on' a few times to compare the differences between the two Precomping modes.

Select all the CH elements and create another Precomp, then Increment and Save your work. Make an RAM Preview of the new logo design to review your work.

Precomping Caveats

As powerful as Collapse Transforms can be, there are a few restrictions to beware: Effects need not apply and Blending Modes are unavailable.

Once activated, Collapse Transforms disables several of the Precomp's layer options. If you try to add an Effects filter or change the Blending Mode, the layer loses its Collapse Transform's special abilities. Though this might be a little

frustrating, because it would be nice to apply a global Effects filter to the whole Precomp at once, it actually makes perfect sense – remember that when Collapse Transforms is functioning all it's really doing is behaving like all its layers are actually still present within the master composition having been grouped together as one layer. If you wanted to apply an Effect to the group, you'd have to apply the Effect to each layer within the group individually. When you add an Effect to the Precomp, you're reverting it to Standard Nesting mode.

Likewise, if you activate the Precomp's Blending Mode you're effectively overriding all the group's individual Blending Modes and again reverting the Precomp to basic Nesting.

Layers – Part 2: Taking Control of Your Composition

Pulling it all Together

Precomping's ability to create groups of associated layers, and apply those Precomps in two different modes, took After Effects to its next level. It opened up a wide palette of 'free-form' design tools encouraging artists to design as they build.

The WONK TV On-Air ID package's design was almost completed in the last section, but as all artists know – their work is never complete. The logos still need animation, effects applied, and additional elements to finish the whole project. The package won't be truly complete until we use some of the more advanced compositing features of After Effects: Parenting, 3D Layers and a simple Shadow effect.

Parenting is one of After Effects' most simple yet powerful functions – attaching a layer or layers to another layer. This is more like the grouping function many other programs offer. But unlike grouping, where all layers operate in concert, Parenting allows each Child layer (layer connected to the Parent) to still perform individually.

Gradient Effects – Play Ball!

For our demonstration on Parenting, create a new Project (with Project Setting at 24 fps) with a new Comp of 512 × 512 with Square Pixels at 24 fps titled *Spinning Balls*. Add a Solid layer of any color (Ctrl + Y), but set its dimensions at 128 × 128. Right-click on the Solid layer, add > **Effect** > **Render** > **Circle** and set the Radius to 64.

Apply > **Effect** > **Render** > **Ramp**. Set the Start Color to very light blue and the End Color to deep dark blue. Magnify the Comp Window 200% (press the Period key). Drag the upper Start of Ramp target to the upper right of the circle. We now have a nice little sphere to move around our Comp. Zoom out ('Comma' or double-click on the Zoom Tool), then rename the new sphere layer to *Sphere 1* and duplicate it three times. Select each layer, then press 'E' to open their Effects properties. Change the Ramp colors of each copy to a different color set as listed in the menu illustration below (Solo each layer as you make the adjustments and amend their names to identify their colors). Drag each color Sphere to a different quadrant of the Comp Window. Your balls are ready.

Parenting with Nulls – Nulls Don't Mean Nothing

Close the Effects properties of all your layers by first selecting all (Ctrl + A) layers, then pressing the tilde key ('~', below the Esc key – sometimes you have to press it twice because at first it might open *every* property).

Add a new Null object to your Comp ('Ctrl + Shift + Alt + Y' or right-click in your Comp > **New** > **Null Object**). A Null Object is a blank layer box absent color or opacity. It's used as a flexible pivot point for other layers to Parent. To quickly

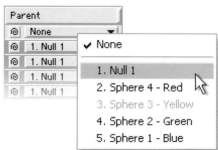

demonstrate this principle, select all four *Sphere* layers, then click on their Parent buttons to open the Parent Menu. Click on Null, then all four layers display their connection. Select layer 1 and open its Rotate (R) properties – click and drag over the Rotation Degrees value to spin the Null to any number. As you change the number, the four *Sphere* layers spin with the Null.

Reset the Rotation value and change the order of Parenting, but this time use the Rubber-band selector tool (left of the Parent buttons) to choose the Parent layers: Parent Sphere 1 to Sphere 2, Sphere 2 to Sphere 3, Sphere 3 to the Null, and leave Sphere 4 as is.

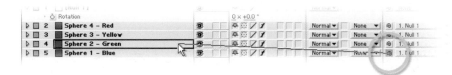

Spin the Null again and nothing has changed – because, ultimately, the Parenting structure has not changed.

Create the following Keyframe animation:

1 Select all layers – go to 0:00, press 'R' and set each Rotate Keyframe with the default values (turn on the stopwatches).

2 Go to 10:00 and set Rotate's first value (number of complete rotations value) to 2 for all layers.

By setting the End Point Keyframe at 10:00, the Comp Window becomes blank because the Timeline's last active frame number is 9:23.

3 Select layer 1 and change its Scale value to 25%.

4 Save the project as Spinning Balls, then run an RAM Preview.

Looping Etiquette – Part 2

When you set Keyframes for looping transformations, or any keyframed event, you must be certain that the end Keyframe is located on the frame *after* the loop's last *visible* frame. This is because if you set the end keyframe *at the*

loop's last frame, you would be applying two keyframes adjacent to one another (the End Point and Start Point) rather than concurrently. This adjacency causes the loop point to hesitate one frame as it plays the loop point's End Point Keyframe then the Start Point Keyframe, which has the same numerical value multiple (or should have) that creates the looping effect.

The image below shows two loop point examples: the first (good) has the spheres progressing smoothly from frame to frame. The lower sequence (bad) shows a clear pause of duplicate images caused by the adjacent loop point Keyframes. Because *Sphere 1 – Blue* is parented to *Sphere 2 – Green*, it orbits the *Green* ball as the *Green* ball orbits the *Yellow* ball, which in turn orbits the *Null*, creating the eccentric compound orbiting Spheres.

Have some fun trying to figure a way to get all the Spheres to orbit the Null the same way they do now, but prevent the balls' highlights from spinning. I'll give you two hints how to do this: use two more Nulls and go negative. To dissect the solution, and there are several methods to solve this, open *Spinning Balls – Solution.aep* and run a Preview.

⬚	#	Layer Name		Parent	
▷ ☐	1	☐ [Null 1]	🎬	None	▼
▷ ☐	2	■ Sphere 4 – Red	🎬	1. Null 1	▼
▷ ☐	3	■ Sphere 3 – Yellow	🎬	1. Null 1	▼
▷ ☐	4	■ Sphere 2 – Green	🎬	3. Sphere 3 – Yellow	▼
▷ ☐	5	■ Sphere 1 – Blue	🎬	4. Sphere 2 – Green	▼

2D vs 3D Layers

With the release of version 5.0, After Effects broke free of its two-dimensional restrictions – layers were open to move in the Z-axis. But more practically, After Effects could intermingle both standard 2D layers and advanced 3D layers in the same Comp. In addition to the freedom of a Z-axis, cameras and lights were introduced. As versions progressed, 3D compositing has extended its capabilities.

 Open *WONK logo Build 03.aep* and, under the Switched Column, activate the 3D Layers for both *CH Elements build* and *WONK Elements build*. The Comp Window should look the same, but if you open the Position properties for each layer a new numerical value has been added – this is the layer's Z-axis values.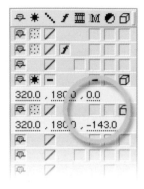

Slowly change the Z-axis value both positive and negative. But nothing happens. Deactivate the Collapse Transforms Precomp mode and try moving the Z-axis again. Can you guess why the Z-axis only works in the Standard Nesting mode? If you recall, when a Precomp is in Standard Nesting mode the layer is processed just like any other layer, whereas a Collapse Transforms Precomp layer is analogous to all the Precomped layers, residing within the Master Comp as a group clustered into one layer. Therefore, if you want to convert a Collapse Transforms Precomp into a 3D layer you have to activate each of its Precomped layers to 3D.

'Alt + double-click' on *WONK Elements build* to open its Precomp source and activate all layers' 3D switches. Return to the Master Comp and try adjusting the Position's Z-axis now. All is well – the Collapse Transforms Precomp layer now moves along its Z-axis. Apply the same 3D setting changes to the *CH Elements build* Precomp. Now both layers are fully 3D savvy.

X-Y-Z 1-2-3

X = Left and Right, Y = Up and Down, Z = Toward and Away – some 3D animation applications think otherwise, but for After Effects these are the orientation directions for each Axis. Also, positive numerical values designate Right, Up, and Away from your view, while negative values are Left, Down, and Toward your view.

3D Layers offer some great functional improvements to even the simplest effect. Take, for example, the logos flying into our scene. Previous to 3D Layers to achieve Z-Depth-like moves you had to perform a Scale. This might not seem like such a big deal, but animated Scaling causes an unnatural motion side-effect: as an object Scales past the view into the scene, the move

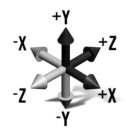

accelerates into its end position rather than decelerates. You could compensate for this non-linear action by adjusting the last Keyframe's Interpolation – but the smoothness is difficult to accurately resolve. But one click of a 3D Switch and the motion is now natural and accurate.

Pan Behind Tool – Part 1: Anchor Point Adjustment

Revert *WONK Logo Build 03.aep* to resume our ID Package's development. In order for our 3D Layers' motion to work correctly, they need to pivot, scale, and move from each of their perceived centers. By default, a layer's center is where its Anchor Point is first set. Select and Solo the *CH Elements build* Precomp layer, then press 'A' to open its Anchor Point properties. Also, press 'Shift + P' to open the same layer's Position properties (pressing Shift with any combination of properties shortcuts will add or remove the properties to the already open list).

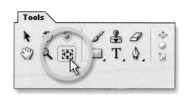

Compare the layer's Anchor Point to its Position – it's the same at first. If you move the layer (V), the Position changes, not the Anchor Point.

A layer's Anchor Point is defined by the layer's absolute dimensions and is not related to the Master Comp's dimensions. But if you move the Anchor Point using the Pan Behind Tool (Y), both the Anchor Point and Position change. This is because the Position has to account for where the Anchor Point is located in the Comp Window. Therefore, Anchor Point values are relative to the layer's individual coordinates, while Position values are relative to the Comp coordinates. Reset both the Anchor Point and Position and move the Precomp's Anchor Points:

1 Press 'Y' to activate the Pan Behind Tool.

2 Select *WONK Elements build.*

3 In the Comp Window drag the green and red Axis anchor (seen below) by its center circle up into the center of the WONK TV logo.

4 Repeat these steps for *CH Elements build.*

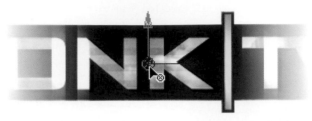

When you select a Collapse Transforms Precomp, the whole layer receives a Transform Box the size of the Master Comp's dimensions. This does not affect the layer's functionality, but it can be annoying when you have to select many Precomps all with their Transform Boxes spanning the entire screen. It would be nice to be able to make a Mask to eliminate the Precomp's excess screen space, but remember, applying a Mask will cause the Precomp layer to behave the same as applying an effect – it forces the Collapse Transforms to revert to Simple Nesting.

3D Layers do not require the use of Cameras or Lights, the system defaults to a compatible viewing mode allowing 3D Layers to move in perspective. We'll be adding Cameras and Lights later in our production – but for these exercises the default perspective view works fine.

Layer Timeline Extension

In the section 'Audio – A Sound Primer', the music track (courtesy of Killer Tracks) had Markers applied to identify the primary music beats. These beats will determine the direction of our animation.

Open the project *WONK Logo Build – 3D.aep* to view these Markers. As previously discussed, running an Audio Preview can extend well beyond its Timeline's End Point. Therefore, some of the Markers extend past the Timeline's last frame and we want our project to have the same duration as our music track:

1 Extend the Timeline's duration (Ctrl + K) to 15 seconds.

2 Open the Audio Track's Waveform Display (L L).

3 Press the '=' key to zoom into the Timeline's Time Scale. Zoom in until the Markers' alignment to the music track's beats can be clearly seen.

4 Slide any of the Markers to line up with the beats.

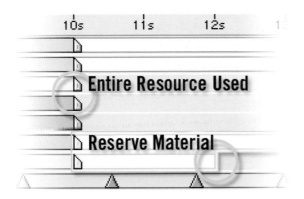

Press ';' twice to re-scale the Timeline full span. Expanding a Timeline will often reveal layers that are not long enough to span the entire Comp. Some of these layers will have plenty of reserve material (the source to the layer is longer than the used segment) to their Timeline Bar duration, while others will be all tapped out, fully used. Whether a layer extends beyond the Timeline's end frame is determined by dependency on its own time or that of the Timeline's.

- Timeline Independent Resources – Movie Clips, Precomps, Imported Compositions, Audio Tracks, and Sequential Still Images.
- Timeline Dependent Resources – Still Images, Vector Files, Solid Layers, Cameras, Lights, Nulls, and Adjustment Layers.

Timeline Dependent Resources duration is always based upon the Timeline's duration in which they reside. Looking at the Timeline there are three Timeline Dependent layers and five Independent layers – all but the Audio Track need extending. Timeline Dependent Resources simply need their Out Points snapped to the Timeline's last frame:

1 Press 'End'.

2 Select the three Timeline Dependent Resources (Vignette Blue, Gray Solid 1, and Lines.tif).

3 Press 'Alt +]' (close bracket) to snap the Out Points to the last frame of the Timeline.

However, Timeline Independent Resources can pose considerable difficulty with their extension. Our background layer, for instance (*CloudsLoop.aep*), only lasts 12 seconds. Earlier we determined that the last 4 seconds of the logo build needed to loop so the client can extend the end indefinitely. Fortunately for us, the Clouds already loop every 4 seconds – all that needs to be done is to extend the clip in the Project Window.

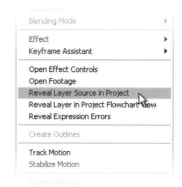

4 Right-click on the *CloudsLoop.mov* layer.

5 Select from the pop-up menu > **Reveal Layer Source in Project**.

6 Press 'Ctrl + F' to open the Interpret Footage dialog.

7 Change the Loop Times to 4, then click 'OK'.

8 Snap the *CloudLoop.mov* layer's Out Point to the Timeline's end.

Return to the Timeline Window and the CloudsLoop background now extends past the last frame. Repeat the same procedure for the *Hair-16.mov* clip; for this only two loops are necessary – the loop point for the Hair doesn't matter because the clip's animation is so disjointed already.

Precomps suffer a problem that other Timeline Dependent Resources do not – Precomps are Timelines and therefore do not have an Interpret Footage Loop Times option. The easiest method for looping Timelines inside Precomps is to make either Precomps of your Precomps or duplicate layers of the layers within your Precomps. It's your choice – but I prefer to make Precomps of Precomps.

9 Select *CH Elements build* – press 'Ctrl + Shift + C' and select 'Move . . .' and check 'Open New . . .'.

10 Append the name to *CH Elements build Loop*, then press 'OK'.

11 Duplicate the layer only once, then go to 6:00.

12 Press 'Alt + [' to snap the In Point to 6:00.

13 Go to 10:00 and press '[' to snap the whole clip.

14 Duplicate the new shortened clip again.

15 Go to 14:00 and press '[' to snap the whole clip.

16 Return to the Master Comp.

The logo elements have reverted to the 2D Standard Nesting Precomp mode, so reactivate the Collapse Transforms and 3D Layers switches. You'll also need to re-center the Anchor Points to each logo element – sorry!

Continuous Rasterization – Illustrator File's Unique Capability

Sometimes the reality (in a virtual sense) of a 3D composite just doesn't give you the look you need – exaggeration works better. To complete the WONK TV Logo package, we add a few other small details: solid text letters and shadows cast on the background.

Residing in the Stills folder of the Project Window is another version of the logo: *WONK Logo Master.ai*. This is an Illustrator vector file, and vector files get special consideration within After Effects. They can be used as rendered bitmap images or as Continuously Rasterized vector images. The former method of

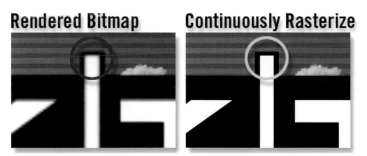

displaying Illustrator files offers nothing different than any other bitmap image – you're limited by the file's resolution as imported. However, if you select the latter option to use an Illustrator file Continuously Rasterized, there's no limit to how far the file can be magnified and remain fully resolved.

Drag the *WONK Logo Master.ai* file into the Master Comp (at 0:00) above the two Precomps. Change its Scale (S) to 400% and you can see that the file becomes blurry from over-scaling. Yet if you turn on the same switch used for Collapse Transforms, activating the Continuously Rasterize mode on vector files, the Illustrator file becomes sharp and clear. Toggling the switch on and off will clearly show the difference between the two modes. Another difference when using Continuously Rasterized Illustrator files is you *can* use Masks and effects (unlike Collapse Transforms Precomps) to isolate and filter your vector layer.

Activate both the Continuously Rasterize and 3D Layers modes for the *WONK Logo Master.ai* layer, then:

1 Open the Position and Scale properties for *WONK Logo Master.ai*.

2 Set the Blending Mode to Lighten and the Opacity (T) to 90%.

3 Pull the logo closer to your point of view by setting the Z-axis coordinate to '−8.0'.

4 Resize and position the logo to cover the logo Precomp's text.

5 Duplicate the *WONK Logo Master.ai* layer.

6 Center each copy's Anchor Points.

7 Apply a Mask isolating each vector logo text.

Masking – Part 4: Compound Masks

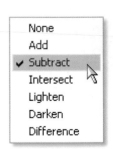

Layer Masks can be composed of many individual paths, either building upon each other or working with various mix modes to create composite masks. The logo's new Illustrator overlay includes an element not needed – the tall bar separating each element's text. You could remove these bars by making smaller Box Masks surrounding only what needs to stay, or you can make another small Box Mask around each bar and set the Mask Mix Mode to Subtract. This is called making a Compound Mask.

After Effects has no limit to the number of Mask paths per layer, so don't be timid on using multiple Masks to allow for better isolation or animation effects. It's important to remember that with Masks, the order of priority (which Mask

affects another Mask) feels reversed from the top-down compositing paradigm After Effects operates. But, in actuality, the order Masks are calculated is similar to the rendering calculations of layers – they actually render bottom-up with the last layer being calculated first, leading upward to the top layer last. The same goes for Masks – the last Mask in a layer is the first to be calculated, then its Mix Mode is applied to the Mask/s above, and so forth. The example below shows you the results different Mask Mix Modes can create:

A **Add** – two or more masks act in concert, making one larger mask with feathered edges blending smoothly.

B **Subtract** – the layer's path shape is removed from the layer above the Subtract Mask layer.

C **Intersect** – where the Intersect Mask layer's path shape overlaps the Mask shape above is the new Mask shape.

D **Lighten** – similar to Add except that Mask Feathering is not smooth but linear in its transition.

E **Darken** – similar to Lighten but works similar to the Subtract mode.

F **Difference** – where the Difference Mask overlaps the Mask path above forms an exclusion area.

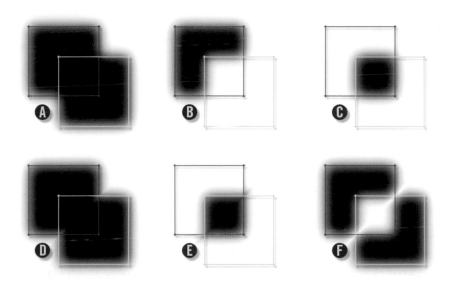

3D Layers – Part 1: Animation

In the development of the WONK TV Logo ID Package, we have covered many of the most commonly referred to functions of After Effects: Project Window, Timeline Window and Composition Window options, File Interpretation, Transform properties, Timeline Editing, Keyframe Animation and Interpolation, and the all-important Precomposition capabilities. Instead of offering a laundry list of key features most designers need to know, I determined that practical application of concepts would be a better method of explanation and clarification, hence the WONK TV project. The upcoming chapters, however, are best presented as individual features unassociated with any larger production – you've learned the methodologies of layer navigation, object manipulation, and options application.

We'll wrap up the WONK TV project by animating the logos flying in 3D space and applying additional effects to the scene.

1 Rename each Illustrator text logo element as *WONK vector text* and *CH vector text* respectively.

2 Parent each to their namesake Precomps.

3 For the *WONK* element layers, go to the Audio Track Marker nearest 3:00 (drag the CTI while holding the Shift key) and create Keyframes for Position, Scale, and Rotate (Orientation and 'X' Rotation).

4 Go back 36 frames ('Ctrl + G', then '+ − 36'), and set the position and rotation coordinates shown at right.

> 160.0 , 180.0 , −600.0
> ⊕ 125.0 , 125.0 , 125.0
> 0.0 °, 75.0 °, 0.0 °
> 0 x +30.0 °
> 0 x +0.0 °
> 0 x +0.0 °

When operating in the 3D Layers mode, your Rotate properties have six different values to calculate: three Rotate values are clustered together in the Orientation properties – these numbers represent the object's absolute rotational XYZ angles. Use these numbers to set starting point and ending point rotation angles. The other three individual numbers represent the object's relative rotation values – use these numbers to fine-tune angle values or to set multiple rotations on a given axis.

For the *CH* element layers, go to the Audio Track Marker nearest 4:12 and create Keyframes for Position, Scale, and Rotate – jump back 36 frames and set the coordinate values at right.

490.0 , 180.0 , -600.0
🌐 150.0 , 150.0 , 150.0
0.0 °, 290.0 °, 0.0 °
0 × -40.0 °
0 × +0.0 °
0 × +0.0 °

It's up to you whether or not to apply Keyframe Interpolation (Ease In) to the last Keyframes of each Transform or to alter the Position Keyframes' Spatial Interpolation to Bezier (to smooth the motion into the frame). But either way, the animation should be complete. It only needs a few little nuances to wrap it up: Shadows.

3D Shadows

Advanced features of After Effects include 3D Cameras and Lighting – but you don't always need to use these capabilities. You can just as easily add a shadow filter of some kind to recreate the same look as the more complicated real light-cast shadow.

1 Select and duplicate both *Elements build Loop* Precomps.

2 Drag both copies down the Timeline stack, place them above *Lines.tif* and press 'U'.

3 Deactivate the Collapse Transforms mode for both copies.

4 Rename both copies as their names + 'Shadow'.

5 Solo both *WONK . . . Shadow* and *CloudsLoop.mov*.

6 Move the CTI to *WONK . . . Shadow*'s last Keyframes.

7 Select *WONK . . . Shadow* and add > Effect > Perspective > Radial Shadow.

8 Move the CTI halfway between the *WONK . . . Shadow* Keyframes.

9 Press 'U' to further open the properties Keyframes.

10 In the Radio Shadow properties, set Opacity = 20.0%, Projection Distance = 20.0, and Softness = 48.0.

11 Set the layer to Multiply.

Use the values above to set your Shadow effect and set the Shadow Color to dark blue. Also activate the stopwatches for Keyframes on Opacity, Projection Distance, and Softness.

Copy and Paste for Effects

To apply the same Radial Shadow effect settings to the *CH . . . Shadow* layer, you could follow the procedures above – but all you have to do is copy and paste the whole Radial Shadow effect from *WONK . . . Shadow*'s properties layer and everything will transfer, including the Keyframes. This is the only exception to the rule: 'All copied Keyframes will paste where the CTI is located.'

Notice that, once pasted, the keyframed effects are located far from the CTI. This is because the system is trying to maintain all effect events relative to the Timeline's first frame. All you need to do now is press 'U' and drag all the Keyframes, aligning the last Keyframes to the rest of the layer's last Keyframes.

If you were to select only the Keyframes from the *WONK . . . Shadow* layer's Radial Shadow effect, only those effects' values would have transferred, leaving you to readjust all the other non-keyframed properties. Alternatively, if you copy the Radial Shadow effect from the Effect Controls window, only the initial values would transfer, not the Keyframes.

Save your work as *WONK Logo Build – 3D Shadows.aep*, then run another RAM Preview (from 1:12 to 6:00) to view the fake shadows in action.

Pan Behind Tool – Part 2: Layer Editing Features

The section 'Focus on the Composition Window' briefly discussed rudimentary editing functions in the Footage Window, while the 'Layers – Part 1: Discovery' subsections 'Splitting Layers' and 'Duplicating Layers' showed even more editing capabilities. There's one more editing capacity to After Effects that assists in the synchronizing and re-timing of footage elements

Like many of the tools in After Effects, the Pan Behind Tool (Y) actually offers two functions: Slip Editing for Timeline clips and Anchor Point re-positioning. Slip Editing will be our spotlight here.

Open *Pan Behind Editing.aep* and run an RAM Preview. This little Comp has the *Axis Spike* floating over the Fractal BG using a few Keyframes for the move and filters. Using the Pan Behind Tool for Slip Editing requires but one prerequisite to function correctly: there has to be additional Reserve Material available to the clip being edited. The selected footage must have its In-Use range (the area spanning the In and Out Points) envelope a duration shorter than the clip's whole.

Select layer 1 of the Comp and press 'U' to review its Keyframes. Using the Selection Tool (V), drag the whole layer's Timeline left until the Out Point is visible. Presently, the entire clip's footage is selected by the In and Out Points, even though as a whole it extends beyond the Timeline's last frame. To use the Pan Behind Tool, you'll need to shorten its selected In-Use range.

1 Press 'Home' then '[' to snap the clip back to the start.

2 Press 'End' then 'Alt +]' to snap the End Point to the last frame.

3 Return to the Timeline's start frame (Home).

4 Select the Pan Behind Tool (Y), click on the layer's Timeline Bar (a new cursor appears), then drag back and forth.

As you drag the cursor, the Axis image starts to move and becomes misaligned to its Matte Source's layer. The first thing you'll need to do is permanently attach the two Axis FILL and ALPHA layers together, so when you use the Pan Behind Tool they remain synched.

Hybrid Precomping

This is a job for The Wondrous Precomposition! But which method of Precomping should be used? You need all the property's Keyframes to stay in the master composition – so you should use 'Leave all attributes . . . '. However, you also need the Set Matte effect's source layer in order for the image to maintain its keying – so you'll need 'Move all attributes . . . '. But if you use 'Move . . . ', all the Keyframes will follow, and you need them to stay put. This will have to be a hybrid of both methods.

5 Select layer 1 and perform a Precomp (Ctrl + Shift + C), renaming the new Comp as *Axis Spike*.

6 In the Project Window, drag and drop *Axis Spike – ALPHA.mov* onto the new *Axis Spike* Precomp.

7 Open the *Axis Spike* Precomp, activate the Track Matte for *Axis Spike – FILL.mov*, setting it to 'Luma Matte'.

8 Return to the Master Comp and select layer 1.

9 Press 'E' to open the Effects properties applied to this layer.

10 Click on Set Matte, then press 'Delete'.

You can delete the old Set Matte source layer (*Axis Spike – ALPHA.mov*) from the Master Comp since you've just combined it to the Precomp. If you drag the CTI back and forth, the *Axis Spike* will still follow its path and change colors as before.

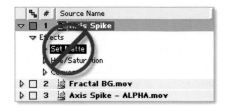

Now when you use the Pan Behind Tool (Y) on the *Axis Spike* Precomp the image stays keyed correctly, while its animated frames advance. By using the Pan Behind Tool you are simultaneously changing both the In Point and Out Point of your clip; therefore, the clip's duration never changes.

Duplicate the Precomp three times. Use the Pan Behind Tool on each Axis layer, click and drag by different amounts – you should end up with each Axis located at the same screen position, but each image should be at different locations of their animation clip.

Pan Behind Tool – Part 3: Keyframes

The Pan Behind Tool can also be used on Keyframes in conjunction with your layer's Timeline. This allows the user to maintain a clip's In and Out Points while shifting the layer's Keyframes.

11 Delete the three duplicate *Axis Spike* Precomps.

12 Select the original Axis layer.

13 Press 'U' to reveal its Keyframes.

14 Select all Scale property Keyframes (click on Scale).

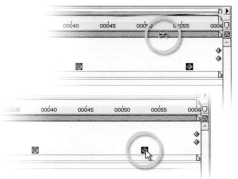

129

Drag over the Timeline Bar to Pan Behind the layer's footage and Scale Keyframes. You are limited by the amount of slip the Pan Behind can provide due to the limited amount of excess footage after the Out Point marker. However, if you were to click and drag over the Keyframes directly using the Pan Behind Tool, only the Keyframes would move – here the Pan Behind Tool behaves in the same way as the Selection Tool (V).

An Artist's Work is Never Done – It's Just Abandoned

I bet you're happy that this section used something other than the WONK TV elements. You're probably sick of WONK TV by now, so for most of the remaining sections of this book we'll be using some different resources. But we will return to WONK TV to add a few tweaks and other interesting elements. This is the essence of After Effects: never leaving well enough alone.

Advanced Timeline Operations

An After Effects composition is the amalgamation of virtually countless elements, features, and computational operations. Some of these operations are spread across multiple layers and resources, while other operations are targeted at individual layers.

Advanced Timeline Operations will focus on preparing, adjusting, and manipulating single resource layers through:

- **Drag and Replace** – swap resources in a single Comp or across an entire project (multiple Comps and layers) effortlessly.
- **Replace Footage** – change resources globally.
- **Advanced Masking** – the Pen Tool and RotoBezier.
- **Text Tool** – typewrite on the screen.
- **Footage Speed Changing** – Frame Blending, Constant and Time Remapped Footage.

Layers – Part 3: Drag and Replace

Of all the great productivity features (Precomping, Parenting, 3D Layers), perhaps the greatest is the all-powerful Drag and Replace function.

Editors – How many times have you created multiple variations of one project and spent hours making copies of resource files, links, and reapplying effects?

Designers – When working in Photoshop, how many times have you had to swap one layer in one Comp into another, re-link adjustment layers, and change scale, position and rotation to match the original's transforms?

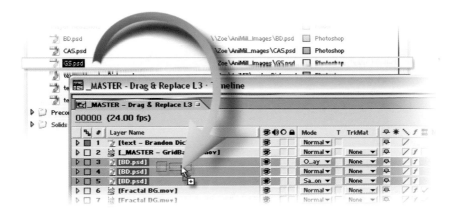

Drag and Replace does all these tasks in one simple mouse action to footage files and compositions alike.

It's as simple as selecting, in the Timeline Window, the file/s that need replacement. With 'Alt' depressed, drag from the Project Window the new file to replace the selected file/s in the Timeline Window. When you release the mouse button, the selected file/s will automatically update, converting into the dragged Project Window file.

Drag and Replace – Part 1: Footage in Single Comps

Take the following scenario. You have a large sports ID project where you have to make different Bumps, Transitionals, Info boxes, and Lower Thirds for 30 different players. Usually, you'd make duplicates for each of the Comps then import each new player, drag their images into the duplicate Comps, and reapply every setting and effect done on the previous duplicates. This is a very time-consuming and tedious process.

Open *Drag & Replace – Build 01.aep*, a Lower Third project for a fictitious game called GridBall that needs its players updated. Included in the Comp are three of the players that need individual Lower Thirds:

1 Select the layers using *BD.psd* image.

2 In the Project Window, locate *GS.psd* in the Player Headshots folder.

3 Depress 'Alt', then click and drag *GS.psd* into the Timeline Window.

4 Release the mouse button at any place in the Timeline.

5 In the Timeline select *text – Brandon Dicks.psd*.

6 In the Project Window, Drag and Replace (click and drag) *text – Grant Salisbury.psd* into the Timeline.

The subtle beauty of Drag and Replace is obvious when you try to manually duplicate the steps above. To see how much work would have been involved, select the three *GS.psd* layers and press 'U U' to display all modified properties and effects. Suddenly, the thought of cutting and pasting effects, adjusting properties settings, and changing Blending Modes becomes more daunting.

Drag and Replace – Part 2: Footage Across Multiple Comps

Now imagine that this one resource is used throughout many other graphics Compositions – how do you address Drag and Replace with a heap of isolated targets to modify? Do the Drag and Replace inside the Project Window:

1 Select *CAS.psd*, then depress 'Alt'.

2 Drag and Replace *CAS.psd* over the top of *GS.psd*.

Anywhere the file *GS.psd* was in use has been updated with *CAS.psd* instead. This is just the simplest example – Drag and Replace across multiple Comps is even more powerful when you realize that using Drag and

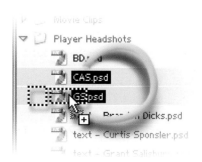

Replace in the Project Window has even more functionality: Comps can replace other Precomps within Comps, Footage can replace Precomps within Comps.

Replace Footage – Permanent Drag and Replace

You'll often discover the need to completely replace one Project Window resource for another completely different (or simply updated) resource. For this, use the

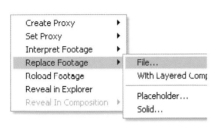

Project Window's Replace Footage (Ctrl + H) function. You can also access this by right-clicking on the file then selecting > **Replace Footage** > **File . . .**.

This is a more permanent version of the Drag and Replace Across Multiple Comps, and it can help reduce clutter in the Project Window.

Replace Footage – Make Replacement Comp

Another instance where Replace Footage becomes very productive: you need to apply some adjustments, masking and/or effects to a *.PSD file that's used throughout all Comps in your project. For this, you have to use the right-click sub-

menu pop-up (> **Replace Footage** > **With Layered Comp**) on the file in need of changing. This option creates a new Precomp using the selected Photoshop file as its reference (similar to the Precomping method: 'Leave all attributes . . .') and replaces all instances of the selected file across your project. The only catches to this option are: the Comp's duration might be set to the last applied Comp Duration used (not a very big issue since all you have to do is change the replacement Comp's duration (Ctrl + K) to the longest length you encounter in the project), and secondly, it only works on Photoshop files.

3 Right-click on *GS.psd* and select > Replace Footage > With Layered Comp.

4 In the Timeline, take note of the duration change and what the Comp should be set to.

5 Double-click on the new *GS Comp 1* and set the new duration.

6 Select layer 1 (1 on the keypad) and duplicate (Ctrl + D) this layer once, leaving the duplicated layer selected.

7 Drag and Replace *CAS.psd* from the Project Window onto the duplicate.

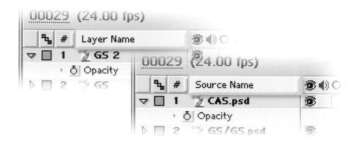

If the Layer/Source Name column in the Timeline is set to Layer Name, layer 1 might still maintain the duplicate layer's name (GS 2). Toggle the column to Source Name by clicking on the column header, or change the layer's name to the name of the new replacement file.

Advanced Masking

After Effects' Masking is not limited to Box and Oval Masks only – it also offers the same Spline Masking capabilities as Photoshop or any vector illustration program. But it also offers an extension of the standard vector Spline Masking function called RotoBezier – an automated function where each vertex you create has an interpolation applied that automatically adjusts the spline path's transition as smoothly as possible from one vertex to the next. Even when the vertices are animated, the RotoBezier maintains its smoothing.

Returning to the GridBall project and the new replacement Precomp, use the Pen Tool (that was used in Keyframe Interpolation) to create a flexible free-form Mask to isolate the glasses of the new layer:

1 Set layer 1 Opacity (T) to 50%.

2 Fiddle with the top image and align their eyeballs (you'll need to scale and reposition *CAS.psd*).

3 Reset the Opacity (T) to 100%.

4 Rename layer 1 (Enter) as *BugEyeBalls*.

5 Select the Pen Tool (G) and activate the RotoBezier check-box.

6 Draw a loose Spline Mask around the glasses until you reach the First Vertex, then close the path.

7 Press 'F' to open the Mask Feather property and set it to 16.

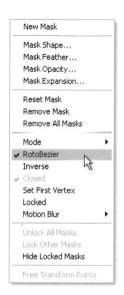

After a RotoBezier Mask is created, it can be converted to a standard Bezier Spline Path with all its vertices individually adjustable. Right-clicking on any vertex point will open a menu showing options available to every vertex and Mask Path. Uncheck the RotoBezier option and the path reverts to a normal Spline Path.

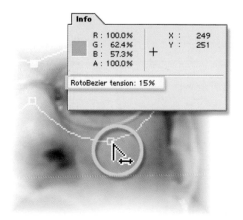

After the RotoBezier Mask is completed, you'll probably need to adjust the vertices to make them flow more evenly around the glasses, and at some points the vertices need to have sharp transitions. You can alter the Tension of each vertex by selecting the Convert Vertex Tool (press 'G' several times to sequentially select the various Pen Tools). Clicking on

135

any vertex, along the RotoBezier's Path, then dragging left and right will adjust the Tension of that vertex. The Tension (how smooth or sharp the spline path will transition into and out of a vertex) is reflected in the Info Window as a percentage: 0% is tight and sharp, while 100% is loose and smooth. Used in conjunction, the RotoBezier and the Pen Masking Tools are the first step in Rotoscope production. Later, we'll experiment with using the RotoBezier on moving footage to isolate an object out of a scene.

Return to the Master Comp then save your work as *GridBall – L3.aep*.

Drag and Replace – Part 3: Comps into Comps or Footage

The power of Drag and Replace becomes even more evident when you consider replacing Precomps residing within multiple Comps. Take our project from above using > Replace Footage > With Layered Comp. We have one image of a team member converted into a Precomp that's using another image to augment the player's picture. You can now use this altered footage Precomp to Drag and Replace into another player's Precomp instances.

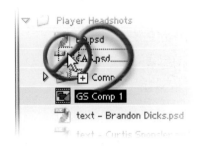

Using the same method for Drag and Replace – Footage Across Multiple Comps, you hold 'Alt' then drag the new Precomp atop any Precomps or Footage you want to replace. The new Precomp then supplants the previous Precomp/Footage everywhere it appears.

Your only limiting factor arises when you attempt to form a paradoxical loop where some resource footage is used within a Precomp, then you try to Drag and Replace that Precomp onto your resource footage. This causes a dilemma – the footage is used within the Comp already, so you can't replace what supplies the replacement.

After Effects understands this paradox, so if you try to Drag and Replace you will not be permitted. Instead of seeing the target item selected as you drag the replacement over the top, it will not become selected, indicating that your action will result in a paradox. In the example above, *GS Comp 1* is trying to

replace *CAS.psd*, but *CAS.psd* is not highlighted, indicating that *CAS.psd* is used in *GS Comp 1*.

Make Replacement Comp for Any Format

Though the > Replace Footage > With Layered Comp function only works on Photoshop *.psd files, it's not all that difficult to replicate its capability for any file format:

1 Re-import the original file you wish to 'Make Replacement Comp'.

2 Select the new import and drag it down
 onto the Create New Composition button.

This second step can trick you because there's
nothing in the Project Window to immediately
identify that a file is in use. You have to select each file in turn and refer to the
File Information thumbnail at the top of the Project Window to see if it's in use.

3 Drag and Replace the new import's Precomp onto the original file in the
 Project Window.

4 Apply the original files' Interpret Footage settings to this copy – select
 the original file, press 'Ctrl + Alt + C', then select the new import and
 press 'Ctrl + Alt + V'.

As suggested many times before, rename your Precomps to better reflect their resources and usage. As projects become flooded with Precomps, it's all too easy to lose track of your resources if their Precomps have similar names.

A quick check of the original file's Information thumbnail will show no instances of its use, while the new Precomp will show the same number of uses as the original had previously displayed.

> Pop Quiz: How many instances of the newly imported file's use show in the Info thumbnail window if its Precomp is used 10 times?

Type Tool – The Basics

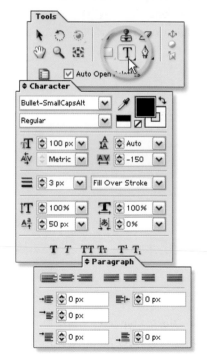

Our GridBall Lower Third IDs are nearly done – all that's needed is the players' numbers to animate onscreen. Version 6 of After Effects introduced the Type Tool, a flexible and animatable text creation tool to simplify and expand your productivity for typographic design.

Previously, text production was relegated to preparing the typographic elements in Photoshop and Illustrator, then importing the finished and unalterable text as a still image file. Alternatively, you would have had to use one of the Text Effects plug-ins to allow for animated typography, but these tools were limited to a host layer to apply the text.

The Type Tool works directly on the Composition Window as horizontal or vertical text or as text on a Spline Path, with all its attributes fully animatable.

 Horizontal Type Tool Activate the Type Tool (Ctrl + T), then click anywhere in the upper left empty space in

the Comp Window. Make sure that the Horizontal Type Tool is selected, not the Vertical. You can change back and forth between the two tools by repetitively pressing 'Ctrl + T'. A vertical line appears on the screen; this represents your Typing Bar, where all the text is generated from during input.

You'll need access to the Character Window palette to modify your typographic settings. The small palette should have opened when you selected the Type Tool (if the Auto Open Palette was checked); however, if it didn't open, click on the small Toggle Palettes button in the Tools Window. The Character palette's properties are shown below, along with a short description of their functions.

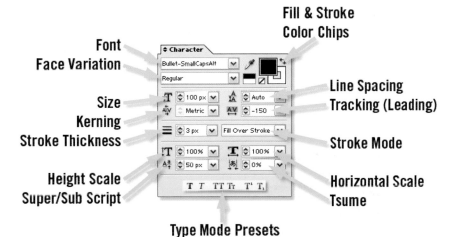

Font
Face Variation
Size
Kerning
Stroke Thickness
Height Scale
Super/Sub Script

Fill & Stroke Color Chips
Line Spacing
Tracking (Leading)
Stroke Mode
Horizontal Scale
Tsume

Type Mode Presets

- **Font** – typeface name.
- **Face Variation** – face option: bold, italics, alternate character set.
- **Size** – typeface size in pixels.
- **Kerning** – intra-character spacing, how characters fit together.
- **Stroke Thickness** – width of outline in pixels.
- **Height Scale** – percentage of size applied to character height.
- **Super/Sub Script** – offset of character's vertical position.
- **Fill & Stroke Color Chips** – selection of face color and outline color.

- **Line Spacing** – vertical distance between line sets of characters.
- **Tracking** – horizontal spacing of characters: leading.
- **Stroke Mode** – method stroke color will affect fill color.
- **Horizontal Scale** – percentage of size applied to character width.
- **Tsume** – tightness of space surrounding characters (Tsume modification is more often applied to font families that have pictographic origins and script faces where characters must flow into each other to make an unbroken flow).

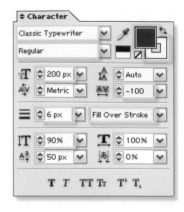

- **Type Mode Presets** – quickly modify your text to commonly needed typographic modifications: Faux Bold, Faux Italics, All Caps, Small Caps, Super-Script, and Sub-Script.

With the Type Tool's Typing Bar set in the upper left region of the Comp Window, adjust the settings to approximate the values shown in the illustration above. Then type: #01.

Reposition the text using the Selection Tool (V) so the text fits within the upper left screen area. Reactivate the Type Tool (Ctrl + T), then drag across the '#' sign to highlight the character. To make the '#' sign raised and smaller, click on the Super-Script Preset.

Type Tool – Animation Effects Presets

After Effects 6.5 has included a powerful set of Text Animation Presets to introduce powerful and intriguing visuals that can be applied to your typographic layers. The amazing aspect to these Animation Presets is their ease

of application:

1 Solo your text layer – identified by both a 'T' icon and the text you type as its name.

2 Open the Effects & Presets palette by pressing 'Ctrl' plus the 5 on your main keyboard, or **Window > Effects & Presets**.

3 Twirl open > **Animation resets > Text > Miscellaneous**.

4 Select **Chaotic** and drag it into the Timeline Window onto the #01 text layer, then run an RAM Preview.

Previews of the various Animation Presets are available in **Help > Text Preset Gallery**. Click on the variety of Related Subtopics to open an animated gallery of the presets.

5 Select the #01 text layer and move the Anchor Point (Y) to the '0' center.

6 At frame 60, create a Keyframe for Scale (Alt + Shift + S) – Scale opens.

7 Go to frame 20 (Ctrl + G) and set the value to 400%.

8 Select the last Keyframe and set it to Easy Ease In (Shift + F9).

9 Go to frame 30 and set a Keyframe for Opacity (Alt + Shift + T).

10 Press 'Home' and set the Opacity to 0%.

11 Activate the Motion Blur check-box in the Timeline's Switches column.

12 Relocate the #01 layer under the GS Comp 1 layers.

Deactivate the Solo and run another RAM Preview to watch the chaotic magic that Text Animation Presets can offer your projects.

Frame Blending – Time Compressing and Stretching Made Good

It used to be that any variable speed changes inevitably resulted in a loss of quality and smoothness in your altered footage. The usual method of increasing or decreasing a clip's playback frame rate was to either duplicate frames (decreasing frame rate) or drop frames (increasing frame rate). The result was usually stuttery and jumpy footage – a ruination of the original footage.

Frame Blending alleviates this stuttering and jumpy footage problem by enabling a process where adjacent frames are mixed together to create smoother transitions from duplicated frames for better slo-mo, or multiple

frames are mixed together, rather than dropped, resulting in more natural, motion blurred, rapid motion. Frame Blending is applied by first activating the Frame Blending button in the Timeline Window (seen at left), then checking the box under the Switches Column (seen below).

Frame Blending works on three modes of footage Frame Rate changes:

13 Interpret Footage – Frame Rate setting.

14 Time Stretch – Constant Speed Change.

15 Time Remapping – Variable Speed Change.

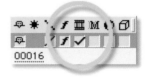

Open *Frame Blending.aep* for reference. The image below illustrates how Frame Blending affects a film clip set to different Frame Rates or with its Time Remapping enabled. The first image is one-third its

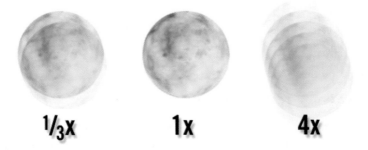

original Frame Rate (8 fps), while the third image is the clip running at four times speed (96 fps).

In both examples, images from preceding and following frames are mixed together at progressing or receding levels of opacity, creating the illusion of slow motion (first example) or motion blur (third example).

Specialized visual effects plug-ins exist to take this Frame Blending even further by incorporating proprietary motion interpolation and extrapolation algorithms in the Frame Blending calculations. For Slow Motion effects they can actually sense missing footage frames and create the additional in-between frames needed to accurately recreate the footage frames that never really existed. Examples of these plug-ins (and many other powerful enhancements) can be found at www.ToolFarm.com.

Frame Blending – Mixing Different Frame Rate Footage

After Effects is a file format agnostic program allowing for the intermixing of footage with dissimilar Frame Rates. You can use 25 fps footage in 29.97 fps comps or vice versa, all with the assistance of Frame Blending.

In our Bouncing Ball project we used 24 fps footage in 24 fps comps. To demonstrate Frame Rate intermixing, create a new Comp (Ctrl + N) with these settings: 640 × 360 at 16 fps and a duration of 90 – yes, 16 fps.

Drag the *Bouncing Ball.mov* into the new Comp starting at frame 0, then run a Preview. You should see a distinct stuttering to the ball's motion. Now activate the Frame Blending for the layer and the Timeline, and run another Preview. Now the motion is smoother, with every frame of the ball blending into the Comp as it's previewed.

The only real physical drawback to activating Frame Blending is that it will slow down your rendering, because cross-mixing multiple frames to make the blends takes longer than simply dropping or duplicating frames here and there.

Interpret Footage – Frame Rate Settings

If you know for certain the Frame Rate needed for any clip you've imported, you can permanently set a value for that clip in the Project Window using its

Interpret Footage (Ctrl + F) dialog. When you open the Interpret Footage dialog the natural Frame Rate is pre-selected ('Use frame rate from file:'). Type a different rate within the 'Conform to . . .' value box and this becomes your clip's new playback Frame Rate.

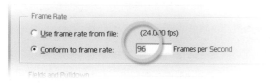

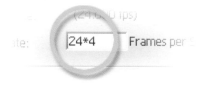

Using a little arithmetic trickery, you can apply simple multiples of the clip's original frame rate, providing you more precise Frame Rate settings. When typing into the Frames per Second value box, you can use the four primary arithmetic function symbols (+, −, *, /; asterisk represents multiply) to modify your input numbers. For example, if you wanted to set your new Frame Rate to 4 times the original value, you would type 24*4, whereas 1/10 speed would be 24*0.1 or 24/10. Your only limitation: Absolute Frame Rates in the Interpret Footage dialog range from 0.01 to 99 fps.

> **Tip:** The arithmetic function symbols (+, −, *, /) method of value input can be used in After Effects anywhere an input value is typed.

Time Stretch – Constant Speed Change

The Timeline Window offers two primary methods of footage speed changing – Time Stretch is the simplest and, like the Interpret Footage Frame Rate setting, is a constant non-animatable setting. Open the *In/Out/Delta/Stretch* pane columns by clicking

on the counter-facing arrows next to the Timeline's navigation zoom slider (seen above right). There are two ways to adjust a clip's speed: through the Time Stretch dialog or by click and dragging directly on the Stretch value to roll the numbers up or down.

Open the Time Stretch dialog by clicking on the Stretch value number. The dialog has two input boxes to enter your clip's Stretch value. You can use a Stretch Factor percentage, where the higher percentages denote slower speeds and lower numbers speed up the clip. You can also enter a clip's absolute duration. The Stretch Factor will automatically correlate to the New Duration value entered.

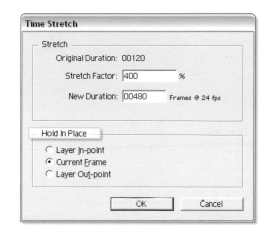

Within the Time Stretch dialog is an area to instruct After Effects how the clip's speed variation is to affect its In- and Out-points.

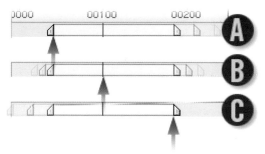

Hold In Place Points

A 'Layer In-point' – clips stretch or shrink from their left In-point handle.

B 'Current Frame' – clips stretch or shrink from where the CTI intersects the Timeline Bar.

C 'Layer Out-point' – clips stretch or shrink from their right Out-point handle.

The second method for adjusting the Stretch value is to click and drag the cursor over the Stretch or Duration values within the Timeline. This is an excellent interactive technique to see exactly how your clip is affected by your adjustments. The Hold In Place selection in the Time Stretch dialog will affect how every clip's Stretch and Duration value reacts to your click and drag within the Timeline.

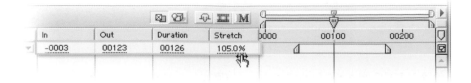

Lastly, you can enter negative numbers into the input boxes and click and drag backwards, causing your clips to run in

reverse. Reversed clips display as stripped Timeline Bars (seen above). You can also press 'Ctrl + Alt + R' to flip a clip into or out of reverse.

Experiment with the *Bouncing Ball – 1x* Comp and the Stretch settings of layer 1. Try sliding the whole clip down the Timeline, then adjust the Hold In Place setting and try the click and drag again.

Time Remapping – Variable Speed Change

Time Remapping is Time Stretch on steroids – it's a fully animatable technique for adjusting a clip's Frame Rate, permitting such effects as simple ramping of speed from real-time to slo-mo speed then back again, to extensive random speed changes and complete time alteration. And when combined with Frame Blending, you can achieve truly bizarre visuals out of bland dull footage. For this example we'll abuse our *Bouncing Ball.mov* clip and give it epileptic seizures.

1 Revert the *Frame Blending.aep* project and select the *Bouncing Ball – 1x* Comp.

2 If the *In/Out/Delta/Stretch* panes are open, close them by clicking on the double arrows in the Timeline Window.

3 To expand our Timeline work area, close the Modes column by right-clicking on the column's header.

4 Also, if open, close the Parent column using 'Shift + F4' or right-clicking the header.

5 Select the *Bouncing Ball.mov* layer and press 'Ctrl + Alt + T' to open the Time Remapping function, or you can activate it in the main menu > **Layer** > **Enable Time Remapping**.

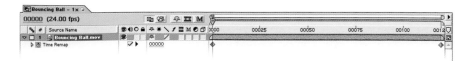

Once enabled, the layer has another property available to animate. The first Keyframe shows the value of 00000 (if you're in Time Code mode the display will show 0:00:00:00 or 0000 + 00 for footage – you can quickly switch display counter modes by 'Ctrl + clicking' on the upper left blue Current Time counter).

You can quickly see the effects of Time Remapping by dragging the last Keyframe left anywhere close to the first Keyframe.

6 Drag the last Keyframe to frame 20.

7 Go to frame 24 and set your Work Area End marker (N).

8 Turn off Frame Blending.

9 Run an RAM Preview of the clip's revised speed.

The clip runs really fast. Now enable Frame Blending and run another Preview. The ball is super motion blurred. Now, to add some chaos:

10 Go to 45 and click on the current Time Remap value of 0120, changing it to 30.

11 Randomly select different times within the Timeline and input any numbers from 0 to 119 (frame 120 is the Out Point and has no image).

12 Expand the Work Area to cover the whole clip and run a Preview.

Applying different Keyframe Interpolations further expands on this chaos by imposing varying rates on Time Remapping from Keyframe to Keyframe.

13 Select all Time Remapping Keyframes (click on the Time Remap property name).

14 Press F9 to apply an Easy Ease to each Keyframe.

15 Run another Preview.

Now the ball gently accelerates and decelerates from Keyframe to Keyframe. To see how this random shuffling of frames affects the clip, twirl open the Value and Velocity Graphs (first example seen at the bottom of this page). The upper graph draws the relationship of the clip's overall duration as it is modified over time, while the second graph displays how severe the change in time occurs from each Keyframe. With the Easy Ease applied you can see how smooth the motion translates from each Keyframe.

There is one more Interpolate effect example – Hold.

16 With the Keyframes selected, right-click on any Keyframe and the Keyframe Options menu opens.

17 Select > **Toggle Hold Keyframe**.

18 RAM Preview again.

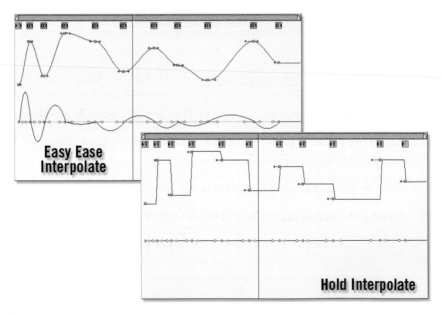

Easy Ease
Interpolate

Hold Interpolate

Now the image stays frozen on each Keyframe's frame number, popping from one freeze frame to the next. The Value graph now shows flattened steps of changing frame numbers, while the Velocity will be flat since there is no speed ramping taking place.

Time Remapping – End of Clip Freeze Frame

One common use of Time Remapping is to add a freeze frame in the middle or at the end of a movie clip. Open the example project *25 Logo Freeze.aep*. This project includes an animated Channel 25 logo seen on the next page.

To create a freeze frame at the end of the clip, you'll need to activate Time Remapping.

1 Select *25 Logo Freeze – end* Comp.

2 Activate Time Remapping (Ctrl + Alt + T) on the *25 Logo Flip.mov* layer.

3 Extend the clip to the end of the Timeline by pressing 'End', then selecting the layer and pressing 'Alt +]'.

4 Scrub the CTI back and forth across the freeze point to see the result.

To create a freeze frame anywhere in the middle of the clip, you'll need to activate Time Remapping and take a few more actions.

5 Select *25 Logo Freeze – middle* Comp.

6 Activate Time Remapping (Ctrl + Alt + T) on the *25 Logo Flip.mov* layer.

7 Extend the clip to the end of the Timeline by pressing 'End', then selecting the layer and pressing 'Alt +]'.

8 Go to frame 36 and set a new Keyframe in the Time Remap property.

9 Jump to the last Keyframe (K) and delete that Keyframe.

10 Scrub the CTI back and forth across the freeze point to see the result.

This may just seem to be too easy – a little *toooo* easy. That's because it *is* easy – but as with all 'too easy' things, there is a catch.

Field-rendered footage (the animation above, for example) or recorded (video captured) resources will have a problem with their hold frame freezes when you render your project in fields. The last frame will freeze on the last field rather than a whole frame. Your playback will look clean and smooth, then suddenly freeze on a half-resolution field, ruining the quality of the image. Depending on the extremity of motion or the clarity of the frame, this can be a big issue, especially with client logos and text, where perfection is demanded.

Take the two Channel 25 logos below – the right one is what we want to freeze upon, but the left image is what we'll end up with at render time due to its field-rendered source animation. This problem will also emerge when you create a freeze point in the middle of a clip by using Time Remapping.

Freeze On Last Field **Freeze On Last Frame**

The solution to this problem has several possibilities. If the footage is a movie clip, import another instance of your footage, but do not Deinterlace the footage in the Interpret Footage dialog, then at the freeze point switch to this footage for your freeze.

11 Select the *25 Logo Freeze – end* Comp.

12 At the freeze point, split the layer (Ctrl + Shift + D).

13 In the Project Window, import another instance of the orignal *25 Logo Flip.mov* clip.

14 With the new import clip selected, press 'Ctrl + F' and disable **Separate Fields: Lower Field**, then click 'OK'.

15 Ensure that in the Timeline the layer that follows the freeze point is selected.

16 Press and hold 'Alt' as you Drag and Replace the new *25 Logo* clip from the Project Window into the Timeline over the selected split layer.

17 Drag the CTI to see the result of the new footage freeze.

If the footage is comprised of sequential series of numbered frames (rendered animation, for example), just import the last frame and, as above, do not Deinterlace the image then use this frame in the Timeline at the freeze point instead of the original footage.

I've already taken liberty to import and preset the animated 25 Logo's end frame into the Project Window. Duplicate the process from step 16 above, but instead of the duplicate imported movie clip, use the *25 logo flip_0090.jpg*

imported still. The result is the same except for one operational difference – because it's a still frame, the layer's Time Remapping becomes disabled.

However, if you create a freeze in the middle of a field-rendered or captured clip, or if the footage is a movie clip with constant motion that never holds, you'll need to follow a slightly different process. We'll use the *25 Logo Freeze – middle* Comp to simulate a hold on a continuous clip.

18 Select *25 Logo Freeze – middle* Comp.

19 Split (Ctrl + Shift + D) the *25 Logo* layer at frame 36 – our new Freeze.

20 Drag and Replace the duplicate import *25 Logo* clip onto the new split freeze point layer.

21 On the freeze point layer, apply the effects filter > **Effect** > **Video** > **Reduce Interlace Flicker** with its Softness set to 1.0.

This filter provides a blending of both fields into one deinterlaced image. If you prefer the look of a freeze on a field, then disregard this last process and simply take advantage of the Time Remapping freeze-on-a-field for your hold frame.

Frame Blending and Time Remapping Applied to Compositions

Frame Blending and Time Remapping offer many solutions to footage that are lackluster and in need of awakening. But there's one more application to remember – both of these functions can be applied to complete Compositions, dramatically altering the look and attitude of a too-clean animated design.

Though there is no option for Frame Blending in the Switches column in the Timeline for Compositions, activating the main Frame Blending switch for the Precomped layer will cascade forward through the project, so when you Time Remap a Precomp the Frame Blending will still affect the Precomp's Frame Blending enabled elements.

Just remember the one small catch to using Frame Blending – activating this option causes After Effects to capture multiple frames from the same clips, which can dramatically slow down the rendering process, especially if you have many source movie clips all with their Frame Blending active.

ADVANCED COMPOSITING FEATURES

Working with Photoshop and Illustrator Files

One advantage of After Effects, among many, is its close relationship to Adobe's other leading graphics production applications: Photoshop and Illustrator. The integration of these three programs comprises a powerful, diverse toolset that builds upon one another. Images created in Photoshop and Illustrator can be imported as Compositions, fully prepared with all their separate layers to be animated. This can save hours of import work because the layout is already prepared – all that's left to add is your design touch.

Many artists and animators prefer to 'design in Photoshop/Illustrator – finish in After Effects'. They work this way because each of these programs is the best at their core mission: Photoshop for bitmap image editing and Illustrator for vector graphics – while After Effects is best in bringing these files to life.

This section will discuss some unique capabilities of the Photoshop and Illustrator imported Comp. We'll also examine how 3D Cameras, Lights, and Layers combined with Parenting to Nulls can create dynamic visuals with depth and impact.

Photoshop Document Import – File Preparation

If you follow the Photoshop-to-After Effects workflow, take this advice to heart: unlike the print world, dpi has no relevance to digital video. **Work exclusively in absolute pixel count.**

At 72 or 2400 dpi, an 800 × 600 pixel file is always the same file size. But this does not mean that you should work solely in the image size you'll be rendering your project. *Au contraire* – if you create your Photoshop canvas at a larger size than you intend to render, you are provided with more flexibility as to how your file will translate

within your After Effects Composition. Besides, with larger Photoshop canvas sizes you can work in Square Pixels rather than any anamorphic or non-square workspace, affording you more accurate WYSIWYG to the output screen.

When you prepare a Photoshop document for After Effects import, certain aspects of the file will not translate directly over and will be collapsed into more compact layers or lose some aspect of their features: layers with linked Layer Masks will import as one Alpha blended layer without the separate Mask, Fonts import as rasterized bitmap images (they lose their editability), and many Blending Modes of After Effects are not supported in Photoshop. But if you do a little pre-emptive layer management, you can alleviate these differences.

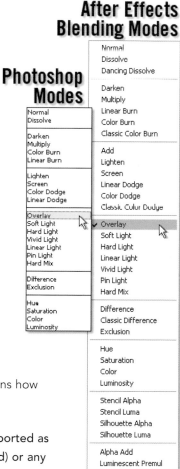

Photoshop File Import as Composition

When you open a Photoshop document in After Effects you are provided several options how these files will import:

- **Footage** – either the whole file will be imported as a single layer (all its layers will be flattened) or any one layer can be selected for separate import.
- **Composition – Cropped Layers** – the file creates a new Comp in the project with each layer's size set to its individual image dimensions; this reduces wasted memory and provides better control over the layer's anchor points.
- **Composition** – the file creates a new Comp in the project with all layers of the same size; this usually uses more memory and makes selecting layers in the Comp Window more difficult.

The WONK TV logo was initially created in Photoshop, so we'll again use this file for Photoshop Import demonstration.

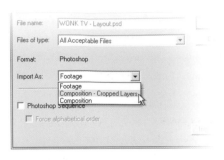

1 Create a New Project (Ctrl + Alt + N).

2 Import (Ctrl + I) the *WONK Logo Build.psd* document as **Composition – Cropped Layers**.

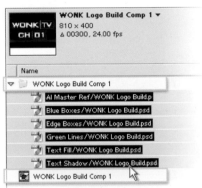

Notice in the Project Window that when the file is imported, two objects are added to the window: the file as a Comp and a folder containing all the file's layer elements.

3 Open *WONK Logo Build Comp 1* to review its contents.

4 Select the layer *Green Lines*.

This layer is a good example of the advantage of the Cropped Layers option. Notice how the transform box tightly surrounds the two green bars. If you were to import the file using just 'Composition', the transform box would match the whole Comp's dimensions.

5 Duplicate (Ctrl + D) the *Green Lines* layer.

6 In the upper *Green Lines* copy, draw a Box Mask (Q) around the upper green bar, then make a Mask for the lower bar in the original *Green Lines* layer.

7 Using the Pan Behind Tool (Y), center each Anchor Point over its associated green bar.

If you can't access the Anchor Point, try selecting a different layer, then use the Pan Behind Tool.

8 Save your work as *Photoshop Comp 1.aep*.

When first imported, the *WONK Logo Build.psd* file dictated the size of its Comp as set by its overall canvas size. But this Comp's size is incompatible with most digital video or film aspects. You can change the Comp's dimensions and proportionally maintain each layer's size using two methods: Parenting to a Null or using the Comp as a Precomp in another Comp.

Parenting to a Null – If you wanted to continue working in the original imported Photoshop Comp, add a Null to the Comp then Parent all the other layers to the Null. You can then scale all layers simultaneously by scaling the Null only.

9 Add a Null (Ctrl + Alt + Shift + Y) to the WONK Comp.

10 Select all other layers of the Comp, then use the Parent column's Pick Whip to attach all the layers to the Null.

11 Resize (Ctrl + K) the Comp to 640 × 360 (uncheck the **Lock Aspect Ratio . . .** box).

12 Open the Scale (S) property for the Null, then set a new size of 75%.

13 Open all the other layers' Scale properties, then delete the Null.

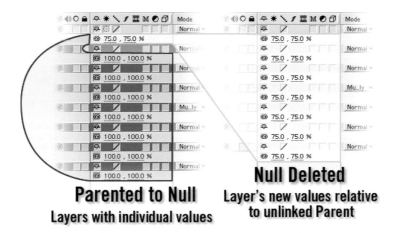

Parented to Null
Layers with individual values

Null Deleted
Layer's new values relative to unlinked Parent

Notice that all the layers first showed 100% size until the Null was deleted. That's because when any layer is attached to a Parent, all the layer's properties maintain their initial values until they lose the link to the Parent. Once that link is broken, all the Parent's transform values are applied, cascading to the child's properties.

Using the Photoshop Comp as a Precomp – The more powerful method is to make a Precomp out of the existing Photoshop Comp, then apply the Collapse Transforms function to the Precomp.

14 Revert the project back to *Photoshop Comp 1.aep.*

15 Create a New Comp (Ctrl + N) with these settings: 640 × 360, Square Pixels, 24 fps at 10 seconds.

16 In the Project Window, drag the *WONK* Comp on top of *Comp 1*.

17 In the Timeline Window for *Comp 1*, change the Precomp's Scale (S) to 75%.

18 Activate the Collapse Transforms switch (seen left).

Using a Photoshop file as a Precomp with Collapse Transforms active provides the most flexibility to the design artist. It allows for the total freedom of maintaining all your Photoshop Blending Modes while permitting the quick assembly of complete projects right from the instant the *.PSD file is imported.

Illustrator File Import as Composition

Importing Illustrator vector files as Comps is similar to the process of importing Photoshop Comps, barring these few differences: imported Layers do not have Blending Modes or Effects, vector outlines are not editable as splines (you can't use the Pan Tool to alter the vertices), and the dpi *does* matter. But once imported, their use is nearly identical to Photoshop layered Comps.

One common problem in general with importing Illustrator files (especially with versions of After Effects prior to 6.5) is that they often display with tiny composition and layer dimensions. Since Illustrator files are dependent on the dpi they are created in, they appear in After Effects rasterized as small images. This can be fixed by rescaling the original file to make it appear larger to After Effects, or by applying the Continuous Rasterization switch to all Illustrator source layers.

Rescaling the Original – The easiest method of fixing EPS or AI files that import too small is to rescale the original file in Illustrator (or whatever vector drawing program you have).

1 In your file Explorer or Finder, copy the original file with a name to remind you that this was the unaltered original.

2 Open the original resource file in **Illustrator**.

3 Select the entire document (be certain that all layers are unlocked).

4 Select > **Object** > **Transform** > **Scale** . . . to open the Scale dialog.

5 Set the Uniform Scale to 400% or greater, and press 'OK'.

6 Save over the original file.

If you had previously imported the file into After Effects, in the imported Comp's folder (like Photoshop's Comp folder) select all the layer elements, then press 'Ctrl + Alt + L' or right-click on the selected elements and click on > **Reload Footage**.

If you had not previously imported the Illustrator file, follow the same steps you would for importing a Photoshop file as a Comp.

Continuous Rasterization – As described in the previous section on Precomps, the Collapse Transforms switch serves double duty: it allows Precomps to transfer all their effects and Blending Modes into the parent Comp, or in the case of Illustrator files it causes all vector source layers

to Continuously Rasterize. This provides for infinite resolution clarity, no matter the level of scale applied to a vector layer.

Take, for instance, the *Grid Ball – Master.ai* file, create a new After Effects project, then import this file as Composition – Cropped Layers. The Comp comes in at 82 × 52 pixels, which is most certainly too small to use as imported. Continuous Rasterization to the rescue!

1 Enlarge the Comp to 640 × 360.

2 Add a Null to the Comp, then link all layers to the Null.

3 Scale the Null to 1000% – yikes!

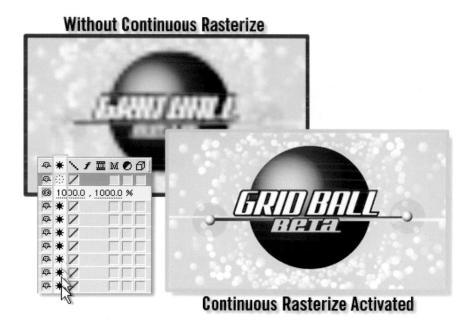

This cruddy image is the result of an improperly prepared Illustrator file. But with the quick click of a few switches, all the layers look perfect.

Click and drag the cursor down the Timeline's switches column for Collapse Transforms to activate all the layers' Continuous Rasterization modes and, in an instant, all is right with the world.

4 Save as *Grid Ball – AI.aep.*

There's one significant difference between an Illustrator (or EPS) file with Continuous Rasterize activated and a Precomp layer with Collapse Transforms applied: the Illustrator vector layer *can* have Effects and Blending Modes applied, whereas a bitmap Precomp cannot.

3D Layers – Part 2: 3D Camera

In a previous section's explanation of 3D Layers, only the layer's transform properties were described. Needless to say, there's a wee bit more to 3D Layers than previously described. 3D Layers can be animated in either the standard view or by using 3D Camera and Lights. Additionally, layers can have Materials Options applied that define, amongst other things: their reflectivity, shininess, and whether or not they cast or receive shadows.

Expanding on the last example's project, *Grid Ball – AI.aep*, this section will demonstrate a common use of 3D Lights, Cameras, and Layers: the emulation of the Multi-Plane Camera.

1 Revert to the last saved version of *Grid Ball – AI.aep*.

2 Delete the Null and the *Crop Marks* layer.

3 Add a 3D Camera to the Timeline by pressing 'Ctrl + Shift + Alt + C' or right-click inside the Timeline, under existing layers, then select > **New** > **Camera**

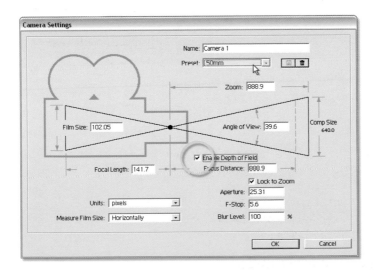

The Camera Setting dialog opens. Within the window is a multitude of interrelated values that construct the Camera's Field-of-View.

4 Open the Preset drop-down menu and choose 50mm for the virtual lens. Then press 'OK'.

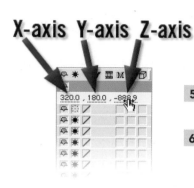

A new Camera is added to the Timeline. Notice that it does not have any Switches, Blending Modes, or Track Matte options.

5 With *Camera 1* selected, press 'P' to open its Position Properties.

6 Drag the cursor back and forth over the third set of values – this is the **Z-axis** (toward and away) of the Comp's 3D space.

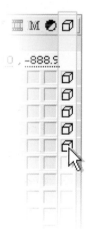

As you drag the cursor, notice that the only thing that happens is that the Camera's Z-axis values change. This apparent bug is actually a distinctive feature of After Effects – the intermixing of both 2D and 3D Layers simultaneously. All of the Grid Ball layers are currently operating in 2D mode, but most of them need to be set to 3D mode.

7 Activate the 3D Layer switch on all layers except Wash.

8 Again, adjust the Camera's Z-axis.

Now the whole scene either zooms toward or away from the camera's view. As it does so, since the layers still have their Continuous Rasterize active, the images stay constantly sharp.

In the Tools palette, select the Camera (C) tool. This has three options – repetitively

pressing 'C' cycles through these options:

- **Orbit** – rotates the Camera's view around the Point of Interest (Camera's Target).
- **Track XY** – moves both the Camera and its Point of Interest target horizontally and vertically.
- **Track Z** – trucks both the Camera and its Point of Interest forwards and backwards along the Z-axis.

Using the Orbit Camera tool, drag the Camera around the Comp Window – the present layout is utterly flat. But not for long:

9 Right-click on the Camera's Position property and select > **Reset**.

10 Add a Null (Ctrl + Alt + Shift + Y), then activate the Null's 3D Layer option.

11 Copy the Camera's Position properties to the Null.

12 Twice duplicate (Ctrl + D) the Null.

13 Drag a Null down directly above each of these layers: *BG Elements*, *Ball*, and *Red Balls*.

14 Parent each layer to its Null directly above.

15 Open the Null's Scale (S) properties and set the following: Null above *BG Elements* = 130%, *Ball* **Null** = 120%, *Red Balls* **Null** = 110%.

16 Select *Beta Text* layer and set its **Z-axis** Position to '10'.

17 Save your work with a new name (> **File** > **Increment and Save**).

With the Orbit Camera tool selected, drag the Camera around the Comp Window – you now have a Multi-Plane Camera rig prepared. Because the *Wash* layer does not have its 3D Layers active, the Camera does not affect it. But the *Wash* layer still affects the BG Elements layer beneath, even though *Wash* is not a 3D Layer. This shows how both 2D and 3D Layers can coexist, thus making your compositing life easier by allowing you to create without restrictions how your layers interact. Sometimes it's just simpler, and looks better, to apply certain graphics as 2D Layers and others as 3D.

All that's left to do is add some lights to complete the effect.

3D Layers – Part 3: 3D Lights

All 3D animators worth their salt know that it's lighting that defines their renderings – good lighting can make a bad scene look great, while bad lighting can ruin a beautiful scene.

After Effects' 3D Lights are less inclined to be so crucial to a Comp's design because you can create so many alternatives to Lights for interesting visual effects. But they still add that edge of realism to a Comp by helping focus the viewer on certain areas of your design and removing the somewhat flat perception of a non-light scene by adding highlights and shadows. Each layer can have different lighting attributes that determine how lights affect their surface, and how the layer affects objects behind.

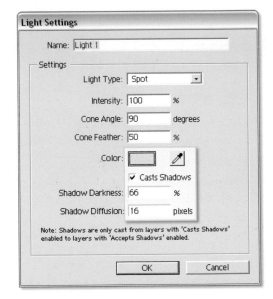

1 Revert to the most recent saved version of the 3D Layer project, *Grid Ball – AI 2.aep.*

2 Add a Light to the Timeline (Ctrl + Alt + Shift + L) or right-click inside the Timeline, under existing layers, then select **> New > Light**

3 Set the **Color** to pink, set **Casts Shadows** active, set **Shadow Darkness** to 66%, and **Shadow Diffusion** to '16', then press 'OK'.

The Light Settings dialog has several attributes you can apply to your lights:

- **Light Type** – conical Spot (diverging light rays), spherical Point (omnidirectional), orthographic Parallel (like sunlight), and Ambient (non-directional light).

- **Intensity** – brightness of each light, relating to layer's non-3D state.
- **Cone Angle** – spread of a Cone Light's coverage.
- **Cone Feather** – the edges' fall-off of a Cone Light's cast circle.
- **Color** – the gel (filter) placed over a Light.
- **Casts Shadows** – activate the Light's shadow rendering ability.
- **Shadow Darkness** – the density of a shadow, relating to the non-lighted state of the layer it touches.
- **Shadow Diffusion** – the softness (defocus) ot a shadow.

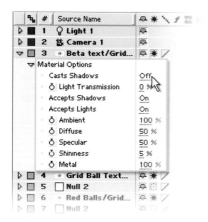

When 3D Layers is activated, a layer's Material Options (A A) open with standard default settings. Don't be overwhelmed by the mass of variables here; for most cases you need only make slight changes to achieve results most designers expect.

- **Casts Shadows** – this has three options: Off (no shadow casting), On (casts shadows), and Only (the contents of the layer are switched off, leaving just the Shadow cast).

- **Light Transmission** – permits the layer's image contents to project upon layers behind in place of its Shadow; percentage is amount of shadow versus transparency.
- **Accepts Shadows** – determines if other layer's Shadows will display on this layer, independent of Accepts Lights.
- **Accepts Lights** – determines if Lights affect this layer, independent of Accepts Shadows.

The layer's surface attributes complete the Material Options list. These settings alter how the layer responds to Light. These attributes are similar to a 3D modeling program's shading operations:

- **Ambient** – responds to Ambient Lights only and affects the layer equally in every direction.
- **Diffuse** – responds to the other Light modes as a flat-painted surface.
- **Specular** – the amount of highlight reflectivity of a layer's surface.
- **Shininess** – the smoothness of a layer's surface.

- **Metal** – how much the layer's image colors affect the Specular highlight colors.

You can conveniently apply common settings to multiple layers concurrently if you select all the layers you want to adjust together. You can then press 'A A' to open their Material Options, then:

4 Set all 3D layers to **Accepts Shadows – On**, and leave all the surface attributes to the default settings.

The initial position of the Light probably doesn't have the correct orientation for where the highlight appears on the Ball layer's image. Moving a light is achieved by several methods:

A Moving the Light's emitter (Position) and target (Point of Interest) points with the cursor in the Comp Window, or by manipulating the Timeline property values in the Transform options.

B Dragging on the Axis Arrow's handles to constrain the Light's movement to one of the three axis directions.

To complete this exercise, drag the light toward the upper left region of the screen, and then drag the Point of Interest target towards the Ball layer's highlight. You should also experiment with dragging the Axis Handles to see their effect on the various layers and shadows they cast.

One word of warning about using lights that cast shadows – they dramatically slow down the rendering process. So use them judiciously – many lighting effects can be faked by using Masks on Solid layers.

Keying and Garbage Mattes

Like spaghetti and meatballs, Laurel and Hardy, software and bugs – Keying and Rotoscope are practically inseparable. All too often when you're assigned

the task of keying a Green or Blue Screen shot, the footage usually has contaminants and inconsistencies to isolate and remove, calling upon the generation of animated Garbage Mattes. Sometimes you're not so lucky and have no color to Key out, so you have to resort to completely manual Rotoscope Masks.

Using many of the animation and masking techniques discussed in earlier sections, and by utilizing some of the Effects tools, you can quickly create flawless Luminance and Color Keys from sub-par materials.

Luminance Keying – Luma Key Effect

The earliest form of image-based Masking is the Luminance Key, where the brightness levels of a given image determine what elements are removed. Good Keying can be achieved through a well-implemented Luma Key. After Effects has several techniques for Luma Key processing, as well as filters to help clean up the shmutz Luma Keys often generate.

1 Open *RotoKey.aep* and select the *LumaKey – Earth* Comp.

2 Apply (either right-click on the image or use the menu) the
> **Effect > Keying > Luma Key**.

3 In the Effects Control window set the **Key Type** to **Key Out Darker**.

4 Apply **> Effect > Matte Tools > Simple Choker**.

5 Activate the 'Toggle Transparancy Grid' button at the bottom edge of the Comp Window.

Since the black sky needs to be Keyed out, the Key Out Darker is used. The Simple Choker was added to help contract the Luma Key's Masking and smooth out the Key's edges.

6 Set the following values for the Luma Key: **Threshold** = 16, **Edge Thin** = −2, **Edge Feather** = 8.0.

• **Threshold** – Luma Keys are harsh Off or On Mattes; this value sets the cutoff where the Key becomes either inactive or active.

- **Tolerance** – if you select either the Key Out Similar or Dissimilar options, this value sets the breadth of the Threshold's range, where it begins then stops its Key.

- **Edge Thin** – use this to expand or contract the Key's influence upon the image; a negative number contracts the Key's Masking.
- **Edge Feather** – adjusts the softness of the Key Mask's edges.

The Key has one flaw: where the Earth's atmosphere meets the black background, the Key hasn't removed enough of the black, leaving a dark edge (top image below). This is where the Simple Choker helps.

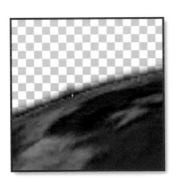

7 In Simple Choker set **Choke Matte** to 2.00.

8 Save your work.

Now the atmosphere blends smoothly into the checkerboard background (bottom image below).

There's one function control missing in the Luma Key Effect's options: Blend, where the harshness of the Key gradually changes from its Off to On states. For Luma Keys where this smooth transition is required, a different method of Luma Key can be employed.

Luminance Keying – Gradient Wipe

Sometimes the harshness of the Luma Key prevents you from achieving the effect where some of the image is translucent with some of

the image's areas gradually fading away to the Keyed area. You can use the Gradient Wipe Effect to make these smooth translucent Keys.

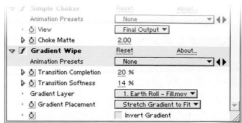

9 To your previous *Earth Roll – Fill.mov* layer add > **Effect** > **Transition** > **Gradient Wipe**.

10 For **Gradient Layer** select the *Earth Roll* layer.

Gradient Wipe is usually applied as a transitional device using a source layer's luminance values to determine how the wipe progresses – but when used without animation applied to the Transition Completion, it performs well as a Luma Keyer.

Transition Completion – Determines the luminance point where the Key begins or ends. Unlike the Luma Key Effect, which uses 0–256 as its scale, Gradient Wipe is percentage based, with 0% (black) as its starting point. You can swap the Key source color from black to white with the Invert Gradient switch.

Transition Softness – Blends the transition point where the Key occurs. Larger values cause increased transparency while smaller values make the Key harsher. Use the settings below to see how these options work in unison to make the oceans translucent.

11 Set the Transition Completion to 15% and the Transition Softness to 25%.

12 Save your work.

Luminance Keying – Extract

The last method of Luma Keying is achieved using the Extract Effect. This filter provides features of both the Luma Key and Gradient Wipe filters: the ability to generate a key based upon the middle gray levels like the Luma Key and the ability to softly blend your key's edges to make translucent mattes. It also provides a histogram to help better isolate your luminance density peaks.

1 Open the Pulp Mill Conveyor Comp.

2 Apply > **Effect** > **Keying** > **Extract**.

3 Adjust the following: **Black Point** = 79, **White Point** = 154, **Black Softness** = 56, **White Softness** = 49.

You can manipulate the values either by dragging the cursor over the numbers or by grabbing the corners of the gray box then dragging them back and forth. By examining the histogram (left image below) you can easily determine the point of greatest luminance density, allowing you to better isolate your Key levels. You can also swap the Key mode, by checking **Invert**, to leave the extreme white and/or black areas untouched (right image).

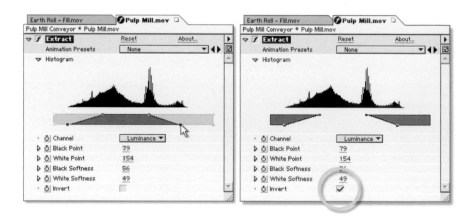

Chroma Keying – Green/Blue Screen Keying with Keylight

There are several specialized plug-in filters available that provide superb Keying from color-field backgrounds. But since version 6.0 of After Effects, The Foundry's 'Keylight' has been bundled into the Professional Effects Filters, providing all the capabilities of other third-party plug-ins. This is an excellent tool for Green/Blue Screen Process Photography, providing superb capabilities and flexible tools. If you do any significant Green/Blue Screen Keying, this plug-in alone should be reason enough to upgrade to After Effect's Professional version.

Using the same *RotoKey.aep* file from the Luma Key exercises, open the PDA Green-Screen Comp and scrub through the footage.

1 Select layer 1 and advance the CTI to frame 24.

2 Add > **Effect** > **Keying** > **Keylight**.

3 Click on the eyedropper next to **Screen Colour,** then sample any green area in the Comp Window.

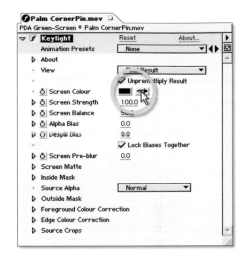

Immediately a fine Key is created. But due to the highly compressed nature of the footage, the JPEG codec causes mosquito noise and color artifacting around the hand's edges. By adjusting a few settings, a more than acceptable Key can be obtained. Detailed tutorials on the implementation of Keylight are included with After Effects, so for now we'll focus on fundamental settings to clean up the image.

4 Set Clip Black to 20.0, Screen Grow/Shrink to – 1.5, and Screen Despot Black to 2.0.

The **Screen Matte** options provide the primary tools for cleaning up your Key. The options used for this shot included:

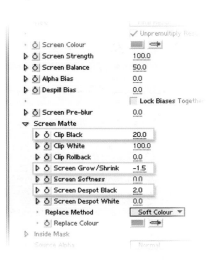

- **Clip Black** – enhances the depth of the Key, but can remove some of the foreground reflections (in scenes with glass in front of the green/blue screen) or details in the color you might need to keep.

- **Screen Grow/Shrink** – expands or contracts the generated Mask's influence; too much of this setting can remove the fine detail of hair.

- **Screen Despot Black** – removes subtle dark speckles that contaminate your Key.

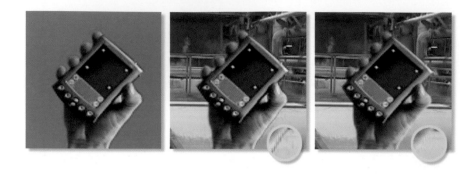

The images above show the progression from step 3 to step 4. And yes, it's that simple. Many of the other Chroma Key utilities available call for many more steps to achieve what Keylight does in just a few mouse clicks.

Chroma Keying – Color Key Effect

If you don't have the Professional version of After Effects, the Color Key filter and the Simple Choker can achieve adequate Keys on well-lit smooth color backgrounds.

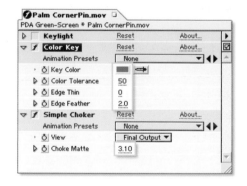

Color Key works similar to the Luma Key filter but replaces the black and white levels with a wide-range color picker, where any color can be isolated and removed.

1 Deactivate Keylight in layer 1's Effect Controls menu.

2 Add > **Effect** > **Keying** > **Color Key** and then add > **Effect** > **Matte Tools** > **Simple Choker**.

3 Use the **Key Color** eyedropper to select the green sample.

4 Set the following values: **Color Tolerance** = 50, **Edge Feather** = 2.0, and **Choke Matte** = 3.10.

5 Save your work.

The images on the next page compare the results of the two methods. While the Color Key composite (left image) looks to be cleaner with smoother edges,

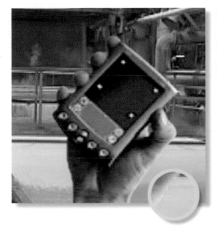
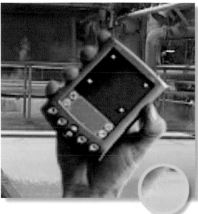

it's actually missing edge details that Keylight keeps that blend the foreground image into the background (right image) to make them look 'as one'.

Rotoscope – Garbage Mattes

For the sake of productivity, pretend that the PDA green-screen footage has all kinds of contamination and obstructions to remove. Usually, when Green/Blue Screen footage is shot, there's much detritus mixed into the shot that needs to be removed prior to the Key. By using the Pen Tool you can quickly (that is a relative statement because Rotoscoping is an inherently tedious process) eliminate the clutter to isolate the objects you want to keep.

1 In layer 1 of the *PDA Green-Screen* Comp, disable all effects.

2 Select the Pan Tool (G) and activate the **RotoBezier** option.

3 Double-click on layer 1 to open its Layer Window.

4 Go to frame 24 and draw a Mask around the hand and PDA.

5 In the Timeline add a Keyframe to the Mask Shape (M) property by activating the stopwatch.

When creating Rotoscope Masks with RotoBezier it's good practice to set your vertices loosely around the object and to use as few as possible. This makes altering the Mask much simpler.

6 Reverse the CTI 10 frames backward (Shift + Page Up).

7 Select the Move Tool (V) and reposition the vertices around the hand, trying to keep each vertex located near the image feature where it was initially positioned.

Sometimes the change in the movie clip is so pronounced that you lose track of the object. To ease this problem you can deactivate the Mask's stencil to view the entire frame as you manipulate the Mask's path.

8 Uncheck the Render option in the Footage Window.

9 Repeat steps 6 and 7 until the object is gone from the clip.

10 Return to frame 24, then advance 10 frames to continue your Rotoscope forward.

As you progress through Rotoscope Garbage Matte creation, you will often have to revise your precision by increasing Magnification (the Period key increases screen magnification), and/or reducing the frame advance/decline from 10 frames down to single frame.

11 Reactivate the Effects for the PDA layer, and reactivate the Render check-box in the Footage Window.

12 Press 'F' to open the Mask Feather properties; set it to a value that blends the green away to black without removing any of the hand.

As a final step, you should examine the Key with the Mask enabled, checking for rouge frames where the Rotoscoped object intersects with the feathered Mask. For these instances you can animate the Feather along with the Mask Shape.

As your scenes needing Rotoscope Masking become more complicated with multiple and disconnected elements, you'll begin to use multiple animated Masks. There's no law that says you have to do all your work with one Mask – use as many as you need. Utilize Mask Blending Modes to make compound animated Masks and Mask Opacity in concert with Mask Expansion to tweak your object's features.

Making Footage Work for You

How often have you seen a commercial where the graphics appear glued to a specific moving visual feature or watched a movie where a floating translucent high-tech screen has amazing footage playing on what you know can't really exist. Perhaps you've seen really old footage that's been restored and is now steady. Effects such as these are achieved through the application of After Effects' Motion Tracking.

Motion Tracking and Stabilization

Of all the technologies programmed into After Effects, I find Motion Tracking and Stabilization one of the most remarkable. The idea that the computer can identify a visual feature and follow that feature as it progresses from one frame to the next is pretty blasé these days, but only a few years ago the technology was the sole domain of the rarified ultra-high-end visual effects compositing supercomputer. Then again, today's ordinary desktop computer clearly lays waste to yesterday's supercomputer – and the high-end motion tracking software has become an everyday feature of many graphics and editing programs.

Motion Tracking and Stabilization for After Effects operates in four modes:

A Single-Point Tracking

B Multi-Point Tracking

C Parallel Corner Pin

D Perspective Corner Pin.

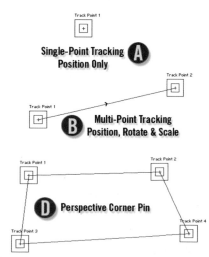

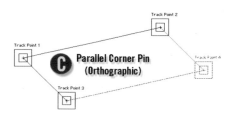

Single-Point Tracking

This is the most basic form of Motion Tracking where the system follows a single feature – a closely focused area of the image that changes location from frame to frame. The easiest features to track are highly contrasting clusters of pixels, where they maintain their contrast throughout their motion track path (i.e. eyes, corners of windows, computer screen edges, light bulbs).

The image below shows two examples of tracking features, both good and bad. The concrete has very low contrast and little for the tracking target to lock on to, whereas the cute little girl has many great features to track.

Single-Point Tracking will often be used for applying visual effects (lens flares, glows, and character thought bubbles).

Open *Motion Tracking.aep* and select *Pulp Mill – Stabilization*. We'll be using this shot for two purposes: Single-Point Tracking exercise and Multi-Point Tracking for Stabilization.

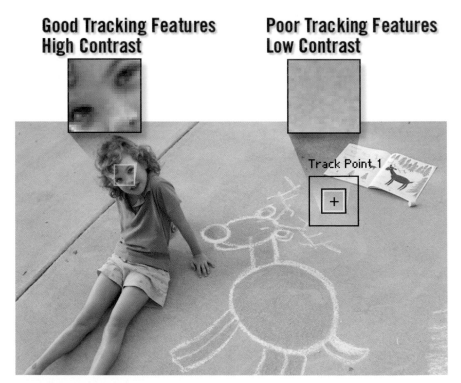

For the first exercise we'll be adding a brilliant flare to one of the lights in the scene.

1 Select the *Pulp Mill – Stabilization* Comp.

2 Right-click layer 1 to track the clip.

3 The menu at right opens – select **Track Motion**.

Open Effect Controls
Open Footage
Reveal Layer Source in Project
Reveal Layer in Project Flowchart View
Reveal Expression Errors

Create Outlines

Track Motion
Stabilize Motion

Invert Selection
Select Children

Track Point 1

The Composition Window changes into the Layer Window, where you can apply trackers, adjust Masks and the clip's Anchor Point (it's similar to the Footage Window, but without any clip editing capabilities). Immediately a Track Point is added to the window. The Track Point consists of three elements utilized for calculating tracker data: the outermost box (highlighted in magenta) designates the Search Region. This is the furthest area the tracker will consider for the tracked feature's motion changes. The inside box (highlighted here in green) specifies the Feature Identifier Boundary: the shape, color, and/or luminosity to track. The cross-hairs identify the Attach Point that will define the tracking data's position to be applied to the object (Motion Target) you want to track in the scene.

Each box is adjustable – the larger the box, the greater amount of time it takes to track because it has so much more image to examine. This can make for a more precise track (unless there's too much clutter inside the search area), but usually it's a waste of time forming the Tracker too large. Also, a Track Point's inside box is limited to searching within the boundaries of the screen area. It cannot travel outside the Footage Window's image – the smaller the Feature Identifier Boundary, the closer

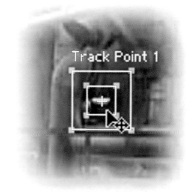

Track Point 1

the Tracker approaches the screen's edges.

As you move *Track Point 1* (drag inside the boxes, but don't grab the cross-hairs), the Track Point boxes change into a magnification box of the area designated by the smaller Track Point box. This assists with the precise placement of the cross-hairs on the feature you're trying to track. You can also zoom into the image for better placement precision either by changing the Magnification Pop Up selector or by rolling the center mouse wheel.

When you first opened the Footage Window and the Track Point appeared, another floating window menu opened as well: the Tracker Controls window. This menu contains the tools and controls used to adjust then run your track. Click on the Options button to access the Motion Tracker Options window, with its tools used to provide more accurate tracking and scene pre-processing.

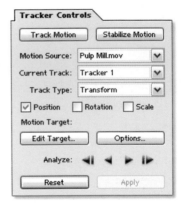

The Tracker Controls window has several functions you can modify: the **Motion Source** defines from which clip it will calculate its track, **Current Track** identifies which Track Point is currently active for modification, **Track Type** designates the operational mode (as described earlier) and, below that, the property (Position, Rotation, and Scale) to be calculated.

By default, the Single-Point Tracking mode is first selected. Its Track Type, 'Transform', pre-selects the 'Position' property.

4 Ensure that the Layer Window's CTI is at its first frame.

5 Drag the Track Point and place it over any one of the lights in the room.

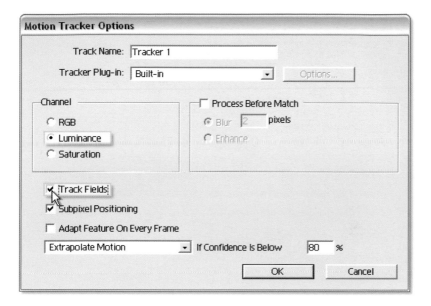

6 Adjust the Track Point to give it enough space (but not too much) to detect the consecutive positions the light follows.

7 Click on the 'Options' button to open the Motion Tracker Options window.

Before you begin any track, you should check the **Motion Tracker Options** are set to the appropriate adjustments for the feature you intend to track. The window consists of filtering techniques to best isolate the tracked feature. In the **Channel** section you can choose one of three methods for isolating your feature's details: use RGB where individual colors are tracked (i.e. blue objects over a red background); Luminance is best for high-contrast tracks where the feature is considerably darker or brighter than its surroundings (as in our example here); Saturation is where a color is tracked over a similar color background but of lesser or greater color intensity (i.e. a vivid green flower is tracked over a dull green pasture).

Process Before Match applies an adjustment to the image prior to the track's calculation. **Blur xx pixels** should be applied to images where the feature's surroundings are too detailed and might interfere with the Tracker accuracy. **Enhance** applies a sharpen filter to increase an image's contrast and exaggerate detail.

Track Fields is an easily overlooked option that should be activated for all field-rendered or recorded footage (including 24 fps footage that has not been 3 : 2 Pulldown reduced). It's overlooked because if your field-rendered footage has been properly prepared via the **Interpret Footage's Remove Fields** dialog, then you won't see any of the tail-tail scan-lines in the Footage or Comp Windows. If you don't activate the **Track Fields** function, the item attached to the track data might appear stuttery or jagged as it moves, with the tracked footage ruining the whole tracking effect.

Subpixel Positioning should be left on – it's what makes the Tracker smoothly flow from frame to frame. If turned off, the Tracker data will round to the nearest pixel, making the motion rough.

Adapt Feature On Every Frame accounts for when the tracked feature becomes obscured by another image item (like a pole in the foreground moving across the scene in front of a person being tracked) or when the feature's surroundings change texture (i.e. color or brightness changes caused by shadows or blinking lights cast upon the feature). You can instruct what the Tracker should do if the Adapt Feature's Confidence (the accuracy of the Tracker's calculations) falls below the set percentage.

8 Set the Motion Tracker Options to the highlighted settings: Luminance and Track Fields.

9 Click 'OK' and return to the Footage Window to add our effect.

10 Right-click on the *Pulp Mill.mov* layer and select > **Effect** > **Render** > **Lens Flare**.

11 In the Effect Controls window, set 'Flare Brightness' to 75% and the 'Lens Type' to 105 Prime.

> **A Quick Word on the Disrespected Lens Flare:** The bad reputation placed upon them is undeserved. They serve a great purpose – an appropriately designed and well-placed moving flare can provide a scene the sense of depth and life animation often lacks. The fact is that animation is often too clean and clear from computer-derived purity. For the best Lens Flare effects plug-in, consider the Knoll Light Factory 2 toolset (available from ToolFarm.com). This is a powerful set of pre-designed and customizable optical effects that will quite simply amaze your friends, astound your clients, and pay for itself in no time.

Now that you've assigned your Lens Flare to your clip you need to instruct the tracker to apply its data to the flare's center point. But since you added the Lens Flare, the Tracker Controls menu has become inaccessible. To reacquire the Tracker Controls you need to change the Footage Window's **View:** selector (close to the bottom edge of the Footage Window) from Lens Flare to Motion Tracker Points. This hides the Lens Flare and returns to the Track Point screen, while reactivating the Tracker Controls menu.

12 Click on Edit Target in the Tracker Controls menu.

13 The Motion Target window opens and has selected the Lens Flare's Center as its point control – click 'OK'.

If your scene had many effects that can use Tracker or other layers to apply the Tracker's data, the Motion Target menu would offer many more selections in its drop-down menu.

Now that you've placed the Track Point and set the Motion Target, your motion track is ready to proceed.

14 Click on the Track Forward arrow in the Tracker Controls menu (seen at right).

15 Once it has finished its track, click 'Apply'.

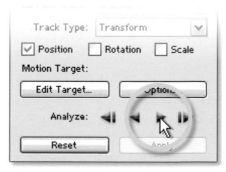

Another menu pops up – the Motion Tracker Apply Options allows you to select how the data will be applied to your target. This is convenient when you want to restrict your target's motions to one axis of motion.

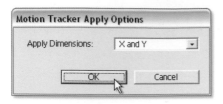

16 Click 'OK' in the Motion Tracker Apply Options menu.

17 Click on the Return to Comp Button at the bottom edge of the Layer Window to review the Tracker's results.

18 Run an RAM Preview.

19 Repeat the procedure to apply another Lens Flare on the other light near the first tracker.

For a challenge, try tracking the light on the left middle screen. It looks easy enough until the steam obscures the light. This is a great example of where to use the Adapt Feature On Every Frame in the Motion Tracker Options dialog.

Multi-Point Tracking – Position and Rotate

Imagine you have some footage that was shot by a director of photography schooled in the MonkeyCam genre, or perhaps you are given a clip shot while the camera operator stood atop a platform with heavy machinery vibrating the platform viciously. Maybe you have an object in a scene where you need to attach a graphic sign but the object that you need to track both rotates and changes size at the same time.

These are examples where Multi-Point Tracking is appropriate. Both Stabilization of shaky footage and Motion Tracking of rotating and/or scaling features are types of Multi-Point Tracking. And fortunately for us, we have excellent case studies of both to practice upon.

Revert the *Motion Track.aep* project and again select the *Pulp Mill – Stabilization* Comp. You've already seen that this footage was difficult to shoot due to the heavy machinery environment, so let's fix it using Multi-Point Tracking.

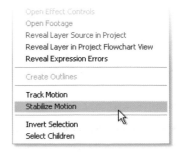

1 Open the *Pulp Mill.mov* clip's Layer Window by right-clicking on the clip, but this time select > Stabilize Motion.

2 Make sure that the Layer Window's CTI is at first frame.

The Track Type should already be set to Stabilize, but the only property to be stabilized is the Position. Our footage has serious twists combined with its jitter, so the Rotation property needs to be selected. When a two-point track is used, a rubber-band line connects the two Track Points, with the first Tracker pointing to the second. The change in angle of this line determines the image's rotation factor.

3 Click the Rotation check-box to add this property to the track.

4 Drag 'Track Point 1', aligning it to the pulp conveyor's left far back corner.

5 Drag 'Track Point 2' horizontally across the conveyor, aligning it to the black dot near its right edge (seen below).

6 Open **Options . . .** in the Tracker Controls menu and activate **Fields** in the Motion Stabilizer Options (this is the same dialog as the Motion Tracker Options dialog), and click 'OK'.

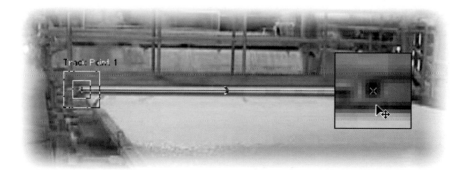

7 Return to the Tracker Controls and run your track.

8 Click on 'Apply', then click on the Return to Comp Button.

9 Run an RAM Preview.

The Motion Target for the track was already pre-selected to the clip itself. So when you clicked 'Apply', the clip inherited the Keyframes generated by the Tracker for Position and Rotation.

As you run the preview notice that the image becomes greatly offset from its initial position. Also note that the layer's Anchor Point (highlighted in magenta at left) is aligned with where the Tracker's first Track Point was set – this is the point where the image also pivots.

As it stands right now, the Stabilization is not very usable: the image is too far offscreen, with vast areas of black filling the view. You'll need to center the clip and simultaneously expand it to fill the screen, as much as possible. The most effective technique to accomplish this task is by Parenting the layer to a Null, then using the Null to both reposition and scale the whole clip.

10 Add a Null to the Timeline (Ctrl + Alt + Shift + Y).

11 Parent the *Pulp Mill.mov* layer to the Null (Shift + F4 opens the Parent column).

12 Adjust the Scale of the Null to approximately 110%.

13 Scrub the CTI through the Timeline to find a point where the image no longer moves abruptly.

14 Drag the Null through the Comp Window until the Parented layer appears roughly centered – you may have to scrub the CTI a few times to find a good compromise for the image's center.

The only remaining issue with the clip is at its beginning: the camera move makes a tilt until it steadies upon the machinery. Again, the Null offers a solution – you'll add two Keyframes to account for the camera's initial downward angle, then move the Null to its current position for the remainder of the clip's playback.

15 Add a Position Keyframe (Shift + Alt + P) to frame 34, where the clip has finished its tilt.

16 Return to the first frame (Home) and move the Null upwards to compensate for the tilt.

17 Add an Easy Ease (Shift + F9) to the second Keyframe to make the tilt transition smooth.

18 Increment and Save your work, then run another Preview.

The Stabilization is now complete. Even with the image's slight scale increase, the overall effect improves greatly upon the original's wobbly shot.

Multi-Point Tracking – Scale

There's one additional Property that can be calculated by Multi-Point Tracking – Scale. By adding Scale, an object can be effectively tracked in 3D space, though it's only acting on 2D data.

Revert the *Motion Tracking.aep* project, then open the *Chuck's Chips – Tracker* Comp. Our task is to glue a sign to the back of the truck's rear hatch, covering the oval logo above the red and white safety stripes. This is a difficult tracking

problem for several reasons: the chips dumping out of the truck add a lot of noise to the shot, the shot doesn't have any well-defined features in which to apply Trackers, and the feature to track moves into then out of the screen.

For cases where the feature comes from or moves offscreen, you have to manually adjust the tracked

overlay to account for the offscreen motion. But other than these offscreen issues, preparing for a Scale Track is the same as any other Multi-Point Tracking:

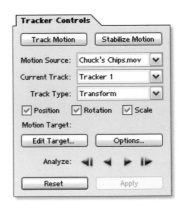

1 To ease the Tracker's setup, choose a frame toward the center of the clip (frame 40).

2 Right-click on the clip layer and select > Track Motion.

3 Check 'Rotation' and 'Scale', in addition to 'Position'.

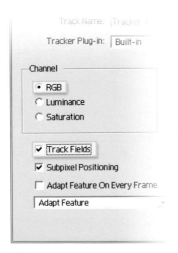

4 Click on **Options**

5 Select both 'RGB' and 'Track Fields', then 'OK'.

We're using RGB to track the features because they have strong color and luminance differences.

The **Motion Target** is blank because there's nothing yet in the Comp to apply the Tracker's data. A good habit to follow is to use Nulls for applying your data. This allows you to make further adjustments to your tracked object after the Track is complete.

6 Press 'Ctrl + Alt + Shift + Y' to add a Null Object.

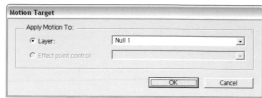

7 Click on **Edit Target . . .**, then press 'OK' – the Null is the only thing in the scene for the Tracker to use.

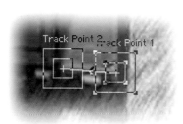

8 Align the Track Points to the lower corners of the door nearest to the oval logo – place Track Point 1 to the right and Track Point 2 at left.

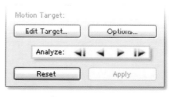

The Tracker Controls menu has four buttons to activate your track: Single Frame Track Back, Reverse Track, and Single Frame Track Forward. Previously, we've been using Track Forward, but since we set up the Track Points within the middle of our clip, this requires reverse tracking.

◀❙ **Single Frame Track Back**

◀ **Reverse Track**

▶ **Track Forward**

❙▶ **Single Frame Track Forward**

■ **Stop Track**

9 Click on Reverse Track to run your Track, but as the Track points approach the screen's edge, click on the Stop Track button (the Play becomes the Stop button).

10 Manually step the Tracker backward with Single Frame Track Back to bring the Track Points center box as close to the screen edge as possible.

11 Jump back to frame 40 (Ctrl + G) and resume your Track Forward, but again stop the Track as it approaches the screen edge.

12 Manually step the Tracker forward with Single Frame Track Forward to bring the Track Points center box as close to the screen edge as possible.

13 Click on 'Apply', then in the Motion Tracker Apply Options dialog click 'OK' to transfer the data to the Null.

14 Click on the Return to Comp Button and then scrub the CTI to review the Tracker's results.

Select the Null 1 layer, then press 'U' to examine its Keyframes for all three properties: Position, Rotate, and Scale. Because the Trackers are limited to staying inside the image area, you have to manually extrapolate the offscreen track data.

15 In the Timeline Window return to frame 0.

16 Drag the Null up to align it to the same feature point just inside the screen.

17 Go to the last frame (End); you'll need to scrub the CTI and tweak the Null, guessing where the feature would be offscreen.

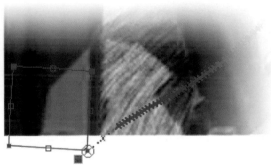

A good trick in offscreen feature situations such as this is to use the Null's edges to line up with some other item in the scene that is common to the offscreen feature – in this case, we'll use the door's blue frame.

The only activity left is to add an item to attach to the Null.

18 Go to frame 40 to prepare the new layer for attaching to the Null.

19 Drag *Chuck's Sign* Comp from the Project Window into the *Chuck's Chips – Tracker* Comp as layer 1.

20 Scale the new layer to 15% then move it, placing the sign near the edge of the truck's door frame.

21 Right-click on *Chuck's Sign* layer and add > **Effect** > **Distort** > **Transform** to the layer.

22 Adjust the Skew (not Skew Axis) to 7.0.

23 Parent *Chuck's Sign* layer to the *Null 1* layer.

24 Activate the Motion Blur switch on *Chuck's Sign* layer and the Timeline's Enable Motion Blur.

25 Run a Preview.

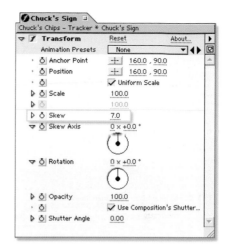

The sign is effectively attached to the truck's doorframe. The Motion Blur adds even more realism by blending the sign into the frame. To really make the effect even more convincing, you could add some noise and color correction to match the image's texture.

Corner Pin Tracking – Parallel and Perspective

We've all seen them – the replacement image tracked inside a TV monitor, the moving-footage photo album, or the animated sign high on a billboard. These are examples of Corner Pin Tracking: the application of a rectangular image distorted to fit within another rectangular moving space. Corner Pin Tracking works in conjunction with the > Effect > Distort > Corner Pin.

There are two modes of Corner Pinning:

- **Parallel** – this mode (top example, next page) is best described as skewing an image where each opposing side remains parallel to each other. Architects would call this orthographic projection. With this mode you only assign three of your four Tracker Points – the fourth is a 'virtual' point that is extrapolated to ensure the shape remains a parallelogram.
- **Perspective** – this mode (bottom example, next page) allows for complete freedom of all four Tracker Points, resulting in an image that matches real-world camera angles more accurately.

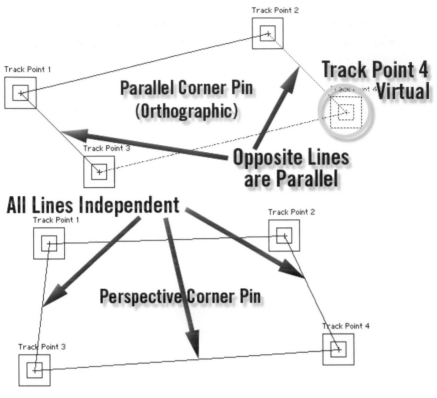

Returning to the *Motion Tracking.aep* project, select the *Palm – CornerPin* Comp. This project offers a common application of Perspective Corner Pinning (but you can try Parallel as well).

Double-click to open the shot in the Layer Window. Scrub the CTI to review the footage and how it moves. Notice that the track points adhered to the PDA's screen have great contrast, but as they move away they change size so severely that the Trackers might become confused to their original placement. This example will work best as a Reverse Track.

For our inserted image Motion Target, we'll be using the previously stabilized *Pulp Mill – Stabilization* footage Comp.

1 From the Project Window, drag your Stabilization test Comp (or dig into the Solutions folder and grab the *Pulp Mill – Stabilize Solution*) into the *Palm – CornerPin* Comp's Timeline.

2 Snap the Pulp Mill's end frame to the last frame of the Palm Comp.

3 Return to the *Palm CornerPin.mov* Layer Window by clicking on the Tab at the top of the Comp Window (or double-click the layer again).

4 Activate the Tracker by clicking on the 'Track Motion' button in the Tracker Controls floater window.

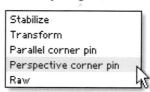

5 Click the Track Type drop-down and select 'Perspective corner pin'.

The three Properties have all been subdued because this special instance of tracking only works with the Corner Pin distortion effect.

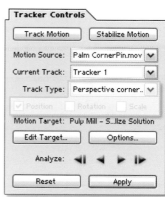

6 Open the **Options . . .** and set the **Channel** to **Luminance, Track Fields**, and activate the **Process Before Match – Enhance**, then click 'OK'.

7 Jump to the last frame (End) to set your Tracker Points, placing each Track Point's center upon the outermost corner of the tracker marks.

8 Drag the cross-hair Attach Point from each Tracker Point's center to expand the Corner Pin frame coverage, fully obscuring the PDAS's tracker marks.

9 Reduce the size of each Track Point to restrict the search areas – this will help when the track markers become so small.

191

The advantage of repositioning Tracker Attach points is most clear when you have an object with features that must be covered by the tracked overlay. Sometimes the best Track Point will be different from where you need the tracked image to align.

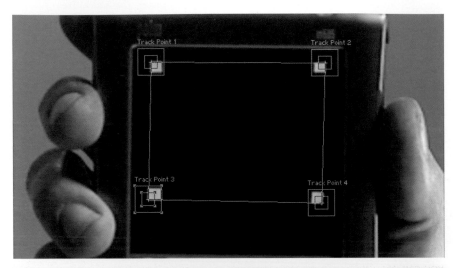

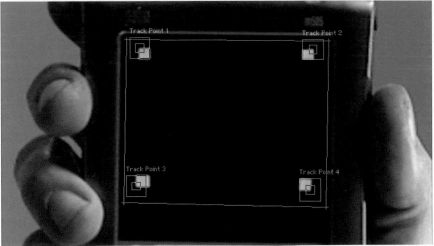

Compare the two images above and you can see how the expanded Attach Points form a more encompassing image area that obstructs the adhered track marks.

10 Run the Track in reverse, then stop it prior to where the Tracker Points run into the screen's edge.

11 Apply the Tracking Data to the *Pulp Mill* layer.

12 Return to the Composition Window and run a Preview.

The Perspective Corner Pin should have worked well enough for this exercise, but if this were a client's project you might have to extend fully the overlay's track, forcing you to manually extend the Track Points offscreen.

This brings up one last important issue with Motion Tracking – fixing aberrant Tracker errors.

When Tracking Goes Awry

The *Palm – CornerPin* footage is a good example of a difficult track due to the PDA track marker's size change. But there are many other far worse problems you can encounter: obscuration by foreground interference, excessive motion blur, extraneous intermittent environmental artifacts (flashing lights), to name just a few.

Revert to the *Motion Tracking.aep* project one more time, then return to the *Pulp Mill – Stabilization* Comp. As we've previously seen, there are many excellent features to track in this shot – and one troublemaker that's hard to track.

In the *Pulp* footage there's a light to the left of the conveyor that becomes obscured by steam billowing out from the machinery. Try to perform a Track Motion on this feature and you'll quickly discover that it's not so simple a task.

193

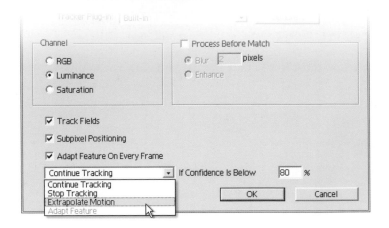

1 Add a Null to the Comp.

2 Open *Pulp Mill.mov* in the Layer Window and set up a **Track Motion** > **Transform** > **Position**.

3 Set the **Edit Target . . .** to the Null.

4 Place the Track Point over the steam-blocked light and make the Feature and Search boxes relatively small to limit interference as you run the track.

5 In the **Options . . .** dialog, activate **Luminance**, **Track Fields**, and set **Adapt Feature On Every Frame** to **Extrapolate Motion**, then 'OK'.

6 Run the 'Track Forward' and watch the disorder ensue.

The Track holds for about 40 frames then loses lock, even with the Adapt Feature option on. Times like this call for manual adjustment and Single-Frame Tracking.

7 Reset the Track Controls, jump to frame 25, and again place the Track Point over the light.

8 Zoom into the image 400% (press the Period key twice) and adjust the Track Point's boxes tightly around the feature.

9 At frame 25, click on the Single Frame Forward to set your first Tracker Keyframe.

10 Use the keyboard's Page Up and Down (PgUp, PgDn) buttons to advance the Layer Window's CTI three to five frames.

11 Reposition the Tracker Point manually using the mouse to re-center over the feature; be ready to use 'Ctrl + Z' to Undo any errors you make when moving the Track Point.

12 Repeat steps 8 and 9 using your good judgement to what constitutes an acceptable loss of lock – try using the Single Frame Forward button now and then to see if the feature is clear enough for an automatic track.

13 At approximately frame 85, deactivate the **Option > Adapt Feature . . .**, then resume the continuous Track Forward until it loses lock again.

After a while the Tracker is all in turmoil – to resume manual Tracking you'll need to remove some of the previously gathered data. The Tracker stores its track info in the *Pulp Mill.mov* layer's Timeline. Open the layer (press 'U' to reveal all Keyframes) to examine all the Tracker data Keyframes created so far (seen below). The first half shows the intermittent manual tracks, while from 85 onward are the sequential automatic tracks. To correct the bad data, delete the offending Keyframes, then repeat your track beginning from the point of the first deleted frame.

Occasionally the Track might throw a sporadic wig-out and then return to normal. For those spikes, manually place the Tracker Point back centered on the feature. However, keep alert to the Tracker's Attach Point cross-hairs – this

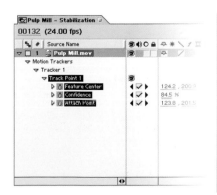

needs to be kept in line with the track path as a whole. When the Tracker goes off half-cocked, the Attach Point goes with it.

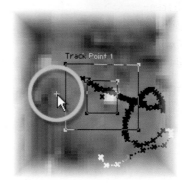

14 Use the cursor to select all the Keyframes from about 120 onwards, then press 'Delete'.

15 Return to the Layer Window and resume the track process, using the Track Forward button this time.

16 Once complete, scrub the CTI to find any aberrant Tracker Keyframes, then re-center them atop the feature – be sure to place the Attach Point back in the center of the Tracker where needed.

17 Once all the latter Tracks are complete, jump back to frame 25, then run a Reverse Track to finish the process.

18 Apply the Tracker's data to the Null, then return to the Comp Window to review the track by scrubbing the CTI – look for any additional bad tracks that need to be manually adjusted.

From now on, you can simply adjust the Null's position to correct for any Tracking errors. But once you select the Null layer, the footage becomes obliterated by countless Tracker Keyframes and its path. Open the > **Edit** > **Preferences** > **Display** dialog to disable the 'Motion Path'. You can then resume your manual repair of the bad track and use the Null as a Parent for whatever element you need to add to the scene.

Tracking is an art on which some people spend weeks or even months perfecting the motion. For many clients, nothing but perfection is acceptable. One bad frame can ruin an otherwise transparent illusion, bringing attention to the effect rather than the effect blending surreptitiously in the scene.

The application of Tracker data is wide and deep: from the obvious attachment of an animated object to real footage, to the correction of color and flicker by tracking areas of an image that should remain constant in luminosity

Once you master Motion Tracking, your project will enter a whole new design realm, where the footage does the work for you.

Typography

Designers have had a long-running affection for creating typographic animation in After Effects. That affection became an obsession when the Type Tool was introduced in version 6.0. With its diverse set of animation functions, the Type Tool offers tremendous flexibility in font manipulation, word construction, and path flow.

However, along with that affection for typographic effects exists a disdain for After Effects' previous method for programming complex mathematical and associative event actions – Motion Math. Though its complexity was marginally founded, a replacement for its functions has been developed with greater simplicity. Expressions has all of the deeply rooted programming capabilities (and more) of Motion Math, but its usability and approachability is an order of magnitude easier to grasp – all you have to know is how to use the Pick-Whip.

The need to understand typography is clear – designers use text elements every day – but the need to know Expressions may seem too advanced for the sporadic times you may think it will be called upon. You would be wrong – many designers (from beginner to advanced) have added Expressions to their 'must have' repertoire, using it as often as Precomping and Drag and Replace.

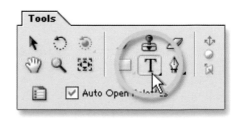

Type Tool Settings

Typography in After Effects used to require all design preparation in either Illustrator or Photoshop, or by using one of the Effects plug-ins available in the Pro version. And though the toolsets in Illustrator and Photoshop are strong, imported text is inflexible – incapable of simple alteration or animation. The Effects plug-ins have animation options, but can't approach the simplicity and flexibility of the Type Tool.

In a previous section the Type Tool's controls were described, as was a quick example of using the built-in Animation Presets for Type. Now we'll expand on those lessons with examples of how to build your own custom self-contained typographic animations.

1 Open *Typography.aep.*

2 Toggle 'on' the first layer to see the text reference that needs to be created.

3 Activate the Type Tool (Ctrl + T).

4 In the **Character** menu, select a **Font** (Bullet-SmallCaps was originally used) similar to the reference.

5 Set the **Fill** color chip by using the eyedropper to sample the burgundy color in the example.

6 Click on the **Stroke** color chip, then use the eyedropper to sample the dark blue text outline.

7 Set the **Size** to '75', the **Stroke** weight to '6 px' with **Fill Over Stroke**, and **Tracking** to '−40'.

8 Click the **Small Caps** option 'on' (circled in the first figure on the previous page).

9 In the Paragraph menu (behind the Character menu), select **Left Justified**.

10 Set the CTI to the first frame (Home), then click inside the Comp Window near the existing reference Name text.

11 Type 'Alec t. sponsleR' with two spaces preceding and following the middle initial.

12 Temporarily lock the new text layer in the Timeline.

By typing the Name with the first and last letters capitalized, you're taking advantage of the automated Small Caps function, saving you a few steps resizing the non-capitalized characters.

For the Title text above the Name, repeat the previous steps using the following settings:

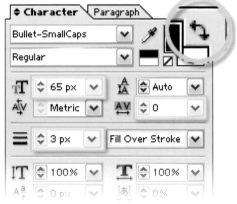

13 Set the font **Size** to '65', reset the **Tracking** to '0', and change the **Stroke** weight to '3 px'.

14 Click on the **Swap Colors** arrow, then change the **Stroke** color to white.

15 Type the Title 'anykey puncher' above the Name.

16 In the Timeline, drag the new layer below the Name text layer.

17 With the cursor, activate the Select and Move Tool (do not press 'V' or you might replace a Type layer with a 'V').

18 Unlock the Name text layer, then drag each Type layer to align it with its corresponding Text Reference.

19 Turn 'off' the original Text Reference layer, then save your work as *Type Over Cute Kid.aep*.

Select the Name layer and twirl open its main properties arrow (next to the layer Color tag), followed by the > **Text properties** > **More Options**.

In the More Options area, change the global **Fill & Stroke** setting to 'All Fills Over All Strokes'. These three options alter the Fill & Stroke of each letter as one master setting:

A **Per Character Palette** – maintains the individual Fill & Stroke settings for each character; characters overlap.

B **All Fills Over All Strokes** – overrides the individual settings with the Fill color taking precedence in the foreground.

C **All Strokes Over All Fills** – overrides the individual settings, with the Stroke color overlapping the Fill.

Type Tool Animation

The Type Tool offers an incredible set of animation options to apply to individual letters, whole words, and compete text lines. Keeping with the style of the existing GridBall logo animation, the Name and Title need to be introduced with extra oomph.

1 Continue with the project (or open) *Type Over Cute Kid.aep*.

2 Solo layer 1 to speed up the design process.

3 Twirl open the Text property (press the ` (grave accent key) next to the '1' on the keyboard), then twirl open > **Text**.

4 Click on the **Animate:** arrow to open the Animator menu.

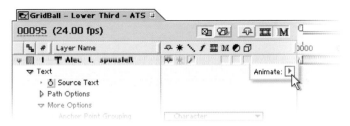

Basically, every property available to layers in the Timeline is available to each individual character of a text object, whereas previously, to animate individual letters in a word or sentence, you had to isolate each character or word as its own layer then animate each layer – this could lead to a Timeline with zillions of separate text layers.

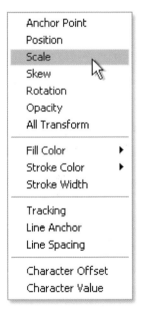

5 From the **Animate:** list select Scale.

6 Twirl open **Range Selector 1**.

7 Depending on the font selected, set the **Start** marker to ~37%, the **End** marker to ~49%, the **Scale** to 200%, and the Offset to ~27%.

Look at the text in the Comp Window. You'll see two vertical lines with small arrows along their centers. These indicators mark where an animation effect **Starts** and **Ends** along the text. The **Offset**

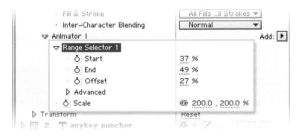

value applies an equal change to both Start and End simultaneously, shifting the **Range** of the markers either direction along the text. The example currently shows the middle 'O'

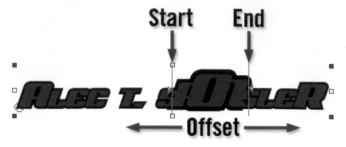

enlarged 200% as the other letters between the Range Selector indicators stay at 100%.

Try sliding the Offset value to see how it affects all characters across the Name.

To animate the Name into the scene, the characters should begin extremely large then zoom down into position.

8 Change the **Offset** to move the Range Selection so the first character in the Name is largest.

9 Set the **Scale** to 400%, then go to frame 24, and activate the stopwatch on Offset to add a Keyframe.

10 Jump ahead 24 frames and drag the Offset value until the last character enlarges and then returns to its normal size.

11 Rename *Animator 1* as *Scale-In*, Increment and Save your work, then make an RAM Preview.

A slight pause is seen as the characters rescale across the empty spaces between the initial. This is because Offset is including the blank spaces as if they were characters in the animation – this pause breaks the flow and thus needs to be eliminated.

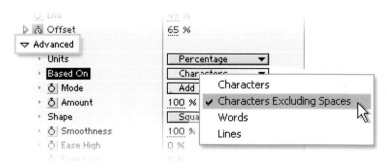

12 Twirl open the **Advanced** (under **Offset**) property in *Scale-In*.

13 Click on **Based On** and select 'Characters Excluding Spaces'.

14 Run another RAM Preview.

Now the characters flow from one another to the next without any pauses at the spaces; however, they sequentially grow then shrink. You want each character, one after the other, to first appear at 100% and then shrink into position. For this effect, an **Opacity** animator is needed.

15 Add another **Animate:** option > **Opacity**.

16 Rename the animator to *Opacity-In*.

17 Reduce the **Opacity** to 0%.

18 Twirl open the **Range Selector**.

19 Jump the CTI to align with the first Keyframe of the *Scale-In* animator.

20 Advance the **Start** marker until only the first character is fully resolved.

21 Set the **Start** stopwatch to add the first Keyframe.

22 Jump the CTI to the last *Scale-In* Keyframe.

23 Advance the **Start** marker to 100%.

24 Twirl open the **Advanced** property and change the **Based On** to 'Characters Excluding Spaces'.

25 Save and Preview.

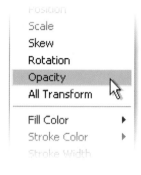

If you had not changed the **Based On** setting to match the *Scale-In* setting, the characters would not have appeared correctly.

The effect still needs one more animator, **Position**, to finish the sequence and

a few Expressions to expedite our Offset animation. The Expressions will link the corresponding properties from the *Scale-In* animator to the new Position animator.

Expressions – Parenting for Properties

Expressions are not the complicated 'Command Line'-driven instructions that only programming geeks understand – think of them as techniques to Parent Properties instead of Parenting Layers. This example will provide a quick introduction on the power and simplicity of Expressions.

26 Add **Animate:** option > **Position.**

27 Rename the animator as *Repo*, then twirl open the Range Selector.

28 In Advanced, match the Based On setting to the other animators.

29 Set the vertical Position to '25'.

30 Select Start, End, and Offset, then apply an Expression to each by selecting in the main menu > Animation > Add Expression, or alternatively use the cursor to 'Alt + click' on each stopwatch icon.

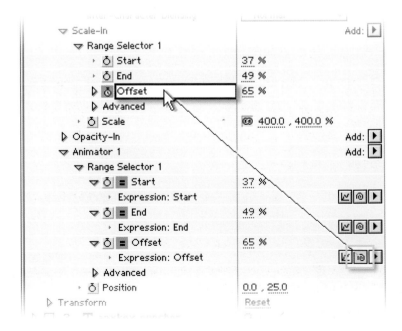

31 Twirl open all three Expressions and drag each Pick-Whip (center button with the whirl icon) up to a corresponding property in *Scale-In*.

Expressions are that simple – you drag the **Pick-Whip** from the property you want to control to the property you want to use as the reference – and they don't even have to match functions: Positions can control Rotation, Opacity can control Scale, etc.

Drop Shadows the Easy Way

It's as ubiquitous as camera shake, motion blur, light bursts, and lens flares. The Drop Shadow is another of the overused and little respected effects all designers rely upon. There are many ways to make Drop Shadows, as shown in previous sections. But the simplest method is to use the Drop Shadow Effects filter:

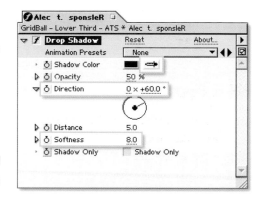

32 Select Alec t. sponsleR layer.

33 Add the Drop Shadow filter > **Effect** > **Perspective** > **Drop Shadow**.

34 With the eyedropper, select a dark blue from the background.

35 Change the **Direction** to '+60.0 °'.

36 Adjust the **Softness** to '8'.

Now the only procedures left to finish the text build are: add **Motion Blur** and change the **In Point** of the whole layer.

37 Activate the Text layer's **Motion Blur** switch.

38 Go to the first Keyframe of all the animators and press 'Alt + [' to set the layer's **In Point**.

39 Save then Preview the final sequence.

40 Oh yeah – repeat everything above for the Title layer, and add a Drop Shadow from the Name, and make it quick! I've got a 'T-off' in 20 minutes. I need to practice my cussing.

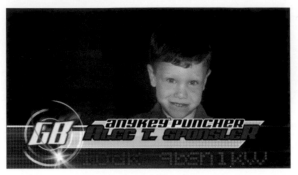

Son with good hair day

Paint by Numbers

After Effects comes with two methods for Painting directly upon your canvas: Non-destructive Bitmap Paint and Vector Paint. Whereas the Vector Paint tool is only available with the Pro version, the Bitmap Paint Tool is standard. The two Paint functions have similar capabilities and operation:

Paint – Permits direct bitmap-like Painting upon images within the Layer Window in a non-destructive mode where each touch of the Paint Brush is individually adjustable. It offers many of the same capabilities as Photoshop's Paintbrush, Airbrush, and Clone Tools, but it can do one thing Photoshop can't: Animated Rotoscoping of your Paint strokes and the brushes' attributes, with varied playback speed of the strokes. With Paint you can:

- Freehand draw upon any image, movie clip, layer, or Precomp
- Erase to reveal the image you paint upon, or the layers beneath
- Clone an image area from the same layer or from a different layer – you can even offset the time from where the source is derived.

Vector Paint – Behaves like the Paint Tool; the brushes offer some unique effects that the Paint Tool can't achieve. Each touch of the Vector Paint brush is added to any previous illustration, preventing individual modification of each stroke. The Vector Paint Effect Tool is applied in the

Comp Window rather than in the Layer Window. The Vector Paint Tool is best for:

- Creating organic flowing paint strokes that can be animated with unusual properties that the Paint Tool does not employ
- Rotoscoping on images with a more graphic illustrative style.

Both Paint Tools have some common capabilities and achieve similar results, but it's their differences that will determine the appropriate tool for different circumstances. For this section, we'll focus upon the Paint Tool's Air Brush and Clone functions, then look at Vector Paint's Erase and Wiggle Control.

Paint Tool – Write On

The standard Paint Tool behaves just like Photoshop's brushes, and even has the ability to respond to a Wacom tablet's pressure-sensitive pen. Using the Paint Tool doesn't require an artist's accreditation, just a Layer Window (your canvas) and the curiosity to play with paint like any kid.

One of the more common uses of the Paint Tool is to have a design progressively Write On the screen or reveal some letters of a logo as if they were being painted on the screen. Since the process of creating animated paint strokes on the screen is similar to making letters appear, we'll just draw a quick picture and animate strokes on it to introduce the concepts.

Select the Paint Tool (Ctrl + B) in the Tool Window. The Paint palette opens and is displayed as a tabbed menu along with the Brush Tips.

- **Opacity** – transparency of the brush's paint color; overlapping continuous strokes maintain a constant opacity.
- **Flow** – density of paint applied; overlapping strokes build up to make heaver strokes.
- **Brush Size and Style** – click on either the Brush Tip icon (next to Opacity) or on the tiny down arrow to access Brush Tip presets.
- **Mode** – the Blending Mode for the paint, just like a layer's Blending Mode.

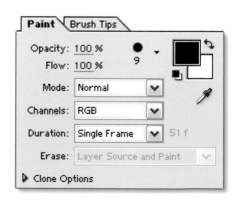

- **Channels** – paint on the Color, Alpha, or both channels.
- **Duration** – methods of how the Paint Brush records your action over time, with several operating options:

| Constant |
| Write On |
| Single Frame |
| Custom |

 - **Constant** – the stroke appears always
 - **Write On** – the stroke is recorded as you draw, then can be played back at any reveal rate you wish (forward or reverse)
 - **Single Frame** – you manually advance the clip to each frame you need to draw upon
 - **Custom** – sets how often the clip advances with each stroke.

The **Write On** process is very simple and will make you smile:

1 Begin with a New Comp (Ctrl + N) titled *Right On!* at 640 × 360 at 24 fps.

2 Create a Solid white layer, then double-click on it to open in the Layer Window.

3 Select a **Brush Tip** that's solid and size 19.

4 Set the **Duration** to 'Write On'.

5 With the CTI at frame 0, draw a big circle in the center of the Layer Window's screen.

6 Select the White Solid layer and press the 'U' key to open the layer's > **Paint** > **Brush 1** > **Stroke Options** animated Keyframes.

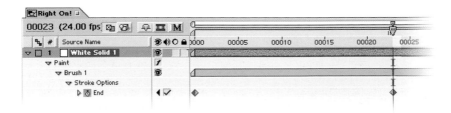

When you finish the circle it disappears. This is because the CTI is still located at frame 0 of the Timeline. Scrub the CTI to view the circle as it animates on.

7 Set the CTI to the last Keyframe of the circle 'Brush 1' stroke.

8 With the 'Brush 1' stroke *not* selected, draw a smile inside the circle.

A new Brush Stroke is
added to the layer's Paint
property. This new
Timeline Bar begins at
the CTI and has two dots
located inside its gray

bar. These are Keyframe markers indicating where the new Stroke begins and ends.

9 Advance the CTI to align with the **End** Keyframe indicated in the bar of 'Brush 2'.

10 Draw two eyes in the circle to finish the face.

This time the CTI was not moved after drawing each eye, thereby permitting both eyes to draw on in unison. Scrub the CTI back and forth to make the smiling face Write On and Off.

Paint Tool – Single Frame Rotoscope

This tool behaves just like Photoshop's brushes, and even has the ability to respond to a Wacom tablet's pressure-sensitive pen. Unlike the Vector Paint Tool, this brush only works in Layer Windows.

1 Open *Bouncing Smiley.aep*.

2 Advance the CTI to frame 12.

3 Select the Paint Brush Tool (Ctrl + B), then open the Paint palette to choose your **Brush** options.

4 Select a solid brush 13 pixels round and set **Color** to black.

5 The **Duration** should be set to 'Single Frame'.

6 Double-click on layer 1 to open *Bouncing Ball.mov* in the Layer Window.

7 Change the **View** selector in the Layer Window to 'Levels'.

8 Draw a smile and eyes on the ball.

9 Press 'Page Down' to advance the frame.

10 Repeat until you tire of this exercise.

This may not have been the most elegant illustration of Rotoscope Painting; that's because this would be the 'hard way' to Rotoscope. There are functions to make this process less tedious.

Paint Tool – Animated Brush Strokes

To simplify and automate the Rotoscope Paint process you can create Keyframe animations of your brush strokes. So, instead of drawing the face frame by frame, you need only to draw the Keyframes and let After Effects do the In-betweening for you.

11 Revert to *Bouncing Smiley.aep*.

12 Return to frame 12 and, using the same Paint Brush settings as before, draw the face again.

13 In the Timeline, twirl open > **Effects** > **Paint** to reveal the Brush Stroke properties.

The smiley face is composed of three Brush Strokes: the smile and two eyes. Each stroke has a Timeline Bar beginning at frame 12 and lasting only one frame (matching the Single Frame option). Their duration, along with many parameters, is easily modifiable.

14 Twirl open all three Brush Strokes.

15 Activate each **Shape** property's stopwatch (the CTI should be set to frame 12, the 'In Point' of each Brush Stroke).

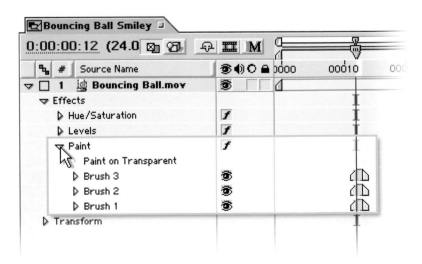

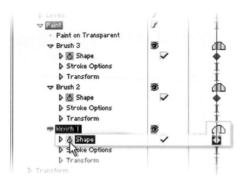

16 Advance the CTI where the ball first strikes the bottom of the image frame – frame 24.

17 Drag the 'Out Point' of each Timeline Bar right to expand the animated stroke's effective range.

18 Click on 'Brush 1' to select the original smile Brush Stroke.

19 At frame 24, draw a variation of the smile on the ball; a new Keyframe is added to the Brush's Timeline Bar.

20 Scrub the CTI across the animated range and the smile morphs into the new face.

21 To animate each eye, repeat the selection and drawing procedures.

Any time you draw on a selected Brush's Shape, you modify that Shape's stroke. When the Brush shape is first selected, the previous stroke is displayed as a path (seen right), providing you with a reference

of its previous position and shape. To add a new stroke, deselect the Brush being modified, select the Paint Brush Tool (Ctrl + B), then draw anew.

A note for Wacom or pressure-sensitive pen users: the Paint Tool takes full advantage of these pens' capabilities to detect pressure and tilt. You can draw a line with a thin angled stroke, then make it heavier and change angle in the middle of your stroke. If you apply a Keyframe to this variably drawn stroke, you can animate the thickness and angles. As you draw at the second Keyframe with different pen pressures and tilts, the stroke properties will morph to different thicknesses and angles over the animated Timeline.

Paint Tool – Advanced Options

Each Painted Brush Stroke has individual controls that provide a diverse variety of animated effects. Additionally, each Brush Stroke has a set of individual Transformations, allowing the Brush Stroke's path to be repositioned, rotated, and scaled. Twirl open any of the previously animated smile Brush Strokes, then twirl open the Stroke Options. These options alter your Brush Stroke's illustration:

- **Start** – applying Keyframes to this allows you to define where on the Shape's path the Paint Brush's Stroke begins.
- **End** – defines the point where the Brush Stroke stops.

- **Color** – you can animate the color of the Stroke, but the color change is applied uniformly across the Stroke's path.

- **Diameter** – the brush size is adjustable, but the size change is uniform throughout the Brush's path.

- **Angle** – if you use a non-round Brush, you can adjust the rotation angle of the Brush.

- **Hardness** – defines the Brush edge fall-off; low numbers look like airbrushes while high numbers give harsher edges.

- **Roundness** – defines how circular the Brush Paint Stroke appears; low numbers are highly elongated while high numbers are more circular.

- **Spacing** – determines how closely Paint dabs are drawn along the path; low numbers make the dabs appear as one continuous Paint Stroke while high numbers look like individual drops of paint.

- **Opacity** and **Flow** – the same as the Paint Brush palette's settings.

It's important to understand that even though the Brush's Strokes options are animatable, their property will be applied consistently along the complete path – i.e. if you animate a Brush Stroke that was drawn with varying Brush sizes (drawn with a Wacom), animating the Brush Diameter will alter the whole stroke, making the thin lines thicker and the thick lines really thick.

Vector Paint Tool – Organic Shape Rotoscope

Vector Paint strokes lack the individual properties of the standard Paint Tool. But this tool offers something the standard Paint Brush does not: the Wiggle function, a really fun modifier that twists, bends, and ripples your Brush Strokes. It also has the advantage of working directly in the Comp Window.

1 Open *Bouncing Smiley.aep*.

2 Add a Solid layer of any color to the Timeline.

3 To the Solid layer, apply > **Effect** > **Paint** > **Vector Paint**.

4 In the Effect Controls window, set the following: **Radius** = 8.0, **Feather** = 33%, and **Color** to bright yellow.

5 Set the **Brush Type** to Paint, **Playback Mode** to Onion Skin, and **Composite Paint** to Only.

When the Vector Paint Effect is applied, the Vector Paint Toolbar is added to the Comp Window. This provides quick access to various options and the ability to select Brush Strokes. Unlike the standard Paint Tool, each Stroke you make in the Vector Brush is clustered together. If you want completely individual strokes, you'll need to apply multiple instances of the Vector Brush.

All Strokes
Past Strokes
Hold Strokes
Animate Strokes
Current Frame
✔ Onion Skin

As you paint on the Comp, the program remembers the time it takes you to draw the stroke, as well as the frame number where the stroke was initiated. The Playback Mode drop-down menu offers several methods for your illustration to be viewed and effects to assist in the development process:

- **All Strokes** – displays at once every Brush Stroke painted.
- **Past Strokes** – depending on where the CTI is stopped, displays all previous strokes.
- **Hold Strokes** – sequentially displays each stroke from the point in the Timeline where they were drawn.
- **Animate Strokes** – every stroke draws on at the rate you painted.
- **Current Frame** – single frame animation, with each stroke seen only on the frame where the CTI resides.
- **Onion Skin** – assists with the drawing process, showing previous and next frames of strokes.

The Onion Skin option displays previously drawn and upcoming strokes as subdued

color overlays. You can adjust the duration of the Onion Skin overlay in the Vector Paint Preferences menu in both the Effect Controls window for Vector Paint or by clicking on the small button at the top of the Vector Paint Toolbar in the Comp Window.

6 Advance the CTI to frame 12.

7 Draw sunrays emanating from the ball

8 Advance the CTI two frames.

9 Draw new rays using the old rays for reference.

10 Repeat forwards and backwards for more rays.

11 Save your work as *Macarena Sunrays.aep*.

After drawing several sets of sunrays, review the motion. For the best Playback Mode for the staggered strokes offset by two frames, use the Hold Strokes setting. Then, for a better grasp of the other Playback settings, alternately select each Playback Mode and run previews with each setting.

Now to add a little more pizzazz to this scene – Vector Paint includes a fun option called Wiggle. This applies a random distortion to the vector-drawn paths, creating a more organic flow to illustrations.

12 In the Effect Controls window, enable the Wiggle Control.

13 Change the **Displacement Variation** to 20.00 and **Displacement Detail** to 200.0.

14 Scrub the CTI to see the new result.

Now your sunrays have a more illustrative feel and randomness to their strokes.

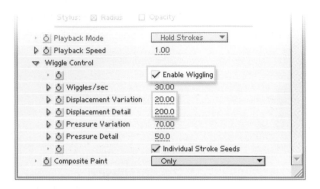

Sun with bad hair day

For a real shock, increase the Displacement Variation until your drawing looks like the sun has an Afro. Of course, all these parameters are animatable.

Compositing Tips for 3D Animators

Prior to the bestowing of After Effects upon the world of desktop digital content creation, we 3D animators were forced to use anachronistic compositing programs included with their 3D animation programs. However, once I was exposed to the potent elegance of After Effects, I abandoned those kludges in a mouse-click. But to this day, many 3D animators still rely upon (struggle with) their old bundled editing or composting software to accomplish their finishing.

Further still, some create all their visual embellishments within their 3D rendering application, certain that it's the *only* way to achieve the purity of image they seek. They apply distortion, depth-of-field, atmospheric fog, film grain and more, all to produce the style they think can only be achieved within the 3D animations program itself.

When it comes to making my 3D animations, I have one simple axiom: make the 3D renderings as clean as possible, render them oversized, and keep the ray tracing restricted to what *has* to be refracted/reflected – it's After Effects'

responsibility to handle the final image tweaking. Whether you're rendering for yourself (you will do the compositing) or for someone else down the production pipeline, use this section as a reference to apply better rendering habits and get jobs done faster.

Over-Rendering

A common misconception that too many animators have ingrained is: render your images at the size you intend to view. For some instances this is fine – when you know with certainty how the file is going to be used, or when the renderings are intended for review purposes. For the vast majority of 3D work I've created, I always Over-Render.

Over-Rendering is quite simply rendering a larger screen area than is needed and rendering at a higher resolution than the output frame size. Think of the combination as the Extra-Safe Area.

Take, for example, the following series of frames. The project required a talking golf club, where its 3D eyes and mouth needed to blend seamlessly into the real puppeteer-manipulated footage. To ensure that the images would align with the live-action plates, I rendered the animation at double the source footage resolution. This allowed me to cleanly scale the animation into the scene without suffering blurring or artifacting.

Image courtesy of Convergence, Orlando, Florida

Blurring and artifacting are the result of the ever-so-slight resizing and repositioning of images that were rendered to the final project's output size. When you scale Over-Rendered images downwards, they maintain superb integrity, whereas applying minor scale changes to smaller images inflicts substantial subpixel blending distortion. Additionally, you have the option to enlarge your renderings without any degradation should the client want to make subtle changes after all your renderings are complete.

Over-Rendering also includes the concept of rendering more than you intend to show. Take, for example, rendering a large 3D environment set where other objects will be composited within. If you render only what you think will be used at compositing time, you are restricting the designer to your estimate. The next image shows a set built for an HD short AniMill created for R&D purposes. The washed area beyond the green box represents unused Over-Rendering. We would often render scenes with Overshot to allow the compositor (me) to reposition the set or add shake to the shot without the edges of the scene becoming visible.

With the abundant supply of hard disk storage, there's only one reason *not* to Over-Render – rendering time, of course, can be the deciding factor to how much you Over-Render, if at all.

Dawn's Early Flight. © 2002 AniMill

Field Rendering

Another fallacy is that you only render with fields at the actual output size of the finished product. Hogwash! You can render with fields for 32 × 24 pixel movies as effectively as you can render fields for 2048 × 1536 sequences. Fields are not the exclusive domain of DV, 601, or PAL sized images.

Though some 3D animators would disagree, Field Rendering can and *should* be used wherever fast-moving objects that need to be clearly perceived are intended to be viewed on a field playback medium. Case in point: text that is moving quickly but must be readable. Or perhaps your client's spinning logo needs to be as clean as possible, but you still want to Over-Render it so it can be repositioned for other uses.

By activating Field Rendering, then properly Interpreting the footage when imported into After Effects, your Over-Rendered footage will be easily manipulated and still possess the smooth motion that Field Rendering provides.

Of course, if all you do is animate for film output or 24P digital cinema, this Field Rendering issue (not the Over-Rendering) is moot.

Render Elements and Layers

Rendering 3D animations as shaded Elements is a powerful and flexible method of achieving photo-realism or to apply stylistic illustrative effects. Rendering shaded Elements is where each visual component of an object's 3D surface is separated into its shading fundamentals.

The images below illustrate some examples of Render Elements, with the top image displaying the finished composite:

A	**Diffuse** – the base color and brightness layer.
B	**Self-Illumination** – items that emit light of their own.
C	**Reflection** – the scene as reflected off objects' shiny surfaces.
D	**Specular** – bright highlights bouncing off the shiny surface.
E	**Shadows** – the areas darkened by obscured light.
F	**Z-Depth** – the scene's 3D space.

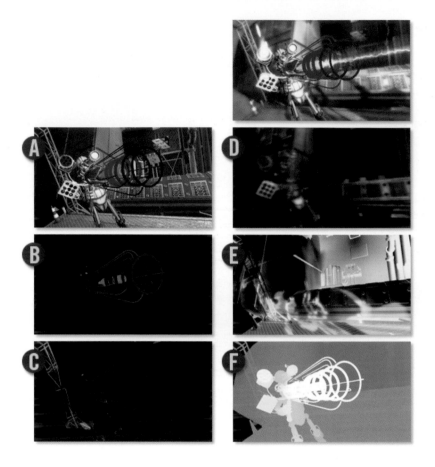

For the scene shown previously, we separated not only the Shaded Elements but also the objects that were rendered, with their Render Elements activated, as individual passes. This made for quite a few layers in the After Effects Comp. But it also allowed me to maintain tight control over how each element was Blended and how Effects Filters were applied.

It takes more forethought to prepare a multi-Render Elements sequence, but the improvement in compositing control and the final results are well worth the extra time and effort.

Ray Tracing for the Rest of Us

My final recommendation to the stalwart 3D animator who intends to render zillions of refractions and reflections in their flying glass logo is this: *don't do it*!

There are times when scenes demand that you utilize the power of your 3D application's Ray Tracing capabilities. But more often than not, complex refractions and reflections can be emulated by using several built-in Effects Filters. The most basic example of this Ray Cheating is to use the Turbulent Displace Effects Filter.

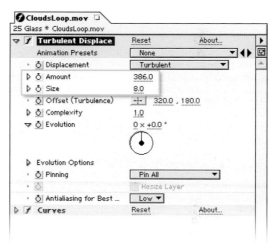

1 Open *Ray Cheating.aep*, then go to frame 48.

2 To layer 2, add > **Effect** > **Distort** > **Turbulent Displace**.

3 Scale (S) layer 2 up to 125%.

In the Effect Controls window, adjust the **Amount** setting to 386 and the **Size** to 8.0.

This applies a severe distortion to the expanded clouds. You next will need to add a Curves adjustment to make the logo stand out from the background even more.

4 To layer 2, add > **Effect** > **Adjust** > **Curves**.

5 Click in the center of the diagonal line to add a vertex, then drag that vertex slightly upper left.

6 In the **Channel**: drop-down menu, select Blue.

7 Again, add a vertex and drag it slightly upper left.

The 25 logo is now floating in the sky, refracting the clouds as if it were made of glass.

This, of course, is a very rudimentary example. Had this been an actual glass logo animation, you would have been instructed to render each bevel and edge with separate masks so additional layers of refraction could be applied.

And that is the gist of the Ray Cheating concept: you only need to render masks of each face section where refractions or reflections are seen, then use these masks in After Effects.

You can even take this process further by utilizing your object's Normals as a source of distortion when using other effects, such as **> Effect > Distort > Displacement Map** or **> Effect > Simulation > Caustics**. I could spend a few pages on Caustics alone, but we're running out of time and need to move on to the *coup de grâce* – Rendering and Output, where you learn how to deliver your finished project.

A Little Nod of Admiration: Though I love the artistry of great 2D and 3D animation, I am actually more astonished and impressed by the motion picture visual effects compositor's often disregarded contribution to 'finishing' the film. Their critical and imperceptible work separates the truly great visual effects from the ordinary and deserves more credit than they receive.

RENDERING
AND OUTPUT

AfterMath

This stage of After Effects is the closest thing you get to pressing the 'Make Art' button and *presto!*, out pops your masterpiece. Here is where all the creativity, hard work, and exhaustion come to fruition. And it's here that you'll quickly discover whether you need to buy another, faster computer or invest in a Render-Farm.

The Render Queue – The Reel Finishing Line

Open the project *RenderMe.aep*. The Render Queue instructs After Effects how and where to build your project, what to do with it after it's complete, and monitors the progress of Renderings.

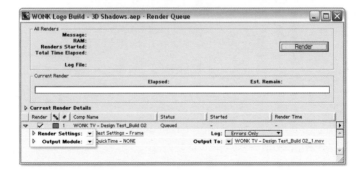

The Render Queue consists of two modules:

- **Render Settings** – determines the technical operations to be performed as the render progresses.
- **Output Module** – assigns the file format options and additional operations to be applied to the file as it is recorded.

To display detailed information about each module's current settings, twirl open the arrows next to each module title.

Render Settings

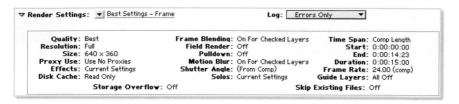

The first module, **Render Settings**, is essentially the opposite of the Interpret Footage dialog for imported resources – it's the *Export Interpretation* settings menu. With this module you assign your project's: quality, size, output time range, interlace options, and whether or not additional composition effects are applied. Many of the Render Settings' options can be left to 'Current Settings' or their default settings. However, some settings must be activated and modified in order for your project to look and perform its best.

Output Module

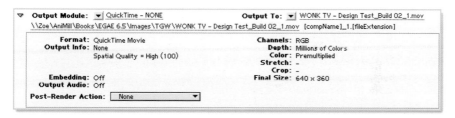

The second module, **Output Module**, tells After Effects what to do with the finished rendered frames. It also allows for one last image-processing pass prior to frames being stored to the output media. Further, you can have more than one Output Module per project creating alternate output versions with different file types and sizes in one Render Queue pass.

> **Rendering Tip:** If you find that your project is running out of memory during the Rendering process, you can press the Caps Lock key to prevent After Effects from updating the Comp Window, thereby reserving some extra memory for your Rendering.

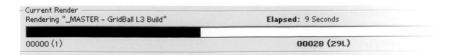

Rendering Your Project

It may seem that the Render Queue is more complex than necessary, but it's actually quite simple to use – especially if you put in a little pre-planning and create some preset Templates for both modes.

To learn about **Output and Rendering**, many of the preceding chapter exercises were developed specifically to demonstrate the variety of output formats you will encounter.

There are certain fundamental questions to answer prior to Output: Progressive or Fields? Square Pixels or Anamorphic? Frame Rate? Playback Medium and File Format? How fast do you need it done?!? Hopefully most of these questions were already defined *before* you began production.

As you've progressed through this *Easy Guide*, several example projects were created and now are in need of rendering, each with a specific Rendering requirement and each an example of common Output modes.

1 **Import & Replace Usage** – Pre-Render Precomps.

2 **Multiple Output Modules** – 29.97 fps Anamorphic Field Interlaced.

3 **3:2 Pulldown** – Square Pixels Letterboxed.

4 **Export to Flash Animation** – SWF File.

Scenario 1: Import & Replace Usage – GridBall Pre-Render

There are two mindsets necessary to work most efficiently in After Effects:

- Render everything when the project is complete
- Render 'as you go' using Import & Replace Usage.

Both options have certain advantages over the other: Rendering everything at once is best for short-form and less complicated projects, while Pre-Rendering with Import & Replace is most effective where Precomps are shared often and when projects become unruly and too massive, placing high demands on your CPU and RAM.

1 Open *GridBall – Import & Replace.aep*.

2 In the Project Window, twirl open the Precomps folder.

3 Select *_MASTER – GridBall L3 Build*.

4 Add the Precomp to the Render Queue by pressing 'Ctrl + Shift + /' or by selecting from the main menu > **Composition** > **Add to Render Queue**

5 In the **Render Settings** section, press the drop-down menu arrow to select 'Best Settings'.

The Best Settings template sets the most common options to their highest quality modes, but as its default will only render the Timeline's Work Area (the area of the Timeline defined by the Begin (B) and End (N) markers) and renders as Frames, not fields. The whole purpose of **Import & Replace** is to Pre-Render a Precomp, and then *wherever* that Precomp is used in your project it replaces the Precomp with the new Pre-Rendered movie.

For this example, we're going to assume that the final project will be Field Rendered using Lower Fields; therefore, our Precomp should also be Pre-Rendered as Lower Fields.

6 Click on the 'Best Settings' template name to open the Render Settings dialog.

7 In the **Time Sampling** section, change the **Field Render:** to 'Lower Fields' and set the **Time Span:** to 'Length of Comp', then press 'OK'.

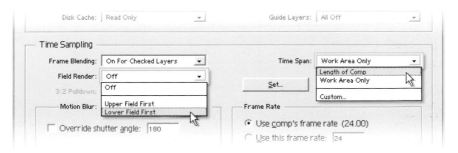

8 In the **Output Module** section, press the drop-down menu arrow to select 'Lossless'.

9 Click on the 'Lossless' template name to open the **Output Module Settings** dialog.

The Output Module Settings dialog offers several options for file format and additional post-processing. We'll first change **Format:**, then alter the **Format Options . . .**, then set the **Post-Render Action:** that will automatically perform the Import & Replace function.

Output Module Settings

Based on "Lossless"

Format: Video For Windows

Embed: Project Link

Post-Render Action: None

☑ Video Output

Format Options...

No Compression

Starting #: 24 ☑ Use Comp Frame Number

Channels: RGB

Depth: Millions of Colors

10 Click on the **Format:** drop-down menu and select 'QuickTime Movie'.

11 Click on **Format Options . . .** to open the **Compression Settings** dialog.

PCX Sequence
PICT Sequence
PNG Sequence
Photoshop Sequence
Pixar Sequence
QuickTime Movie
RealMedia
SGI Sequence
TIFF Sequence
Targa Sequence
Video For Windows
Windows Media

12 Open the drop-down menu, select 'None', and set the **Depth:** to 'Millions of Colors +' to include the Alpha Channel when rendering, then press 'OK'.

13 In the Output Module Settings dialog, open the **Post-Render Action:** drop-down.

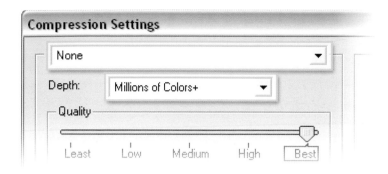

14 Select 'Import & Replace Usage'.

15 Press 'OK' to exit the dialog.

The last procedure is to assign both a name and location to record your Pre-Render movie.

16 Click on the **Output To:** file name already displayed in blue.

17 In the **Output Movie To:** dialog, navigate to where you want your Pre-Render Movie to be saved, then type the name you wish to save or simply use the default name, which is based upon the Comp's name.

18 Press 'Save' to set the file name and destination.

19 Save your project as *GridBall L3 Pre-render.aep*, then click on the 'Render' button in the Render Queue.

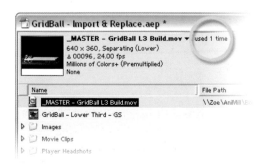

Once the render is complete, return to the Project Window. The completed Pre-Render has been Imported and the Information thumbnail shows that the file is 'used 1 time'. Right-click on the Imported file and select > Reveal in Composition > GridBall – L3 – GS, Layer 2 to show where it's been used.

Scenario 2: Multiple Output Modules – 29.97 fps Anamorphic and Fields

The ability to simultaneously Output different files while performing one Render is a really convenient function of the Render Queue. For this example we'll be finishing the WONK TV Logo Build begun early in the book and Outputting it as an Anamorphic DV file and Low-Rez web downloadable review file.

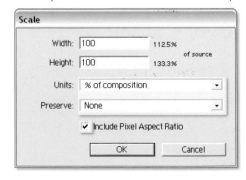

1 Open *WONK Logo Build – 3D Shadows.aep*.

2 Select *WONK TV – Design Test_Build 02* in the Project Window.

3 Drag the . . . *Build 02* Comp onto the **New Composition** button.

4 Rename the new Comp to *WONK Output*.

5 Modify the Comp's Settings (Ctrl + K) and select the **Preset:** 'NTSC Widescreen, 720 × 480'.

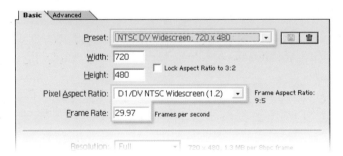

The Comp is now set to Anamorphic 16:9 DV movie specifications. The only problem is that the original *WONK TV* Precomp does not fit within the new Comp.

6 Open the Precomp layer's Scale (S) property, then right-click on the Scale values to open the Scale dialog.

7 Set the **Units:** to '% of comp' and **Preserve:** to 'None', then set the

Width: and **Height:** to '100%' each and check the Include Pixel Aspect Ratio box, then 'OK'.

You might be wondering how it is that the original *WONK TV Logo Build Comp*, which runs at 24 fps, can simply be dropped into a new Comp with a different Frame Rate and not suffer frame stuttering at playback. After Effects is an intelligent program; it knows that, whatever your final Comp's Frame Rate setting, all layers residing within as Precomps will replicate that final Comp's Frame Rate – even if they initially have vastly different Frame Rates. The only problem you may experience is with Movie and Sequential files, where they have different pre-set Frame Rates from the final Comp. There are many solutions to this problem, but the simplest is to activate Frame Blending on all Movie and Sequential Files throughout the Comp and its children. But for most cases, just keep your Frame Rates consistent.

8 Add the Comp to the Render Queue by pressing 'Ctrl + Shift + /' or by selecting from the main menu > **Composition** > **Add to Render Queue**.

9 In the **Render Settings** section, select 'Best Settings', then open the **Render Settings** dialog and set **Field Render:** to 'Lower Field First' and click 'OK'.

10 In the **Output Module** section, select 'Lossless' then open the **Output Module Settings** dialog and select 'QuickTime Movie'.

11 Open the **Format Options . . .** and select 'Photo – JPEG' with its **Quality** slider set to 'Best', then click 'OK'.

12 Click 'OK' to set the Output Module.

13 In **Output To:**, assign a name and folder to save your project.

This prepares the WONK TV project for Output to one QuickTime Movie, but we need two files created. The second file will be optimized for the web for client review. Setting multiple Output Modules is very simple: either select the **Output Module** section itself and press 'Ctrl + D' to duplicate its settings, or in the main menu select > **Composition** > **Add Output Module**.

14 Duplicate or Add the second **Output Module** as described previously.

15 Open the **Output Module Settings** dialog for the second module, then activate the check-box in the **Stretch** section, setting the **Width** to '320' and the **Height** to '180', and set the **Stretch Quality** to 'High'.

16 In the **Format:** drop-down select 'Windows Media' (Mac users: try QuickTime with Sorenson 3 Codec instead).

17 Click on the **Format Options . . .** to open the **Windows Media Settings** dialog and select the **Preset:** WM9 NTSC 256K download.

There are numerous adjustments available: pre-processing, encoding controls for video and audio, metadata, and post-processing.

18 Activate the check-box in the **Basic Video Settings** section to 'Allow interlaced processing', then press 'OK' to close the **Windows Media Settings** dialog.

19 Click on the second Output Module **Output To:** file name and set the destination and a new name that will help identify that it's the low-rez **Windows Media** review file.

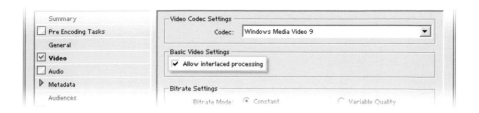

20 Press 'Save' to set the file name and destination.

21 Save your project, then click on the 'Render' button in the Render Queue.

Once done, it's easy to watch your finished work, even if it's located in some obscure destination. Twirl open the **Output Module Details** arrow, then click on the folder link to open the folder in a separate window.

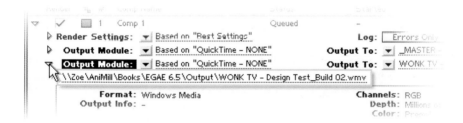

Scenario 3: GridBall Lower Third with 3:2 Pulldown

Our third example is a reprise of the first – *GridBall Lower Third*. This time we'll be rendering the complete project, but with the Pre-Rendered footage already prepared. We'll also be Rendering it at 29.97, so we'll need to convert the 24 fps Comps to 23.976 fps (don't ask!), then let After Effects create the 3:2 Pulldown during the render.

1 Open *GridBall L3 Pre-render.aep*.

2 Select *GridBall – Lower Third – GS* in the Project Window and drag the Comp onto the **New Composition** button.

3 Rename the new Comp as *GridBall – L3 GS Output*.

4 Modify the Comp's Settings (Ctrl + K) and select the **Preset:** 'NTSC D1, 720 × 486'.

This is the 601 component digital video standard for professional Post-Production Studio Switchers, VTRs, DVRs, and DDRs. Our GridBall graphic expands to cover most of the screen width, with Letterbox bars at the top and bottom.

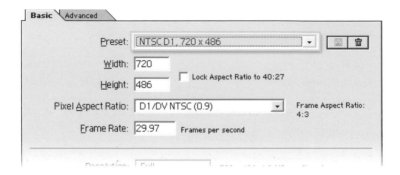

5 Add the new Comp to the Render Queue (Ctrl + Shift + /).

6 Open the **Render Settings** dialog and set the **Field Render:** to 'Lower Field First', then open the **3:2 Pulldown:** drop-down menu and select 'WSSWW'.

This is the command to render the project that converts 24 fps Comps to 30 fps movies. The Appendix on 'Practical Concepts of Things You Need to Remember' has an explanation of the 3:2 Pulldown process.

7 Keep the project's **Time Span:** set to 'Work Area' for this example, then press 'OK' to close the dialog.

8 Set the **Output Module's Format:** to 'QuickTime' and the **Format Options:** to 'None'.

9 Select an **Output To:** name and folder, then save the project and press **Render.**

Watch the Comp Window as it renders and you'll see the 3:2 Pulldown in action, with Whole frames followed by two interlaced Split frames, then back to Whole frames.

Because the GB Lower Third graphic was Pre-Rendered the final output progresses quickly. Remember: Pre-Render Good.

Scenario 4: Logo Risen > Flash (SWF)

Our last example is to create a Flash 'SWF' file. The SWF Exporter is a great option for creating client review files for the web. The Flash SWF Exporter in After Effects is a separate function from the main Render Queue.

1 Open *Logo Risen.aep* and select *_MASTER – Logo Rise* Comp.

2 In the main menu at the top, select > **File** > **Export** > **Macromedia Flash (SWF)**

3 A **Save File As** dialog opens – select a name and destination for your Flash file, then press 'Save'.

The SWF Settings dialog opens. In this dialog you can tweak your file settings for optimum file size and performance.

A critical feature to use is the **Unsupported Features** option. Flash prefers using vector-based graphics for best performance, but supports bitmap images. When this option is set to Rasterize, all layers with Mix Modes and Effects applied are first Rasterized into finished frames then converted into sequential image files that Flash can display.

4 Set the **Unsupported Features** option to 'Rasterize', then press 'OK'.

The instant you click 'OK', the Render begins.

To review the finished
Flash file, navigate your
way into the storage
folder, then open the
HTM file created by the
SWF Exporter, or open
the SWF file itself.

Exporting "Logo Risen - Solution.swf"

Frame 36 of 300. See export report "Logo Risen – SolutionR.htm" for details.

Stop

Network Rendering: Get Your Project Done Now!

Once that Render button is pressed, it's time to recompose yourself and prepare for the final result: will it have the impact and intrigue you designed, will it satisfy the client – will it *ever* finish rendering?!

More often than not, projects take longer to render than expected, or allowable. It's time to go Network Rendering.

Network Rendering is the process where you use another computer, or set of computers, to perform your rendering off-line, allowing you to continue working with your main workstation on yet another project. The most common form of Network Rendering involves the use of a Render-Farm.

A Render-Farm is a cluster of network-connected computers, each working on consecutive frames of the same Comp. A Render-Farm can consist of one additional computer connected to your main workstation, to thousands of RenderNodes dedicated to processing After Effects Comps and other animation application projects.

A modified form of Network Rendering can also be performed on a single workstation that supports multiple instances of After Effects open at the same time, thereby functioning like a second computer in a Render-Farm.

Many designers who think they can't afford to Network Render really can – if their main workstation operates as a multi-processor machine. However, if you

have the wherewithal, start planting RenderNodes to increase productivity on a geometric scale.

The following section will offer two scenarios for preparing your projects for Network Rendering offloading:

- **Render-Garden** – where you have one multi-processor (or HyperThreaded) machine to run concurrent sessions of After Effects.
- **Render-Farm** – where you have multiple network-connected RenderNodes working together on complex, deeply layered Comps.

The Render-Garden – When You've Only Got One Machine

Even with what seems like the price of computers dropping every day, many designers simply can't afford to have multiple computers to work upon. This is especially true at big corporate IS controlled environments, where asking for an upgrade is akin to asking for a raise.

If you're one of these 'restricted access to additional machines' people, you can use your lone machine as a little Render-Garden to expedite project output. This way you can render while you work on other projects – though this depends heavily upon the machine you use.

A dual-CPU machine with lots of RAM will perform best with two instances of After Effects running, though a single-CPU machine with lots of RAM will also work, just much more hesitantly.

To prepare your machine to run multiple instances of After Effects, you need to modify the following:

For Mac-OSX

Make a copy of the Application using a different name, i.e. 'AEX-NET' or 'After Effects RenderNode'.

For Windows 2000/XP

1 Right-click on the shortcut link to After Effects and select **Properties**.

2 In the Shortcut tab, after the **Target:** command line text string, add the text '-m', then click 'OK'.

Now you have the option to have a second instance of After Effects open to render your finished projects.

Rendering with a Second Instance of After Effects

If you decide to run multiple instances of After Effects with one copy rendering and the other copy still in production use, be prepared for your computer to get real slow if you don't have enough RAM. Also, if the rendering project places a high demand on the hard drive, your system could suffer more of a slow-down.

Nevertheless, if you've got the power and you're under a time-crunch, any performance hit your machine experiences may well be worth the productivity advantage. Then again, you'll lose your excuse for taking a break while rendering.

The Render-Farm – True Network Rendering

So what exactly is all the hubbub about Network Rendering? Imagine for the moment you have a project that has 1800 frames to render and each frame is taking 5 minutes to complete – not an absurd prospect. Five minutes multiplied by 1800 frames equals 150 hours of rendering (almost a week) on one machine – eeek! Now imagine that you have eight dedicated machines (each with a similar speed as your workstation) on your network, where each simultaneously renders your 1800-frame project. Now the project takes just under 19 hours to compete. Exaggeration? Well, reduce the 1800 frames to 300 frames, a common duration, and the whole shebang now takes

3¼ hours to wrap on an eight-machine Render-Farm versus 25 hours on one machine.

After Effects comes with the license to install multiple copies of its automated Network Rendering application – the Watch Folder Render Engine. This is simply a lite version of After Effects that only permits Rendering of your projects and is intended for installation on machines other than your workstation.

When activated in Watch Folder mode, After Effects will wait patiently for projects to be saved to a common folder, and then render the projects' Render Queue contents.

Installing the After Effects Render Engine

Preparing a RenderNode (Network Rendering computer) requires few special considerations for use with the After Effects Render Engine. The Render Engine installation process is practically identical to the normal After Effects install, except you select the 'Render Engine' option in the Setup dialog.

Once the install is complete, open the After Effects Watch Folder on your RenderNode/s.

Watch Folder Setup

With Watch Folder rendering, the Render Engine of After Effects operates as an automated rendering helper. This helper is directed to a specific folder, which you deposit projects into, commonly accessible to all RenderNodes.

Before you can use the Watch Folder command, you first have to create the common destination for the Watch Folder. This file should be located on a robust file server, but can just as easily be located on your main workstation (Windows users: do not use Mapped Network Drives).

1 On your server's fastest hard drive, or your local drive, create a new folder somewhere within another network accessible folder. It can be called anything you want, but you might as well call it 'Watch Folder'.

2 On your RenderNode/s, open the **Watch Folder** command located in the main menu: > **File** > **Watch Folder**

3 Navigate through your network to the Watch Folder's location, then click 'OK'.

The Watch Folder dialog is now awaiting projects to render.

Preparing Your Project for Watch Folder Rendering

There are four prerequisites to preparing your After Effects project for Network Rendering:

- All your Imported resource files need to be accessible to your RenderNodes
- All Render Engine copies of After Effects on your RenderNodes must have the same authorized plug-ins as the machine that created the project
- All RenderNodes need the same fonts installed as the machine that created the project
- All RenderNodes need the same Codecs installed as used in all your file resources.

Import Network Accessible Files – This is the most common SNAFU of novices to Network Rendering. If all of your files reference your *local* hard drive, versus your hard drive as seen on a network, the RenderNodes won't be able to find the project files needed to render.

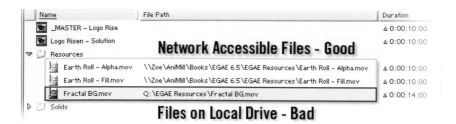

Name	File Path	Duration
_MASTER – Logo Rise		⚠ 0:00:10:00
Logo Risen – Solution	**Network Accessible Files - Good**	⚠ 0:00:10:00
Resources		
Earth Roll – Alpha.mov	\\Zoe\AniMill\Books\EGAE 6.5\EGAE Resources\Earth Roll – Alpha.mov	⚠ 0:00:10:00
Earth Roll – Fill.mov	\\Zoe\AniMill\Books\EGAE 6.5\EGAE Resources\Earth Roll – Fill.mov	⚠ 0:00:10:00
Fractal BG.mov	Q:\EGAE Resources\Fractal BG.mov	⚠ 0:00:14:00
Solids	**Files on Local Drive - Bad**	

This might seem an unnecessarily complex and convoluted process, but in practice it's not all that difficult to use: merely remember to import your resources through your Network Directory rather than your local hard drives.

RenderNodes Need Authorized Plug-ins – Another mistake to Network Rendering is forgetting to install the same plug-ins as your main workstation. Some plug-in developers allow unlimited Render Engine copies installed, while others demand a license fee for their plug-ins' use on each RenderNode.

RenderNodes Need The Same Fonts – Failing to have the same fonts installed on the RenderNodes as was used in the production workstation is frustrating, because the fonts have to be individually installed into each RenderNode's OS. Remember, when you use a font in the Type Tool or in the Effects plug-ins, install that font onto all your RenderNodes.

RenderNodes Need The Same Codecs – The last mistake is failing to have the same Codecs installed on the RenderNodes as are used for the video resource files imported in your projects. Just like fonts, be certain to install all your Codecs in your system's OS.

Watch Folder Rendering – Ready, Set, Render!

Once all of your resources are Network Accessible, plug-ins have been installed and authorized, and all fonts are installed, you can submit your project to the Render-Farm's Watch Folder to begin Rendering. This submission process is just like saving your project, but with a few options.

Instead of using the > **File** > **Save As** command, you use the > **File** > **Collect Files . . .** command. This is the 'packager' for sending After Effects files to the Watch Folder.

1 Open *Logo Risen.aep*, then select the *Logo Risen – Solution* Comp and add it to the Render Queue (Ctrl + Shift + /).

2 Set the **Rendering Settings** to 'Best Settings'.

3 Set the **Output Module** to 'Lossless'.

4 Click on the **Format:** drop-down menu and select 'JPEG Sequence'.

5 Click on **Format Options . . .** and set the > **Image Options** > **Quality** to '9', then 'OK'.

6 Press 'OK' in the **Output Module** Settings.

7 Click on the **Output To:** file name. In the **Output Movie To:** dialog, navigate to where you want your sequential files to be saved, then type the name you wish to save or simply use the default name, which is based upon the Comp's name.

8 Be certain to keep the brackets ([]) encasing the number (#) signs.

When you output sequential files, After Effects applies a special suffix to your file name to designate that a numerical sequence needs to be added to the file name. The amount of number signs indicates the length of the numerical string to be appended to the name (i.e. FileName_[####] equals FileName_1234.jpg).

9 Press 'Save' to set the file name and destination.

10 Click on the 'Best Settings' template name to open the **Render Settings** dialog.

11 Set the Field Render: to 'Lower Field First'.

12 In the **Options** section, uncheck 'Use storage overflow'.

13 Activate the 'Skip existing files' check-box, then click 'OK'.

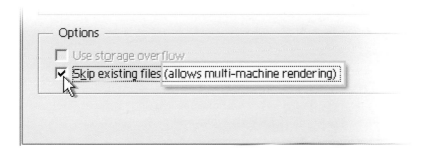

This is a critical operation to allowing Multi-Machine Rendering. This enables all the After Effects Render Engines to Render the same project, but work on unique files at the same time. If it's not selected, only one machine will work on each Render Queue project item at a time. This is also why you can't Multi-Machine Render QuickTime, MPEG, or AVI movies, since they are single self-contained files of multiple frames, rather than multiple files of single frames.

As always, it's best practice to save your work with a new name prior to rendering. But to prepare for Network Renderings, you should perform one last procedure: Reduce Project. The Reduce Project command removes all unused file resources and Comps from your project. This can greatly help speed up Network Rendering, because your RenderNodes won't have to access or load unnecessary files. Reduce Project can be applied to multiple Comps at the same time and takes into account all deeply rooted Precomps, so you don't

have to select every file you use in your projects – only the final top-level
Comps need be selected.

14 Select the *Logo Risen – Solution*
Comp.

15 Select > **File** > **Reduce Project**.

16 A dialog appears informing you of
how many files were elminated –
click 'OK'.

17 Now **Save As** your project with a new name (*Logo Risen –
NetRender.aep*) that reminds you that the project has been **Reduced**
prior to Network Rendering.

18 Select > **File** > **Collect Files . . .** to activate the Network Rendering
process and the Collect Files dialog opens.

This is the final step for Network Rendering preparation. Under the **Collect
Source Files:** drop-down menu are options for how projects are 'Collected':

- **All** – every file listed in the Project Window is saved; this can make for
 huge Collected Project files and take a *really* long time, but it's great for
 project archiving.
- **For All/Selected/Queued Comps** – only files associated to Comps are
 collected.
- **None (Project Only)** – saves the After Effects Project file only to the Watch
 Folder.

The **None** option takes advantage of the Network Accessible Imported
resource files by saving only the Project file, not the actual resource files, unlike

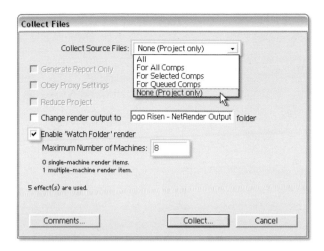

the other options. If you have minimal resources to Collect, you can use the other options and standard file Importing.

19 Select the **Collect Source Files:** 'None' option.

20 Click on the **Enable 'Watch Folder' render** check-box.

21 Enter the number of RenderNodes you want to include in this project's render into the **Maximum Number of Machines:** value box.

22 Click 'Collect . . . ' and navigate through your network to where the Watch Folder has been set up, then click 'Save'.

Once you click 'Collect' the project is saved to the Watch Folder as a folder containing the After Effects project, along with some other setup files for the Render Engines to access.

As your project renders on your Render-Farm, you can observe its progress via the Watch Folder Progress web page found inside the Watch Folder itself.

Depending on what your final output needs to be, after your project has rendered you can simply import the finished file sequence then compile a single movie for client delivery or web review.

Of Codecs and File Formats

A short note on using the 'right' codec and file formats. As of my last count I have 32 different QuickTime flavors available to me – and there are probably

many more. AVI has 16 or so flavors (that makes QuickTime twice as good?). After Effects can output 24 formats (more are available as plug-ins) with and without the Alpha Channel included with many of them. That's 72 different methods to render and deliver your project to your client. So which should you use? Which is the 'best' flavor? 'Cookie Doh!' comes to mind here. Well there really isn't any single best format, but there are a few more commonly shared formats: QuickTime is the standard-bearer for the vast majority of digital motion graphics. Many designers like to use the Animation codec of QuickTime, but with disk space no longer an issue None is a safe bet, guaranteeing quality and compatibility. Even if you are a Windows OS only user, you should have the QuickTime codec installed so you can share your files with a Mac OS facility.

Codec Issues

Be certain that every machine you use or will be providing files to all have the same common Audio and Video Codecs installed. A common problem designers face is seeing a white QuickTime movie. This is usually caused by a missing video Codec in your system that was used to generate the movie. To discover what Codecs are used in a QuickTime movie:

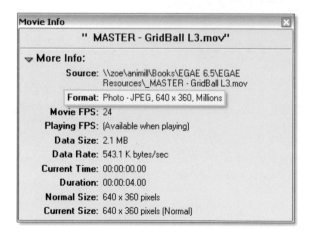

1 Open a QuickTime movie in the **QuickTime Desktop Player.**

2 Press 'Ctrl + I' or select > **Window > Show Movie Info.**

3 Check the **Format:** line for the Codec information.

APPENDICES

Practical Concepts of Things You Need to Remember

Using After Effects can be both inviting and intimidating at the same time. As you'll come to learn, the program is an empty canvas with many tools, options, and capabilities waiting for you to dabble. Using After Effects right 'out of the box' doesn't require much setup – you just need to know how After Effects interacts with your computer and media resources, that and how your project will be used.

In addition, it also helps to clarify a few concepts of technical gobbledygook. What's an Alpha Channel (and can I get it on my satellite?) and where's this 3:2 Pulldown I've heard about? Pixel Aspect Ratio – aren't all pixels square? And what's all the malice regarding Fields vs Frames?! Understanding these four technical issues, and their impact on imported files and your rendered production, will vastly help simplify your workflow and probably make your peers gasp in awe.

Project Preparation – Who, How and Why?

Are you a non-linear editor about to add some cool typography effects to your AVID/FinalCut/Premiere Pro project or are you an on-air broadcast designer who needs to build a quick promo bumper with a transition that has to offer a keyable wipe into and out of the footage? Or perhaps you're a 3D animator making a photo-reel visualization of a client's product to be composited over live footage. No matter who you are, you need to ask yourself (and your client) two things: 'who' is going to use your project's final result and 'how' are they going to use it. If you know the answer to these two little questions, your production flow will progress much more smoothly, your client will appreciate your diligence, and your bottom line will just appreciate. It just makes sense to spend a little pre-production time determining the answers to these little details.

Who Will Use My Project?

Are you delivering your work to another After Effects user? Or perhaps an editor who does a significant amount of compositing will use your work. Master control? A promotions producer? A web designer? An art director? A moving

billboard programmer? Each of these people has extensive knowledge of their craft, but probably not very much knowledge of your craft. It's your job to learn from them what specifications they demand before you deliver your project to them. You don't have to educate them how you do your work – you simply want to determine the best method to build and deliver your project.

How Will My Project Be Used?

How many people know the difference between an Alpha Channel and a Keyable Mask? Or how about a Straight vs a Premuliplied keyable movie? What's a 3:2 Pulldown? Can Progressive Scan footage or animation be intermingled with Interlaced Field footage? Am I allowed to say intermingled in an internationally distributed book? These are just a sampling of file formats you'll be generating when you render your finished project. Few people know (nor do they need to know, but I'm going to teach them anyway) what a Premultiplied movie is or how a 3:2 Pulldown works. All they want to know is that the finished project will work flawlessly to their specification.

This all may seem like rudimentary information, but as I explain these and other concepts, keeping your project's 'who' and 'how' in mind will help you know better how to apply the lessons in this book.

Project Setup – Target Your Project Settings

For most examples in this book I'll be using either HDTV 1920 × 1080 Comps at 24 fps or USA Digital TV 720 × 486 at 29.97 fps. Generally, for those of you who use DV, PAL or Film, the concepts still apply, only the screen sizes and frame rates have been changed to protect the innocent.

Media Formats – Knowing What to Look for in a File

Each type of media file has its own special qualities that make it unique to the Import dialog and how it's used in your projects. There are generally five kinds of media you'll be importing:

- **Bitmap Images** – BMP, CIN, JPEG, PSD, PICT, PNG, RLA, TGA, TIFF.
- **Movie Clips** – QuickTime, DV, AVI, MPEG, OMF, SWF.
- **Vector Images** – AI, EPS, PDF, PICT.

- **Audio Clips** – IFF, MP3, WAVE.
- **Project Composition Files** – AEP, PRPROJ, PPJ.

Each of these files has attributes that should be addressed as they are imported, before they are used in your project.

Alpha Channel – The Embedded Mask Layer

Many of the media formats described previously can have more than just the visual data included, they can have additional Channels or Embedded Data that After Effects uses for proper layering and other unique effects. Perhaps the most common extension is the Alpha Channel – the image's embedded mask. All too often, a well-designed animation is ruined when its Alpha Channel is misused.

The Alpha is an additional channel of visual data (in addition to the RGB or CMYK color channels for print) that has a range of luminosity from black to white. Usually a full value of white indicates the RGB image will be seen completely when layered atop another background item, whereas a gray level Alpha allows both the background and the RGB image layers to mix together.

Black will prevent any of the foreground RGB image from being seen, making the background fully viewable.

Notice the image at right. It's composed of two images: the foreground robot with its Alpha, and the background stage. The foreground layer shows the RGB image data with the Alpha Channel separated beneath. The white areas in the Alpha create a mask that blocks the background from being seen (it creates a hole in the background for the robot to fill), while the black areas allow the background to be seen.

In a perfect world your images would composite perfectly every time with all edges blending seamlessly into the background or next layer beneath. But it's not a perfect world and we'll always have issues with improper keys not blending the way we expect.

Black Lines Around My Logo

How many times have you seen a great looking logo (or simply some text treatment) keyed over some cool background only to be ruined by a distracting black line around its edges? It happens all the time, and it's usually caused by a graphic designer rendering their project as Premultiplied Alpha when their client can only use Straight Alpha files. There are ways for your client to compensate for Premultiplied Alpha files, but a vast percentage of clients don't have the technical understanding to identify and correctly use Premultiplied Alpha files.

Premultiplied vs Straight Images

To the previous robot image we'll add another layer applying some energy glows to the robot's gun. When these glows were rendered, they had a special option applied to the Alpha and RGB Channels to allow proper blending of the layers.

Notice the two images below; the left image has the glows blended correctly while the right image appears muddy and darkened. The image at left was imported with a Premultiplied Alpha, whereas that on the right was imported Straight but was rendered Premultiplied.

Correct Glow Blending

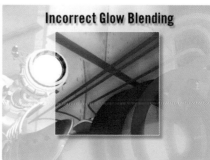

Incorrect Glow Blending

Usually you can simply let After Effects determine the Alpha interpretation by setting 'guess' in the **File** > **Preferences** > **Import** menu. But if your image doesn't look right in your project, you'll need to manually adjust its Alpha interpretation.

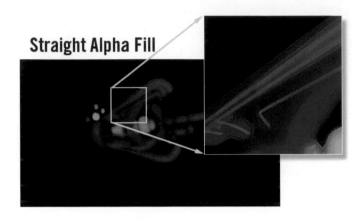

Straight Alpha Fill

Look at the image of the gun's rendered glows above. Notice how the colors are strangely bleeding into each other. This is because when the glows were rendered, the computer inflated the color channels beyond the clean fade away that you'd expect. To print artists this is the equivalent of a bleed. This color expansion allows the Alpha Channel to smoothly blend the colors into any layer beneath. If this color expansion did not take place, the colors would fade to black as the Alpha Channel fades, creating a compound fade to black: the colors would look dark and muddy (as seen in the Incorrect Glow Blending illustration) as they blend into the layer beneath.

The Premultiplied Alpha version of the previous file example appears on the following page. See how the colors smoothly fade away to black. When After Effects uses a Premultiplied Alpha image it automatically accounts for the natural fade to black (or any color used as the background for that matter) when layering the image atop other images. Here the glow of the gun will blend correctly because After Effects compensates for the Premultiplied Alpha.

So here's a good tip: when providing keyable files with Alpha Channels to other designers or compositors using After Effects (or other high-end compositing programs: Shake, Combustion, Commotion), render your projects with Premultiplied Alpha (usually the default). But when preparing your output for

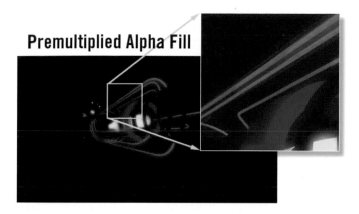

Premultiplied Alpha Fill

editing programs (Avid, Premiere, Edit, FinalCut), render your files with a Straight Alpha. The files' weird color blending might surprise your editing client, but they'll thank you when they begin keying your files over their footage.

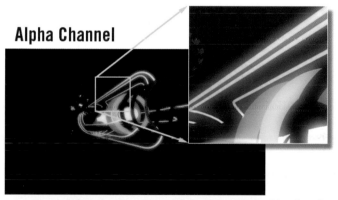

Alpha Channel

For Reference, Here's What the Gun Glow File's Alpha Channel Looks Like

Pixel Aspect Ratio – When a Square Pixel is Not Square

Pixel Aspect Ratio (PAR) refers to a spatial (visual screen area) correction applied to an image as it is displayed on a TV. Put more simply: it's a kludge to fit more visual data on your TV screen than it was ever intended to show. Each video system has its own unique frame size and PAR to fit the production workspace on their corresponding screens. The next page shows four different NTSC and PAL screen areas, and a correlation to its actual workspace and PAR you'll be using in After Effects. The top four illustrations on the next page show how we

are supposed to see our finished images as viewed on either standard 3:4 TVs or wide HDTV 16:9 screens. The lower panel displays the same four images as the top, but as the physically rendered digital files for use in an editing or graphics program, or recorded to DVD and tape.

As you can see, Non-Square Pixels create a distorted image that must be compensated for prior to display. When 16:9 images are compressed to fit on

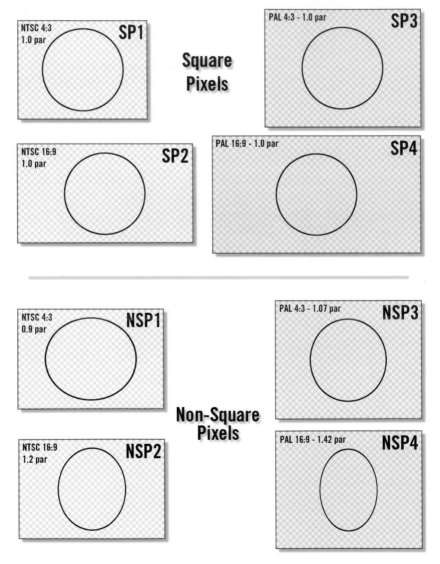

an NTSC or PAL standard screen space, it's often referred to as an Anamorphic compressed image. After Effects will both import and render all eight (and many more) of these PAR examples – and you can work in any of these layouts as your composition canvas.

Yes, it is complicated, but don't get scared. Because After Effects offers so many options to the designer, you can construct the same project several ways and end up with the same visual result. Take, for example, the following scenarios for an NTSC 16:9 Widescreen Standard Definition video (canvas refers to the workspace or preview screen):

1 16:9 – 1.0 PAR flat canvas at 29.97 fps rendered with Anamorphic compression.

2 16:9 – 1.2 PAR Anamorphic canvas at 29.97 fps.

3 16:9 – 1.0 PAR flat canvas at 24 fps, rendered with 3:2 Pulldown with Anamorphic compression for 29.97 fps playback.

4 16:9 – 1.2 PAR Anamorphic canvas at 24 fps rendered with 3:2 Pulldown for 29.97 fps playback.

Each of these compositions would provide approximately the same visual result – a widescreen 16:9 NTSC video. Argh! So which to use?! The answer lies in how you choose to work and how sensitive to motion artifacts and visual distortions you or your clients are. The only objective fact about the four scenarios listed above is this: '1' takes up the most memory, hard drive space, rendering time and screen real estate (your workspace), whereas '4' requires the least, but also has higher levels of motion artifacts (stuttering motion) and a distorted workspace.

But a subjective opinion is this: in this world of fast CPUs, cheap RAM, hard drives, and big computer monitor screens, it just doesn't matter very much that scenario '1' demands the most of your computer. But what does matter is that '1' will look the best to your audience and be easier for you to work within. This will be demonstrated later.

3:2 Pulldown – How to Force 24 into 30

Once again, you PAL people can laugh this off because you simply run your movies at the same Frame Rate as your TV – 25 fps. But for us NTSC or SECAM users (or anyone doing work with film to be output to these TV formats), we

have to deal with the inequity of trying to shove 24 fps of film (or now HDTV) into 29.97 fps of video.

The 3:2 Pulldown process is actually very simple and only requires a little remedial math to understand. Here's how it's done:

One second of film equals 24 and one second of NTSC equals 30 (rounded up). Simplification equates every five frames of NTSC to four frames of film – that is, the two media are in synchrony every 1/6th second.

So how do you make four frames of film equal five frames for video? Through a process where one frame of film is duplicated across two frames of video utilizing video's interlaced fields to split the shared frame. Look at the illustration at right. Notice how frame 1 of the film clip becomes interlaced with frames 0 and 2 to create the frames required to extend four frames of film into five frames of video. The term '3:2' is derived from this

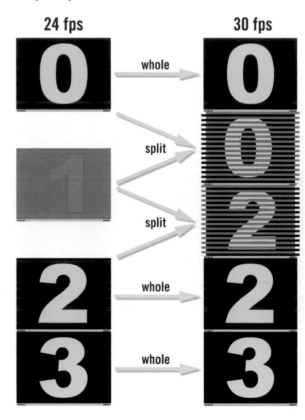

process of frame interlacing, keeping three frames 'whole' or transferred directly and two 'split' or interlaced frames.

Fields vs Frames – A Hot Topic Issue

The Fields vs Frames issue is almost as hot as the Mac vs Windows dispute. I'm going to give you my angle on this issue: Fields are good, Fields are our

friend – especially when it comes to typography builds. Fields exist for a reason (though that original reason is obsolete today) and should not be dismissed as passé. Fields (Interlaced Mode) offer more temporal information to the viewer than an equivalent frame rate Frame (Progressive Scan) Mode does. That is, if both modes are running at 30 fps, the Frames Mode system will show 30 full-resolution frames per second, whereas the Fields Mode system will actually show 60 half-resolution images per second. Our brains automatically compensate for the corresponding loss of resolution interlaced footage displays but benefit more from the doubled rate of motion smoothness. We are more sensitive to motion smoothness than image clarity.

Opinion: If you're going to be playing your project's output on a field-scanning environment (NTSC, PAL, SECAM), then render your projects in fields! I know, I know – I hear the hate mail already, 'But I can save 20% of my work if I render with 3:2 Pulldown added' or 'I really prefer the cinematic look rendering frames offers'. All I have to say is this: if your client doesn't care or see the difference and likes what you do – then, by all means, do what you prefer. But if you prefer smooth-flowing, easy-to-read text, logos and transitions, use fields – especially with text treatments. Text is far more readable on a field playback medium when rendered in fields, not frames.

Fact: If you don't properly interpret your movie clips' field order, wherever your project uses these clips, this footage will look bad when rendered. Knowing what field order to use just isn't that hard to figure out. What can be difficult is figuring out what field order to use when rendering your finished project to an unknown output format.

Project Settings and Preferences

Once you have a grasp of how to navigate and build projects, you should become familiar to some critical tweaks to key After Effects functions. By doing so, you will help prevent much aggravation as you progress in your quest to learn the right way to make your projects. There are two places you can adjust or customize how After Effects works for you.

Project Settings

The first area is Project Settings. Click on **File > Project Settings**, then the following dialog opens.

A few topics to consider prior to building your first project are as follows:

- What Timecode Base format or Frame Rate will you be outputting to?
- Do you need to run After Effects in 16 bit Color Depth mode instead of the standard 8 bit Color Depth?

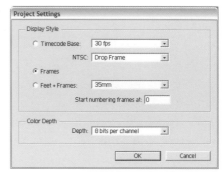

Display Style – Timecode Base

This option does not affect your project's actual working Frame Rate, but how the user views time as displayed in After Effects. Set this to the method you most prefer to view your time. A brief note: if you're working on an NTSC project, match your display (30 fps Drop Frame) to your files' Timecode Base. This sets your Timeline to 29.97 fps. Refer to the Glossary for further explanation on this relic from the bygone black and white era.

As for the starting number, some people prefer '0' while others prefer '1'. I use '0' because it makes for easier looping. Besides, most editing system Timelines begin with 00:00:00:00, just as most 3D programs render from frame '0', incrementing onwards. Keep your Timecode Base systems consistent.

Color Depth Modes

Generally, run After Effects at 8 bits per channel. Switch to 16 bit when you expect to need a wider color space gamut. The advantage to using 16 bit (281 trillion colors) Color Depth is the elimination of color banding and a deeper color palette. The illustration at left shows an exaggerated example of color banding. Notice how the color ramp

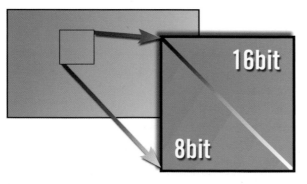

changes in steps at 8 bit rather than the smooth gradient in 16 bit. If you expect to be using a tight range of colors in your palette, then you might want to experiment with 16 bit. Just remember this: 16 bit takes up twice the disk space for your files and twice as long to calculate the results. Some people insist that if you output to film, you *have* to use 16 bit mode. But the fact is, there have been plenty of feature films rendered at 8 bit with spectacular results. If you will be creating HD graphics (which operates in a 10 bit color space) and you intend to do much color screen keying (blue or green screen), you'll be better off working in 16 bit color space.

Application Preferences

After Effects offers you additional options to customize how you interact with the interface, and how projects and files are utilized.

Click on **Edit > Preferences > General**. A dialog opens with a number of options. The illustration at right shows my preferred settings; you should experiment with the options to see what works best for you. I do recommend the following for the General settings: check 'Synchronize Time . . .'. This ensures that, when you have Timelines (Precomps) nested within other Timelines, all the Timelines' cursors will match each other's Timecodes. As for the number of 'Levels of Undo', the higher the number, the more RAM is used to keep track of your changes.

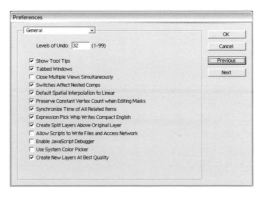

Previews – Here you adjust the interactivity of the After Effects Composition Window (Preview Window) and OpenGL information with options. You can set the level of

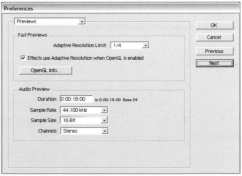

adaptive degradation – the ability of After Effects to automatically reduce preview resolutions to increase preview responsiveness. With slower CPUs and hard drives, set it to 1/8, otherwise 1/4 is fine.

In the Audio Preview section, you can set the duration of preview audio that After Effects will loop and the quality of that preview. To save RAM, drop the Sample Rate to 22 kHz, 8 bit, and Mono. This will give you more RAM to make longer and quicker audio previews.

Display – This page lets you change the way the Composition Window will show motion path trajectories. Setting this to 'All Keyframes' can cause your screen to become a jumble of criss-crossing lines. Keep it set to a few seconds or frames.

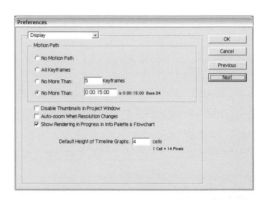

Import – These settings adjust how your resources are 'seen' in After Effects. 'Still Footage' should be set to 'Length of Composition'. When you import series of numerically incremented stills (for example, rendered 3D images or time-lapse stills), After Effects applies this Frame Rate to the sequence, making the sequence appear as a movie clip. Be certain to match your

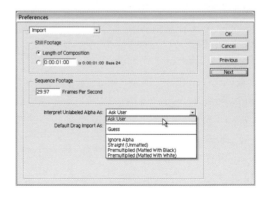

sequences' Frame Rates to your project's Timecode Base. Set your Interpret Alpha to 'Premultiplied . . . Black', since most graphics with an Alpha use this method of matting. You can always change the Alpha setting later should some graphics not work correctly. The 'Default Drag . . .' setting lets you choose how After Effects prepares items when you use drag and drop from the Finder/Explorer. Just leave it as 'Footage'.

Output – Press 'Next' for Output options. If you do a lot of cross-platform file sharing (Mac > Windows), you might have run into some file size limitations. In the Output page you can select the option to automatically divide your project into short QuickTime segments as After Effects renders. Just click on the 'Segment Movie Files At' check-box and then type in the file size limit you need (for most system sharing, set it to 4095 MB or 4 GB). But remember to uncheck it for your usual work or else *all* renderings will get split. The other settings perform a similar function of segmenting files, but for other reasons: Overflow allows you to render to multiple drives and automatically move from one to the next when the previous drive fills up.

The next three pages are pretty self-explanatory, so for the sake of Carpel Tunnel prevention, I won't go into detail about these screens. I will say this though: the use of colors to identify (and group) your layer contents is a great way to keep track of your elements. And knowing what your grid settings are can help you break down a composition into a well-balanced visual. Needless to say, just keep these at their defaults – you can always come back to customize them should the need arise.

Memory & Cache – With the advent of version 6.5, After Effects now offers Disk Caching to preserve unchanged, often accessed files or layers. This expedites the whole I/O process, giving the user quicker response

times for composition development. This function creates a dedicated file of the preset size to keep track of your unchanged resources or layers. You can set this to whatever you like, but a file too large can reduce your system's overall performance. Try keeping to 2 GB or 4 GB (if you're using a Windows PC running the FAT32 file system, you cannot have this file any larger than 4 GB). Set the 'Choose Folder . . .' location to your fastest hard drive and select a folder wherever you want (you cannot just select the root drive without a folder). The other settings determine the allocation of system memory and how much virtual memory is shared. The default settings are fine, though if you run many other applications at the same time (i.e. Photoshop, Illustrator, Maya, 3DS MAX, etc.), you may discover that your system memory runs out a wee bit too soon. Then it's up to you to decide who needs the most memory and how best to share.

Video Preview – If you have a FireWire capable machine (and you should!), or a dedicated D1, or HD video output card, After Effects can display its Composition Window (Preview Window) out to a TV or HD monitor. This is extremely convenient for ensuring 'what you design is what you see'

(WYDIWYS?). The fact is computer monitors don't even come close to accurately (or more correctly – inaccurately) showing what a regular TV displays. By hooking up a DV display device to a TV, you are more likely to see color artifacts and errors than just viewing your work on a computer monitor.

Use the drop-down menus to select the Output Device you can use, and then select the Output Mode (NTSC or PAL). Other options offer After Effects more

or less interactively and affect the speed of your interface and workflow. Remember, more options equal less speed.

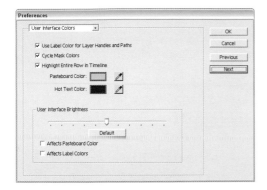

User Interface Colors – The last page offers you the option to adjust the 'look' of After Effects. Lighten or darken the interface to your liking – or leave it 'as is' to match the look of other Adobe interface applications.

Conclusion

There are only so many features that could be covered in this *Easy Guide*. I have tried to cover the most commonly accessed features and most often faced obstacles without becoming too intricate in the details. After Effects is so all-encompassing it's impossible to cover the features every user expects.

But that said, it's astounding what can be accomplished with After Effects even knowing only a smattering of its capacity. All that's required to create superior work from After Effects is the desire to experiment, take chances, and become immersed within its toolset. And learn from the experience of others.

Become *inspired* by other designers' work, not *intimidated*. Seek out as many resources you can find and absorb their knowledge. Remember: nobody knows everything, but everybody knows something. This is especially true with After Effects. I find that every day I discover something new and helpful that makes my work easier and more rewarding.

But most important, enjoy what you create. I said at the beginning of this *Easy Guide* that the primary reason for After Effects' success is its accessible power to create memorable visuals – but that's only part of the story. The real reason is because it's fun to use: once the apprehension is overcome, the enthusiasm overcomes you.

So now get to it! I look forward to learning from you.

Glossary – Big Words to Know, Impress Others With, and Love

Alpha An additional picture channel (usually composed of black and white and shades of gray) embedded in an image's data that identifies what parts of the image appear solid or its levels of transparency when that image is composited on top of another image.

Anamorphic A process used to take a widescreen image and squish it in one dimension (usually horizontally) to fit it inside a standard frame space. '16 by 9 Anamorphic' takes a 1.77:1 image and squeezes its width into the space of a 1.33:1 standard frame, giving the final image a tall and skinny look. CinemaScope or Panavision are 2:1 Anamorphic processes that create hugely widescreen images out of standard film.

Anti-aliasing The process of removing the rough staggered or stair-step look of an image's lines and edges. Since a screen has a limit to how many pixels it can show, angled lines or a shape's edges must be smoothed to account for the limits it's called to fill.

Aspect Ratio The dimensions of the screen in terms of its height versus its width, i.e. 1.33:1 (1.33 to 1) refers to a rectangular screen with its width 1.33 times the dimension of its height. Likewise, the '16 by 9' designation commonly referred to as widescreen has an aspect ratio of 1.77:1.

Boolean A mathematical calculation where one object applied to another object affects a combined resultant of the two objects.

Bump A short transitional video sequence used in TV broadcasts where a show makes a dramatic change of subject or in-and-out of commercial breaks.

Codec Short for **Co**mpressor/**dec**ompressor – the method by which a digital file is converted into a smaller and/or faster, more easily distributed file. All audio and video files have a codec assigned as they are saved and require the same codec available to the user to play the file.

Color Space The range of colors that can be described mathematically for display and output. Variations of modes to describe Color Space include LAB, RGB, HSV, and CMYK. They can be sampled from 1 bit to 16 bit accuracy.

De-fragment When a hard drive has many new files added or old files modified, moved or deleted, often the organization of the file structure becomes severely discontinuous or 'fragmented'. De-fragmenting your drive makes these broken-up files continuous and moves them closer together for faster access.

Drop Frame A method of compensating for an arithmetic error caused by the color TV signal recording system. In black and white days, TV was precisely 30 fps; when color was invented for USA TVs (NTSC), the Frame Rate (now 29.97 fps) had to be slightly altered to allow for the color system to work. Drop Frame timecode accounts for this slight change by displaying 30 fps, but dropping two frame numbers (not images) every minute of video, but not at every 10th minute (this is where you can slap yourself on the forehead in frustration).

FAT32 The structure for file storage on large Windows hard drives created by Microsoft. FAT32 (File Allocation Table 32 bit) allows for hard drive partition sizes up to 2 terabytes, but individual file size is limited to 4 gigabytes.

Fields The method by which video images are assembled to increase perceived temporal and spatial resolution. Each image of a video frame consists of two clusters of alternating horizontal scan lines, where the image is split in half, then transmitted as these split 'Fields'. Upon reception, the 'Fields' are interlaced, forming a whole frame.

Gamut The distribution or extent of a Color Space. The amount of colors a system can display.

Interlacing The stitching of alternating scan lines of a field-recorded video frame. First, the frame is displayed at half resolution, then the remaining missing field is 'interlaced' into the first field's missing scan lines, forming a complete full-resolution image frame.

Interpolation A calculation done to determine a missing value existing between two known values.

Keyframe/s A specific instruction or point in an animation where some form of event occurs. Keyframes are indices where the animator wants the computer to begin, continue, or end its interpolation or translation of a motion or effect sequence.

Network Rendering By distributing your project's workload to multiple remote computers (Render-Farm) you both speed up the production process and release your main workstation to continue with more production. There are two types of Network Rendering: Distributed Rendering, where each computer is assigned its own unique project frame; and Concurrent Parallel Rendering, where all computers are assigned individual chunks of the same project frame (often called bucket-rendering).

Partition An internal electronic hard drive structure where data is allowed to be contained. Every hard drive must be initialized or formatted so the computer knows where to save its data. A partition is the dedicated area created to allow data storage. A hard drive can have one or many separate partitions. Operating Systems determine the size limit of a given partition.

Pixel Aspect Ratio The dimensions of each pixel's virtual height versus width. It usually refers to the method of image squish to create widescreen images inside standard frame space, otherwise known as Anamorphic compression.

Progressive Scan A method of recording a full-resolution image in one frame without resorting to interlacing scan lines. Each scan line is recorded in succession or all at once, resulting in clearer definition.

RAID Redundant Array of Inexpensive Drives, a cluster of hard drives that are attached to each other in either a managed group for security reasons, where data is divided up to each drive using a secure recording code (RAID 5), or acting as one big fast drive where the data is shared alternately across the cluster (RAID 0).

Raster An array of individual pixels clustered together to create one complete image. Usually measured by the number of horizontal pixels versus the vertical pixel count.

Rasterize The process of rendering a vector file's line drawings into a bitmap image. Since a vector file only contains mathematical descriptions of a shape and its color, before it can be visualized it must interpolate where the image's lines and colors appear on the screen.

Render-Farm The use of one or more simple dedicated remote computers in the process of building your project while your workstation is free to create more projects.

Ripple When a sequence of clips (all the way to the end of the show) moves as one group as a new shot is added to or removed from a show.

Rotoscope The process of frame-by-frame manual image adjustment by either painting or masking a specific area within the frame. Used to create loose Garbage Mattes or excruciatingly detailed object/character isolation.

Temporal Aliasing A perceived duplication or stutter of a moving image caused by repeated display of the image. Your eyes get fooled into seeing multiple instances of a single rapid moving image rather than seeing a single smoothly moving image (an optical illusion)

Index

Italic page numbers refer to illustrations.